P9-BJO-935

WRITTEN AND PHOTOGRAPHED BY

IAN GITTLER PORNSTAR

SIMON & SCHUSTER

SIMON & SCHUSTER
Rockefeller Center
1230 Avenue of the Americas
New York, NY 10020

COPYRIGHT ©1999 IAN GITTLER
All rights reserved,
including the right of reproduction
in whole or in part in any form.

Simon & Schuster and colophon
are registered trademarks of
Simon & Schuster, Inc.

Designed by Shawn Dahl and Ian Gittler.

Printed in Italy.

FIRST EDITION

10 9 8 7 6 5 4 3 2 1

Library of Congress
Cataloging-in-Publication Data
Gittler, Ian.
Pornstar / written and
photographed by Ian Gittler. — 1st ed.
p. cm.
1. Erotic films. 2. Motion
picture actors and actresses—
United States Biography. I. Title.
PN1995.9.S45G58 1999
791.43'6538—dc21 99-27281
 CIP

ISBN 0-684-82715-8

This book contains sexually
explicit text and photographs.

"My childhood? It didn't last long but it was good."

Debi Diamond

"Who sends the children out to war? Their parents do."

Bob Dylan

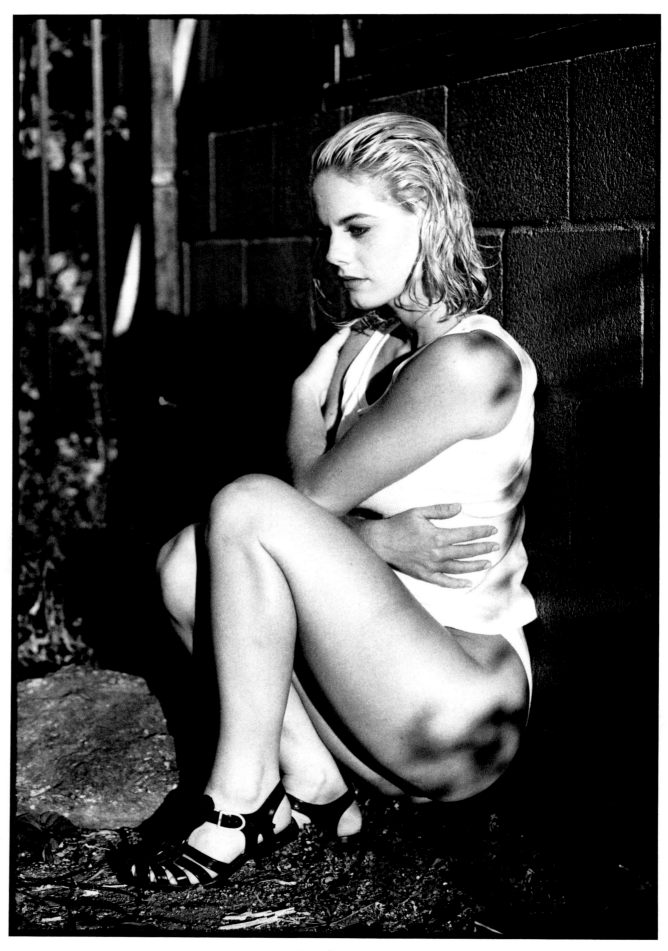

Jamie Summers

"HELLO, THIS IS ————. YOU MIGHT KNOW ME AS JAMIE SUMMERS."

I don't. The extent of my research: the video booths at Show World Center, across the street from the Port Authority Bus Terminal on Eighth Avenue and Forty-second Street in New York; *Hustler's Erotic Film Guide*; a handful of other magazines that feature stills from porn videos (black bars over insertion points); and the sex loops run on cable TV in between ads for escort services. Research by default. The name "Jamie Summers" sounds familiar, but I don't think I know her face.

Jamie keeps the call brief. She invites me over, this afternoon, to talk more, and possibly to do pictures. That'll depend on how she feels.

I wasn't expecting a call from Jamie Summers, or anyone else. I'd already resigned myself to the fact that my trip to Los Angeles had been a bust, that Jenny Wren, the publicist at Vivid Video who had sounded so encouraging at first, forgot who I was by the next call, and then sounded all encouraging, again, once I'd explained myself all over, had done everything she could, or at least everything she planned on doing for me. Her conclusion, a lesson: These people don't pose for pictures for free.

I've never met a porn star.

The girl who opens the door looks nervous. She's young, "twenty-three," she says. A thick base doesn't conceal a broken-out complexion. Her eyes are set close together. Her clothing doesn't reveal much about her figure. In heels, she's no more than five-foot-five.

Her Hollywood apartment is a classic example of postwar LA architecture: arches, elaborate crenellations, window crowns, a garden enclosed by wrought-iron gates. Inside it's airy and spacious.

Jamie and I sit in her living room and make awkward small talk. She says Jenny Wren—who did turn her on to what I'm trying to do—goes out with Steven Hirsch, who owns Vivid. Jamie says that at one time she went out with Steven Hirsch, too. She says Wren is an ex–porn actress.

"She's nice . . . but a little flaky," Jamie says.

I ask her stupid questions about her career, like, "You've had sex with Peter North?" Jamie looks at me like I'm a little strange and laughs. Obviously I'm more impressed with the whole idea of what she does for a living than she is. Jamie says she just wants to act in "real movies." She's surprised that anyone would give a shit about her present career. But I'm persistent so she humors me. She acts bored, though—except when she talks about this book.

"I love those pictures you gave Jenny. I want ones like that of me."

Jamie says she's going to take a shower and then I can photograph her. She drops her pants in front of me and lifts her blouse over her head as she walks toward the bathroom. Before disappearing she glances back to make sure I've seen her body.

I follow her and lean in the doorway of the bathroom. She smiles. Somehow her getting naked breaks the tension. Her transformation is palpable: She seems easier, more confident; her body is how she asserts control. It's a relief. I was worried about photographing her, worried she wouldn't look pretty.

I'm not here to document her acne, and Jamie telling me in the first five minutes that she's trying to change careers, get out of the sex business, just kind of gets stored away. Jamie is a movie star—a dirty one, but still a star—and her fancy apartment, her BMW; these are things I use to confirm ideas I had coming in to this. Her looking good completes the picture.

Two Jil Sander advertisements Jamie cut out of a magazine are taped to the inside of her closet door. She rummages through dozens of pairs of shoes, all kinds of dresses, bustiers, boas. Stripper things in every color share overflowing shelves with designer stuff from stores on Rodeo Drive. Jamie wets her hair once more then we walk out through her garden and find an alley around the corner of the building.

Jamie's left eye flickers, a nervous tick or something. She jokes about it, then takes a couple of deep breaths. She flares her nostrils for a second, tries to focus, to make it stop, and it makes her look like a bad girl, almost evil. Images of abused pets pop into my head. I prefer the idea of Jamie as the pretty, happy daughter of an LA physician—"My dad's a great guy," she says—who just happens to be a porn star. Jamie breathes deeply, relaxes, and we continue. A Mexican couple watch from behind a screen window.

"I think that's my super," Jamie says.

She lights a Marlboro 100.

IN HER BEDROOM, Jamie stands in front of a bureau mirror combing her hair. Herb Ritts's *Men/Women,* in the hard-shell dust jacket, rests on the headboard of her

queen-size bed. She walks over to the window, turns, and looks at me from across the room. There's a poster of Marilyn Monroe on the wall behind her, a potted tree in the corner.

"You have a girlfriend," she says.

I ask Jamie if she has a boyfriend.

"Kind of. I mean there's a guy who kind of takes care of me. He's older, not really a boyfriend. There was someone else recently, too, you know, an actual boyfriend, or potential boyfriend. When I told him I'm 'Jamie Summers' it freaked him out, I think. He's only called once since then. I'm not sure what's gonna happen with that. I've been *there* before, y'know?" She pauses. "I've been hurt, too."

Jamie smiles, then looks at the floor as the smile goes away. She sits on the corner of the bed.

A key turns in the front door.

"That's Steven," Jamie says. "He's like my roommate, I guess."

Steven, a slight, handsome, gay twenty-one-year-old sometime film student, is Jamie's assistant/roadie/sycophant/friend. He lives in a second bedroom, off the kitchen. Jamie supports him. She takes Steven with her on dance tours. He carries her bags, "watches over me." Steven is impressed with my pictures, too, or at least with the magazines that have published them. I think if Jamie had any reservations, her seeing Steven's reaction helps.

"I bet ——— would do photos," she says, excited. "She used to be called Careena Collins. She got out, y'know, of the business, and started law school. You'd really like her, though. She's really cool. She's into bondage and stuff like that.

"And you have to meet Tommy, too" Jamie says. "Y'know, Tom Byron. He lives with Jeanna Fine and her boyfriend, Sikki Nixx. They're all gonna think you're so cool."

Jamie Summers is on my side. That feels cool.

I DISCOVERED SEX IN AN ERA WHEN FUCKING WAS A WAY OF EXPRESSING FREEDOM.

I was a child of that movement, its poster boy. Remember those old pictures of the Stones? I'm not saying Annie Leibovitz fucked her subjects but God her photographs made it look like she had and that was always the myth—that she was part of it somehow, and that we, as viewers, had access into a world of renegade sexuality through her participation. And of course the music could withstand that subtext; it had inspired it. Mick and Keith once lashed tongues on national television. As a teenager that meant something to me. It still does.

Then there was the tragedy of AIDS. Homophobia and misogyny were acknowledged aspects of white American youth's appropriation of rap and heavy metal. The sexual arena became a different kind of proving ground for young people. Promiscuity was about self-destruction, disaffection, and violence—not liberation.

A friend suggested I do a book about rock stars. "Since you're a musician, too," she said. But I couldn't get it up for that, couldn't think of an angle that interested me. My rock heroes had already been photographed. And as a fledgling commercial photographer I'd had a taste of what it was like shooting bands for magazines. There was always some publicist pointing at a watch. Serious pictures don't happen that way.

The pre-Nirvana music business had developed as homogenized a corporate identity as fast food. Image control had reemerged as a celebrity status symbol. In a way porn stars were an anachronism. The life I imagined them living was one more related to my sense of what "rock & roll" meant than anything I could see on the pages of *Rolling Stone*.

Fucking on film was *very* rock & roll.

I figured once the porn stars met me and saw that I could identify with them—or with what I thought they stood for—access wouldn't be a problem. They'd enjoy the attention. They were real movie stars, but ones that Herb Ritts hadn't already photographed. Jack Nicholson's smile through a magnifying glass. Madonna, cross-eyed, wearing Mickey Mouse ears. In two images Herb Ritts summed up America's collective preoccupation with larger-than-life fame and fortune. But the eighties were over. *PORNSTAR* would be my response, sort of the inverse version of the eighties celebrity coffee-table book. Instead of beloved icons, I would glorify reviled (or at least only secretly admired) ones.

I was addressing letters to porn-star fan clubs before taking the time to think it through. A celebrity coffee-table book about porn stars; that was it, that's what I was doing. I dismissed any suggestion that there might be unhealthy pathologies at work in these people's lives. I didn't want to hear it, didn't want to know. That's not what my book would be about.

It didn't occur to me that in the name of my one-man crusade to vindicate American sexuality (in the shadow of Madonna's one-woman crusade), my desire to glorify the porn stars' lives might really be motivated by a need to in some way validate my own. All I knew was *PORNSTAR* could be the first cool picture book by an openly straight guy to come along in years.

Fucking was, in my mind, in the summer of 1991, as a guy in his late twenties, still the essence of rock & roll. Sexuality was a stance, an attitude, at the core of how I saw myself, and how I wanted to be experienced by others.

DAY ONE OF MY SECOND TRIP TO LOS ANGELES. JEANNA FINE SAYS IF I WANT TO MEET her it'll have to be this weekend, in San Francisco. After that it's more dance engagements, she says, a minitour. It's a test, like if I'm willing to travel to meet her then she'll take me seriously.

I try to reach Nina Hartley to see if I can meet her while I'm up there. Nina calls from a hotel in Detroit and says she doesn't have time to shoot but hopes we can at least meet at the Exotic Erotic Ball, a San Francisco Halloween party. That's the only night she'll be in town. Jamie Summers is away, too, dancing at a military base in Guam. Her gig was a last-minute thing. So for now Jeanna Fine is it.

Highway Five is a two-lane blacktop, hundred-mile-an-hour straightaway from LA to San Francisco.

The sky is dark. It's been raining on and off all day. Jeanna's here for the Exotic Erotic Ball, too. She decided to come a couple of days early to make an in-store appearance at a video retail outlet and do a few shifts in the jack-off booths of a local sex parlor.

"Doing the booths gets me off . . . it's a power trip," she says.

JEANNA IS in the hotel bar. I introduce myself. We shake and Jeanna holds on to my hand with both of hers and stares into my eyes. There's a smudge of red lipstick on one of her front teeth. She catches me looking at her mouth, grins, licks it. I blush, fluster. Her boyfriend, Sikki Nixx, is waiting upstairs. Jeanna senses my hesitation and her vibe changes: Her available sex goddess veneer disappears like the flick of a switch. The next ten minutes are spent trailing her around the hotel lobby as she runs a series of errands and acts annoyed with everyone who tries to help her.

Jeanna has modified her image—from flat-chested, spiky platinum blonde to jet-black hair and an explosive tit job. She says she was retired from porn, that she worked for Todd Rundgren for two years.

"I didn't wanna come back and be the same ditzy kid all over again," Jeanna says in the elevator. "This is me now."

Their room is a mess. Garters, feather boas, whips, stripper clothing and accessories, wet towels, fan-club flyers are all strewn around. A room-service cart with their half-eaten breakfast.

Jeanna introduces her skinny, pierced, tattooed boyfriend. Sikki is twenty-one and cute, not scary like in *Bad News Brat*, a tape Jamie gave me. He has stringy, long hair, and he's handsome, in a junkie-rocker way. He talks like a burnout, but a really friendly one.

Compared to her boyfriend, Jeanna is bouncing off the walls, speedy. Sometimes she smiles at Sikki and holds his hand, but she addresses him with impatient snaps. Her in-store appearance is in two hours, and Jeanna made Sikki in charge of getting her ready. Bad decision. He's lying back against the headboard breaking apart another bud to stuff in his pipe while she does her face.

Jeanna examines herself in the bathroom mirror. She tries to cover five stitches on her hairline with makeup. She's worried they'll show up in the photos.

"During my closing number I get on my knees and swing my hair around and around." She kind of demonstrates, whipping some toiletries. "The last show in Chicago I banged my head on the stage."

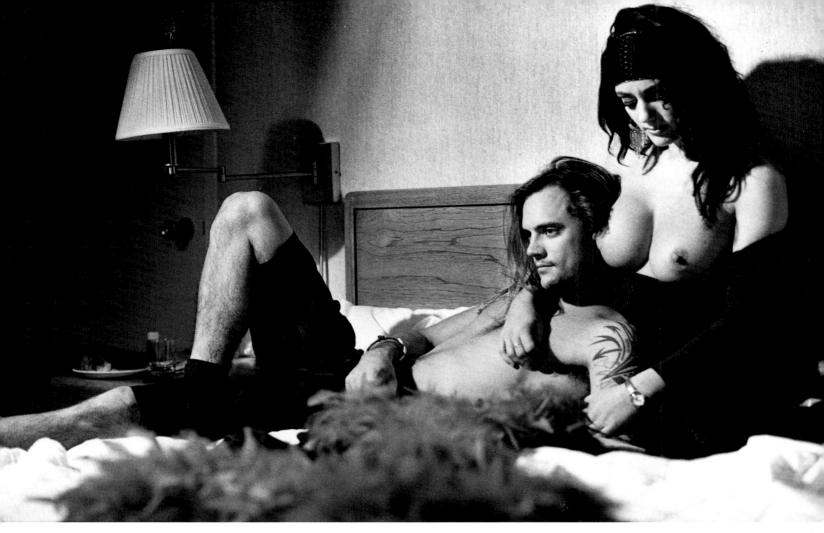

Jeanna Fine and her boyfriend, Sikki Nixx.

She looks for a reaction, even squints, like she's waiting for the laugh so she can go off on me, but I don't, and she's satisfied.

"I rocked that place," she concludes.

Jeanna has thick, tough hands.

Someone knocks. Jeanna goes to the door. A maid enters, a black woman in her fifties.

"Whew girl, you have something else!" the maid says, staring at Jeanna's chest.

"I'll tell my doctor you like his work," Jeanna deadpans.

"Those aren't real?" the maid says. "Can I see? I've never seen that before."

Jeanna brightens. "Sure you can, honey." She smiles, pulling her top down. "You can touch them. Don't be shy."

The maid raises her hands to Jeanna's tits. She squeezes two times gently, then more aggressively on the third and fourth. "Wow" is all she says, smiling, looking at Sikki then me like she's amazed.

This is a picture, of course, but I realize too late, fumbling for my camera, not quick enough. The maid is happy to wait and pose for a shot but I missed the *squeeze*.

Jeanna comes over to me.

"Feel," she says, all serious. It's an order.

I do what she says. Sikki watches from the bed. He doesn't seem to care. Jeanna

keeps staring at my eyes. I squeeze. They're heavy, dense, big. Up close the scars around Jeanna's nipples are severe. They look chewed up. One is pierced. She's had three operations already. I cop a clinical, removed feel. The whole thing probably lasts an excruciatingly long three seconds. Then Jeanna turns away, back to the maid.

The maid sees a dildo sticking out of the panty pocket of an open suitcase. The porn star is on a roll. Jeanna bends down, grabs it, licks the end, then pushes the head of the fat, eight-inch rubber dick past her lips and down her throat. The entire thing disappears. Jeanna offers the maid a tight, close-lipped smile and a wink before opening her mouth and letting the dildo pop out, her eyes watering. Sikki has a surprised smile on his face.

"No one can deep throat like I can," Jeanna says. "Ask anyone."

Jeanna and the maid hug. The second she's gone Jeanna's edginess returns. She's annoyed. She berates Sikki for not getting it together. Sikki is passive—he agrees with Jeanna. Jeanna surveys the mess, deals with the phone. She ignores me until she sees me pick up the camera, then pulls her tits out again and continues what she's doing.

"The maid said she'd come back later," Sikki says, reassuring her.

I know a rock star who lives in New York. Anyone who spends any time around him, including me, ends up working, or at least thinking, on his behalf, toward his end, his goals. It's all about him. It's like that in Jeanna's room. Even I've been recruited—when Jeanna asks, I tell her a red boa looks better than a blue one.

JEANNA CROSSES the street, struts, shows off her tits. Pedestrians pass in every direction. She acts like a porn star in front of a camera, as opposed to acting like a porn star in a messy hotel room. Jeanna concentrates on the camera, connects. She sends out practiced "fuck me" messages with her mouth, eyes, and posture. Sikki joins her, in wraparound shades, plays the straight man, ogles her chest with an ear to ear grin.

Sikki and Jeanna embrace. They gaze into each other's eyes, then kiss. The kiss lasts. For a couple of seconds their attraction seems romantic.

Later, in an alley, they romp on a discarded mattress. There's a rip in the crotch of Jeanna's pants. She tugs at Sikki's fly and sucks on him for a minute. They both laugh. The rain starts coming down hard.

Back in the room, Jeanna fills a shopping bag with "Jeanna Fine" promotional material. Posters, video cassettes, fan-club flyers. She packs a Polaroid camera, lots of film, and a Sharpie to sign the photos.

THE VIDEO STORE is empty. It's dark now, still pouring. Jeanna acts positive. She and the owner know each other from an appearance here a few months ago. Jeanna will get something for just showing up.

Sikki sets her stuff up on a folding card table, and they stand around waiting. A balding, middle-aged man in a tan raincoat emerges from the back of the store. He's been in a twenty-five-cent-token video booth since before Jeanna arrived. He approaches the star.

"Are you Jeanna Fine?"

"Yes, I am. How do you do?" Jeanna replies.

"Uh, fine," he says. "I mean good. Uh, are you doing Polaroids?"

"Sure. One shot for ten, two for fifteen, or three for twenty."

"I'd like two please."

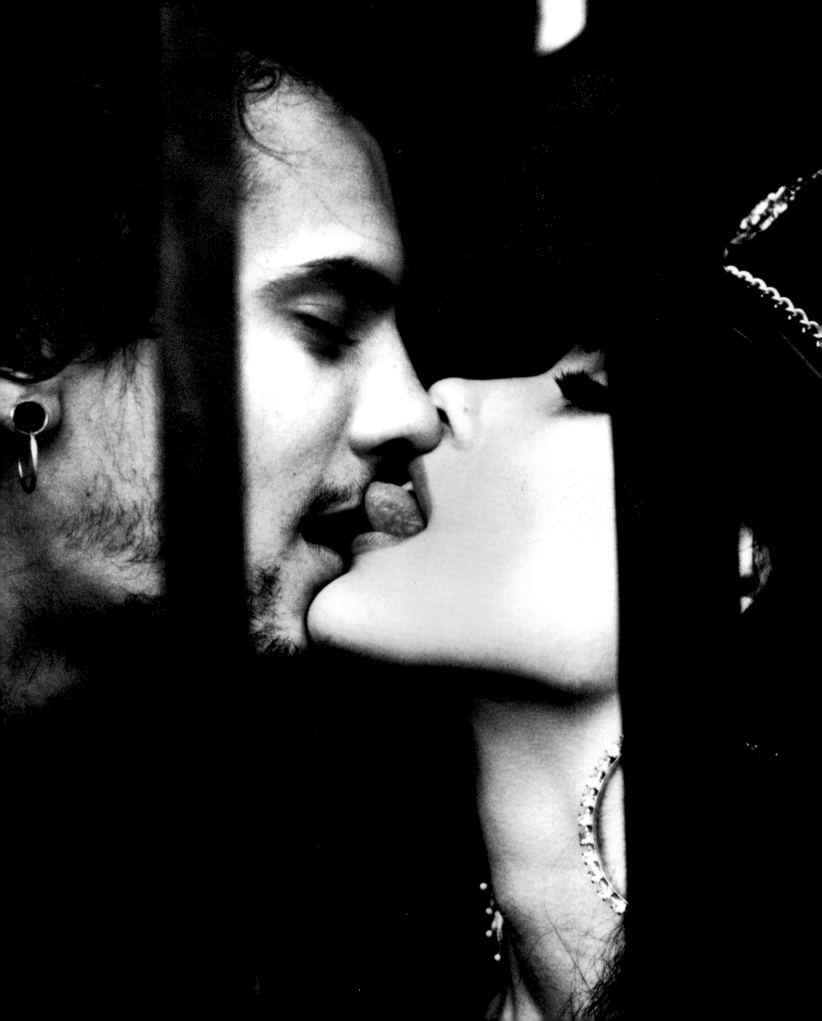

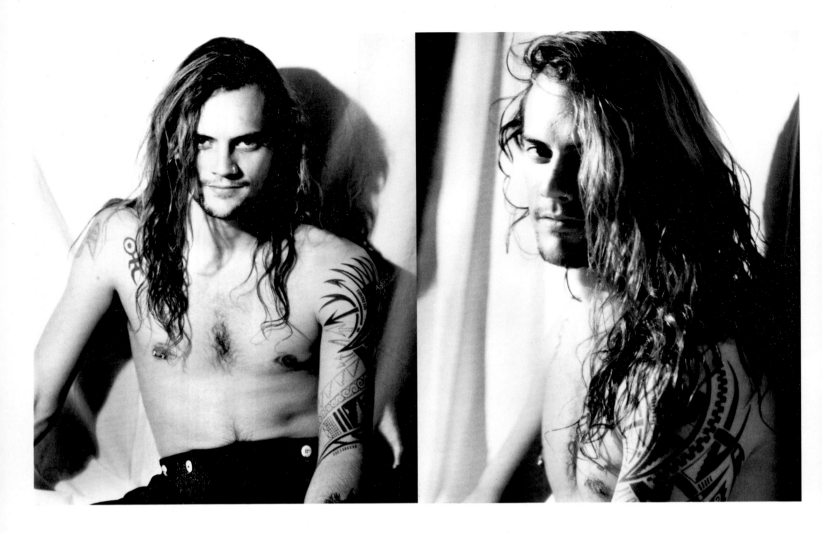

Sikki has the camera in his hand. Somehow the man knows to give the money to him.

"How do you want me?" Jeanna asks.

"Topless? Would you take your shirt off?"

"Sure." Jeanna removes her leather jacket, pulls down her top. She stands in front of the man with her back to him.

"Here," she says, taking his hands and pulling them around her. "You hold my tits, OK?"

"OK," he says, gingerly cupping Jeanna's tits under her nipples. He looks totally un-comfortable, but manages a weak smile when Sikki says, "Say cheese."

For the second Polaroid the man sits on a chair and Jeanna straddles his lap. She stands just high enough to press her chest into his face. He turns red. Sikki snaps the shot.

Jeanna gets off the man and they both stand. He straightens his coat.

"Can you sign those to Rob, please. R-O-B."

"Sure, Rob," Jeanna says. Rob laughs nervously.

Jeanna writes, "For Rob, Good Fuxx!" then signs her autograph. Rob thanks her, mumbles something about loving her movies, then leaves.

That's it for the in-store appearance. The store is now officially empty. The owner comes over to check on Jeanna. She asks him to shoot one of her with Sikki and me.

IT'S 6:45 P.M. and Jeanna wants to do her shift at the jack-off parlor alone. She makes that clear.

Sikki drinks Guinness in an Irish tavern and eats fish and chips. Sikki met Jeanna at the Consumer Electronics Show, CES '91, last January. He and a friend drove from Boulder to Las Vegas for the convention.

"We knew there'd be porn chicks," he says.

He stood in line for Jeanna Fine's autograph. Jeanna signed the poster and asked him to meet her later that night. His friend went back to Boulder alone. Jeanna took Sikki home with her to Hollywood.

"And the rest is history," he says. "I PA'd a little, then made the jump into acting. One day I was a fan, the next I was a porn star."

THE ROOM is still a mess. Sikki forgot to take the DO NOT DISTURB sign off the door knob. He's not too worried about it.

He shows me five or six T-shirts with the names and logos of obscure hardcore bands printed on them. Sikki says he has a band with Tom Byron in LA, but that he wants to form his own band where he's the only singer.

After the release of *Edward Penishands,* in which he had the lead role, the producer received calls from Tim Burton, John Waters, and Johnny Depp.

"They wanted me to autograph their tapes," he says.

Sikki wants to start working behind the camera more.

Jeanna said Sikki had to take off his condom in order to finish a scene with a young black actress named Dominique Simone. Jeanna said she wasn't happy about it but that she understood.

"That's what I told her," he says. "The truth is, I was really into doing Dominique. I didn't want to spoil it with a rubber, y'know? I knew Jeanna would be pissed 'cause she's working so hard to get everyone in the business to, y'know, send out the safe-sex message."

Jeanna returns looking worn out. She's still fidgety, still talking fast. Under the spotlight, in front of the camera, Jeanna is uncomfortable. She's unhappy with her makeup and all shifty. She apologizes for the way she looks, more than once. She's still wound up, but now she seems vulnerable. Somewhere along the way, since we last saw her, Jeanna lost her angry confidence. She doesn't bring up the jack-off booths, and I don't ask. Neither does her boyfriend. After a few rough minutes of slow shooting Jeanna sits up.

"Look," she says, "I really think I should take my shirt off for this shot."

She pulls it over her head then lies back. Jeanna *does* have confidence in her doctor. She lets go. Her eyes drift, soften, like for a minute her life isn't all about a fight.

THE PEOPLE I'm staying with up here—friends of my girlfriend—think I'm weird, I'm sure. I show them the Polaroid Jeanna gave me, but cover everything except Sikki with my palm.

"God, who's that? He's cute," one says, sort of surprised I'd be in possession of any-thing she'd like, since I'm not "goth" at all.

"Is he in a band?" the other one asks.

They can't believe Sikki is a porn star. Then they see the rest of the picture, and

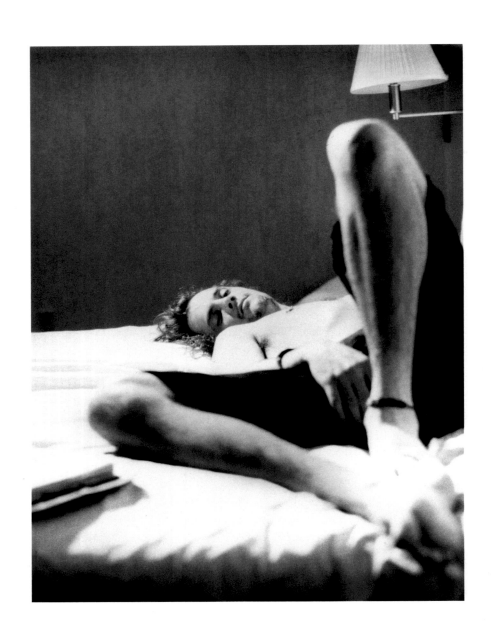

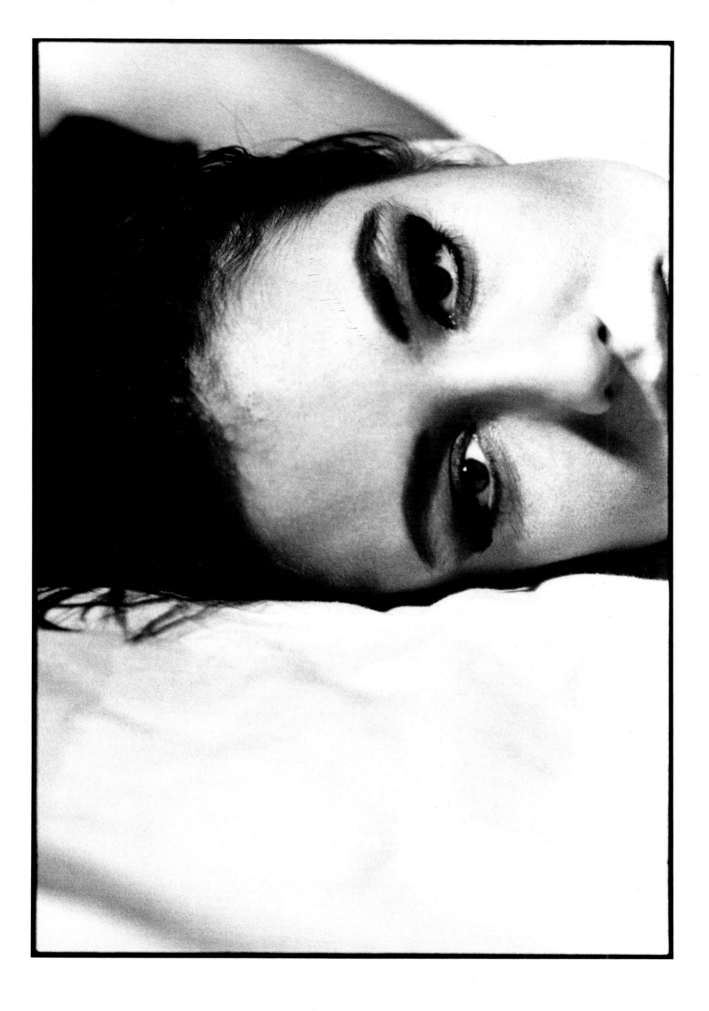

probably can't believe a topless biker chick has her gigantic tits pressed into their best friend's boyfriend's side.

SIKKI AND JEANNA ARE HANGING OUT WITH PORSCHE LYNN, ANOTHER PORN STAR, IN a suite Porsche is sharing with some friends at a different hotel.

Porsche looks like a bad girl, but forty. She's going to the ball as Elvira. Sikki has a realistic gunshot wound in the center of his forehead. He's wearing a baggy Charles Manson T-shirt.

Jeanna Fine is going as Jeanna Fine, porn star. Her costume: pumps, leopard-spot stockings, satin bra, G-string with rhinestones, satin gloves that cover her arms, and a miniskirt with the word FUCK printed over and over. She has a black bolero hat and a red feather boa.

Jeanna's in Porsche's bedroom. The bed is littered with hair-spray cans, pins, the odd pair of panties, et cetera. There's a hand-held mirror with "powdery residue." Jeanna covers that with a paperback book—*The Yeast Connection*—as I walk in.

JEANNA BARES her tits and panties for a snapshot in front of the hotel, ignoring a passing group of elderly theatergoers in black tie and evening gowns. They ignore her, too.

The closer the taxi gets to the arena, the more congested the streets are. A quarter mile from the entrance the driver refuses to go on. It's forty degrees and really windy, but the streets are filled with pedestrians in risqué outfits, lots of exposed flesh, all kinds of bizarre getups.

The place is a mob scene. The air reeks of pot and cheap beer. When Nina Hartley first mentioned the Ball, it sounded like an intimate, sad little attempt at keeping the torch of the swinging seventies burning. Then the Ticketmaster agent said it was $38.50 a head. The event is a cross between an AC/DC concert and a New York Rangers hockey game—except that everyone is semi- or completely nude.

One guy is in a diaper and bow tie, carrying a baby bottle filled with beer. Jeanna spots a six-foot walking penis. The parade is endless. A fat, fat lady in stockings, garter, and high heels—that's it—walks her fat, fat nude husband on a dog leash attached to his studded collar.

There are a few imaginative costumes that are skillfully, expensively executed, but mostly the arena is filled with trashy exhibitionists and voyeurs, and lots of tough guys in togas.

It turns out Jeanna is here with a purpose. Two $10,000 prizes will be awarded; one for the best costume and one for "sexiest lady." Jeanna intends to win the latter. The judges—a couple of local DJs—will gauge the audience reaction to decide the winners. There must be five or six thousand people here, but a short guy in leather (nothing wild, just a look) emerges from the crowd, takes Jeanna by her hand, and leads her backstage for the competition. Jeanna tells Sikki, like a mom, all stern and focused, to meet her at the mezzanine bar after she wins her prize. Then she disappears.

Sikki has a drink in each hand, alternating between sips from both plastic cups. He looks happy. Strangers compliment his gunshot wound. He's buzzing.

Porsche appears. She's hooked up with two broad-shouldered, nineteenish guys dressed in black, head to toe, with black and white paint covering their faces. They're leading Porsche around on two thin, silver chain leashes attached to her leather collar. Her Elvira dress is pulled open to show off her tiny tits and pierced nipples.

Porsche and her teenagers drift off into the crowd. Sikki positions himself at the railing of the mezzanine, overlooking the orchestra section, to watch the stage.

A nine-foot-tall space creature wins for best costume, then it's on to the girls. There are a bunch of contestants, but in a matter of minutes the competition boils down to three women sticking their asses out for applause. Then it's two: Jeanna and a tall, blonde Texan. They're called back to the center of the stage to compete for the noisiest ovation.

The Texan is in white. She's radiant. She never even shows the crowd her tits, but the applause is decisive. Jeanna is the loser.

She finds Sikki. Jeanna is bitter.

"That bitch isn't hot," she says, spitting. "Fuck. If she wasn't a blonde, she wouldn't even be up there. It's bullshit."

Jeanna acted in porn movies as a bleached blonde for six years, built her career as a bleached blonde. She and Sikki continue drinking hard. Jeanna begins flashing her chest for random passersby. In a minute a crowd of sweaty, half-naked men has formed around her.

They snap pictures and lewdly assess her body. Jeanna swings her FUCK miniskirt around and tucks her G-string off to the side, showing them her shaven pussy. She is totally into it, not like she enjoys it, just like she's into it. She eggs them on. Jeanna turns to Sikki, who's standing back five feet or so, and says, "This is out of hand."

Suddenly the crowd bursts apart. A young guy in a toga reels back, holding his face as blood runs out of both nostrils. Jeanna punched him right in the nose. She takes a step toward him, and he takes three quick ones backward then disappears into the crowd.

"That fucking asshole grabbed my tit," Jeanna says, looking pumped. The group has dispersed. Sikki holds her hand. He's so out of it. His lazy eye is twisting off into another direction, no hiding it now, and his face is green. His makeup is smeared around a peculiar, frozen smile.

Jeanna looks him up and down. Her eyes dart in my direction, then away. She turns around, looks out at the mob. I offer to get her and her boyfriend out of here, but Jeanna is transfixed. She doesn't want to leave.

She takes a couple of steps forward. She begins luring men in with her body, again, just like before. Jeanna Fine can get a crowd. Fast. I can't tell if these guys know she's Jeanna Fine or just like standing near her naked parts. The new Jeanna Fine—black hair, tattoos, nose ring, new, big, fake tits—is a whole different thing.

"Wild, man. This is a strange trip," Sikki says.

I agree but he corrects me.

"No, man. I dropped acid."

This zoo is a bad trip sober. Sikki's peculiar frozen smile is intact.

Jeanna has surrounded herself with leering, drooling guys all over again. In the same instant someone's hand makes contact with Jeanna's ass, her elbow is already slicing into the perpetrator's neck. She grabs his hair as he goes down, punching the side of his head twice and stomping on his stomach with a spiked heel as two of his buddies, both wearing penis masks, drag their friend away.

Sikki is dazed. This got through. His mouth hangs open; he is not able to deal. The scene is ugly. Jeanna makes it look like sport. She can fight, that's obvious. I wish I hadn't seen this, or come here at all.

A shirtless, tattooed, six-foot-four biker dude is at Jeanna's side. He has a press pass—*Easy Rider* magazine—clipped to the strap of his Nikon F4. He knows Jeanna and shields her. Jeanna gives him the OK—for a second it's uncertain if she will—and the biker eases up, lets Sikki step close.

Jeanna laughs like nothing has happened. There are fights breaking out. The crowd surges dramatically when someone shouts, "He's got a knife!"

The house lights are turned on. There's no air, just the sour smell of cheap beer, piss, and vomit. Security guards in riot gear charge into the crowd.

Jeanna and Sikki make their way toward the exit.

It's freezing outside. Sikki is visibly shaking, but Jeanna still looks rushed-out on adrenaline, or speed, or both.

"Those fucking guys were completely out of hand. Totally," she says, exhilarated. Her words squeeze through a clenched jaw.

Sikki, beginning to calm down, says, "Man. Wild. It was really wild."

A quiet, benevolent smile passes across Jeanna's face when she looks at him. A second later, though, it's, "Hey, why the fuck are you going this way?!" as she orders the taxi driver—not happy about the freaks he's just picked up—to take a different route back to Porsche's hotel.

Two friends of Sikki's who drove in from Boulder are already there. They were at the Ball, too. She's a student and he makes brass instruments. They're tripping. Everyone's in the kitchen of Porsche's suite eating Halloween candy. Jeanna goes on about the contest.

"Blondes. It's just the same shit. To tell you the truth, I think my applause may have been louder. But those judges, I guess they're just programmed to vote for blondes."

"You were so hot up there. You won, really, as far as I could see," Sikki says.

The door to the suite swings open and Porsche calls out, "Hey everyone, I'm home."

She appears in the kitchen doorway flanked by the two boys she picked up at the ball. Porsche surveys the scene in the kitchen, smiles, then leads them to her bedroom and shuts the door.

Porsche's screaming—total howling—cuts through the walls. For half an hour. Nonstop. No one in the kitchen ever acknowledges the noise. The conversation just goes along, with Jeanna doing most of the talking.

"That scene was really fucked. I mean some guys just don't have any control. They see a pair of tits and they just lose it," she says.

"Of course, baby," Sikki says. "When I see your body I lose it, too. And I see it every night."

Everyone laughs.

Then the suite is quiet. The noise from Porsche's room has stopped. The bedroom door opens and she comes out in a tiny blue towel. In her timid baby voice, Porsche asks if anyone has a condom. Jeanna shrugs. Try in there, someone jokes, pointing at the sliding doors to the second bedroom.

She does. Porsche slips into the dark room where her other friends are already asleep, then emerges, a second or two later, waving a single condom packet. Then Porsche's moaning resumes, louder than before. No one in the kitchen lets on that they even hear it.

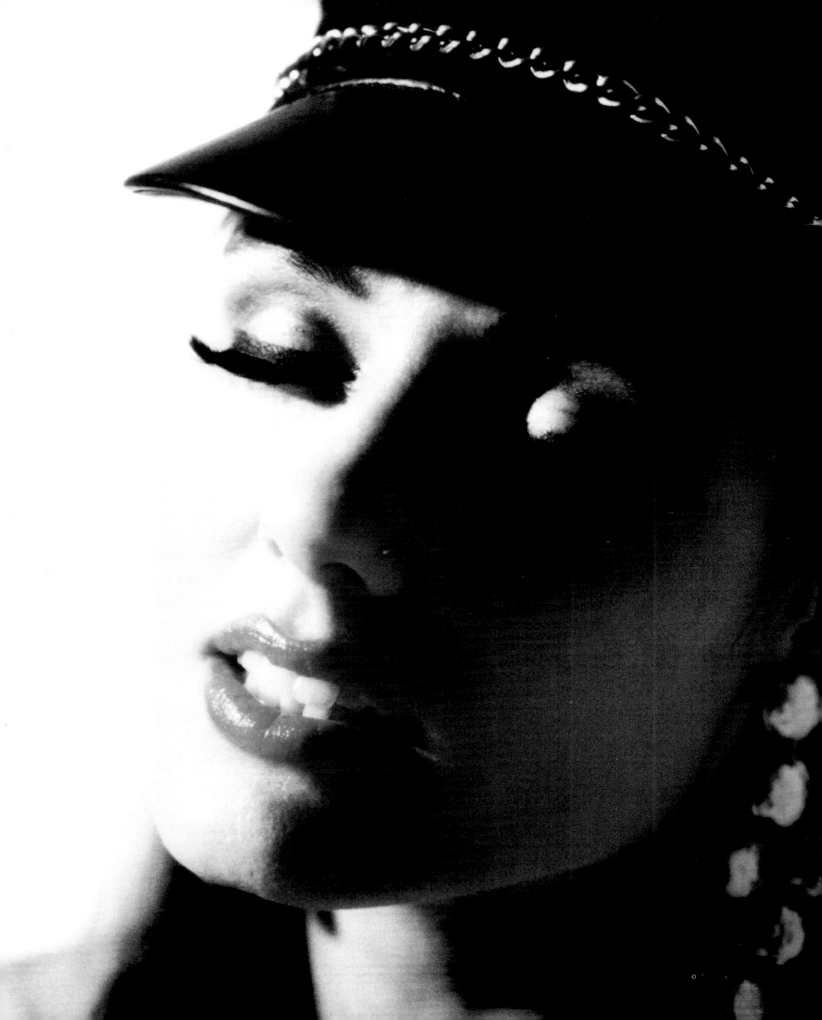

"I'M TALKING TO SOMEONE AT WILLIAM MORRIS ABOUT A BOOK DEAL. YOU KNOW, ABOUT my life. I need to find a writer. Do you think Bret Ellis would be into it?"

Tom Byron's place on North Stanley, the half-house he shares with Jeanna and Sikki, is underfurnished and poorly lit, like an off-campus flop. It's cool, in a college way, as long as you don't walk around barefoot. A couple with a nine-year-old son live on the other side of the kitchen wall. The place reeks of freshly smoked sensimilla, years of it. There's a rusty bench press and some weights on the patio outside the living room. A slate path cuts through the backyard.

"That book by Jerry Butler is bullshit," Tom says, referring to another porn star's autobiography. "I mean all he really does is put down everyone in the business. He's an asshole. My book will be about my life. Y'know, I've done over a thousand movies. I mean that's pretty interesting. My life is pretty different from the average guy."

Tom isn't fully convinced himself, judging by how bored he looks.

His bedroom is the suburban bachelor pad part of the house: drawn miniblinds, black carpet, arching floor lamp hanging near his big bed, black comforter and pillows, Frisbee sitting in the middle with a Baggie full of weed. The fireplace mantel is lined with awards, porn-style Oscars. There's an X-Rated Critics Organization Hall of Fame plaque, and a little red bong. His big TV and VCR are set up in a corner near the window.

Tom has some tattoos, a pierced nose, and a pierced nipple. His rocked-out image might be the influence of Sikki and Jeanna—Tom's is less authentic—or maybe it's just the beginning of a trend in porn to look like Guns n' Roses. For most of his career, Tom has looked like an innocent kid—played the pizza delivery boy, the nephew who gets seduced by his wild aunt, roles like that. Underneath it all he still looks boyish. But for the pictures Tom puts on his best bad-ass face. He mugs like a hardened ex-con, putting an unexpected amount of energy into *projecting*, like being in front of a camera is nothing new for him. His torso is soft and he asks that his belly not be "highlighted." Once the camera has been put away Tom reverts to boredom mode.

I ask about Traci Lords.

"That whole thing is bullshit," he says. "I mean she used this business and loved it—no one made her do anything. But when the whole thing came out about her age the business changed. Since then the IRS has been on my back nonstop. It's a fuckin' drag."

"Did you work with her?"

"She was my *girlfriend*. We were in love. I mean I didn't know she was thirteen at the time. Yeah, we worked together.

"You guys all want the sensational stories. That isn't really what the business is about. Day to day it's just like anything else. No one seems to get that."

Tom's cautious reply regarding Sean Michaels's Halloween party is, "I might be there." Then, "Hey, don't forget to ask your friend if he wants to write my book."

"THERE WON'T BE ANY PRESS, SO YOUR PICTURES COULD BE VALUABLE," SEAN MICHAELS says. "And remember, it's a costume party."

Sean is currently the biggest black male actor in the business. He's doing his own movies, too, says he's on a mission to "break down all the old racial stereotypes."

"Like the John Singleton of porn?" I ask.

He laughs, then says, "Did you *know* I directed *Girlz 'n the Hood*?"

Sean's building is a couple of blocks south of Sunset. The party is being thrown in

a sparsely furnished lounge on the first floor, not his apartment. Sean is friendly, but he speaks low and soft, so it's hard to hear him over the stereo. A square-looking white guy tells him the tap isn't working. Sean puts his arm around the guy, who has microbrewed a batch of beer especially for this party, and excuses himself to deal with the problem.

Buck Adams, Amber Lynn's brother, and Cal Jammer, both porn actors, are here. They're dressed like suburban frat boys—baggy drawstring pants with Aztec prints and elastic ankles, oversized varsity T-shirts, all freshly laundered like college jocks. Except Adams looks middle aged.

They joke around with a girl in a Snow White/Little Red Riding Hood/Easter bunny outfit, her fur bra covering an obvious tit job. Maybe she's supposed to be Pebbles.

Sikki and Tom arrive in shorts, flannel shirts, and leather jackets, their street clothes. Grunge uniforms. Jeanna is still on the road. Jamie's still in Guam.

Sikki introduces a little girl with red hair who's dressed as a flapper.

"Hey man, I want you to meet Flame," he says. "You should take her picture. Flame, you should meet this guy. You should be in his book."

For a snapshot with Sikki and Tom, Flame bares her teeth like an angry little doggie, and pulls her dress off her shoulders, flashing her freckled, white, flat chest. Sikki says she's eighteen, but Flame looks younger.

Flame's boyfriend is Rob, a PA on porn shoots. He's the kid brother of another porn actress, a famous one named Raven. Rob is a cowboy, but it's a kid's costume— the hat is way too small for his head, and his holster and guns are tiny. He has black makeup around his eyes. Flame met Rob on one of her first shoots.

The girl in the Pebbles costume is Trixie Tyler. She doesn't have anything to say, seems dumb, humorless, but sexy anyway. She's hesitant, seems skeptical, and looks bored. Sikki flops down on the sofa.

He says he worked with Flame. "This week was the first time. She's a little angel."

Sharon Mitchell arrives with John Stagliano, a director who calls himself Buttman. Mitchell looks late thirtysomething. Her short hair is slicked back in a DA, and her makeup is silvery seventies glam. She's in a leather body suit with slits that reveal her nipples. Stagliano is dressed as a priest in horn-rimmed glasses, except from the waist down he's in fishnet stockings, a garter belt, G-string, and black pumps.

Mitchell is totally approachable. She has a husky, soothing voice, knowing. "I'm always on the road," she says. She sounds nothing like Nina Hartley, but both actresses have a quality, a tone, that says, "You're a guy, but I forgive you."

Tom Byron steps up behind her. He reaches around, gropes her crotch and chest. She laughs, then ignores him, and continues talking.

Stagliano is cooler, aloof.

"I'm here to see my friends," he says, moving away from me.

Tom clings to Mitch.

Sikki says, "Ever since Jeanna got Tom into only working with condoms, he's working a lot less. He's getting a lot less sex. He hasn't had to think about trying to pick up a girl for, like, more than ten years, y'know, since he was a kid." Sikki pauses, smiling. "Well Tom has no fucking idea where to even begin. He's kinda confused."

Sean Michaels, who has been in a naval officer uniform, changes into a Chicago Bulls jacket with his real name stitched into the shoulder, and a wolf mask.

Flame is drunk, dancing barefoot, tits out. She pushes her boyfriend up against the

Following pages: Tom Byron

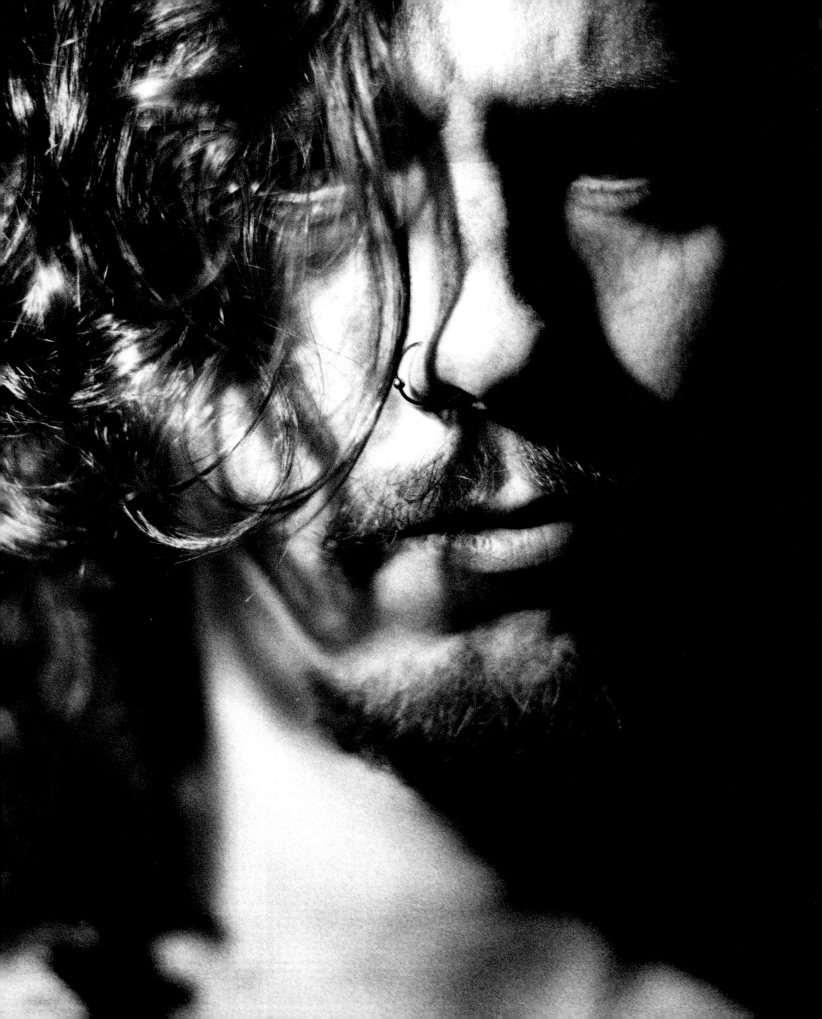

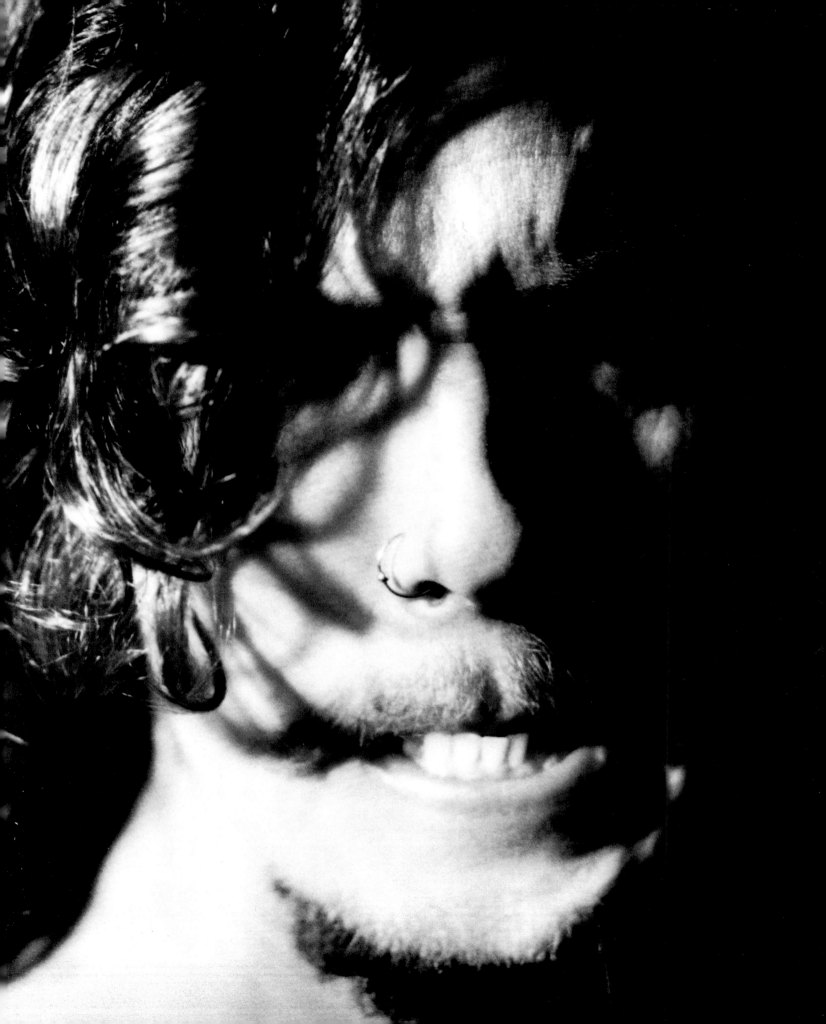

bar. He's drunk, too, and shirtless. His eyes look dead, and not just from the black makeup. Flame bends at her waist, pulls Rob's dick out, and begins sucking it.

Rob sees me watching them. First he pulls his girlfriend's dress up. He fingers her ass a little. Then he swings Flame around. She thrusts her hips forward, pulls her panties to the side. Rob empties his Heineken over her crotch, then Flame goes back down on him.

People keep taking short trips upstairs to Sean's apartment. It's immaculate. There's a framed Michael Jordan poster hanging in the foyer.

Eight people crowd near the front of the one-bedroom. Sean asks everyone to keep it down. Ashlyn Gere, another porn star, is in a bedroom with the door closed. Sean says her baby is sleeping. When Gere sticks her head out, Sean asks everyone to go back downstairs.

In the lounge the party is thinning out. A Spanish transvestite wearing a red satin dress gives Tom head while he leans back against the bar, next to Rob. Flame is still on her knees, or on them again, sucking Rob. The guys have their elbows on the bar, and each has a bottle of Heineken dangling from one hand.

"I guess I'm kind of a slut," Tom says, smiling.

He closes his eyes, hangs his head back. Rob leers. The black eye makeup is smudged. He looks wrecked. A half-smile forms as he recognizes someone, makes some sort of connection. He lifts his free hand slowly, points, then looks down at the top of Flame's head, at the blow job he's getting, his outstretched arm left suspended.

There are more people in the lobby than in the lounge, hanging out, making plans for the rest of the evening, or trying to. A guy who does porn soundtracks hears my idea for a coffee-table book about porn stars.

"Why?" he says. "You think anyone cares about these people?"

It's midnight. Sikki is gone. Stagliano, too. Sharon Mitchell is still here.

"Promise me you won't forget to call me, OK?" she says.

Tom comes out to the lobby, looking bored again, looking for something to do. He asks Mitch to come back to his place. She doesn't say yes or no, just mentions another party she wants to go to.

"I HAVE A REALLY NICE PICKUP TRUCK. I JUST DON'T HAVE MONEY FOR GAS," APRIL Rayne says. Then she laughs. "Could you come get me?"

April lives in a run-down-looking section of Hollywood east of Highland and north of Franklin.

A small, punky girl with shoulder-length hair, dyed black, stands behind a screen door. She smiles, her face hard but friendly. April's wearing a flannel shirt tied in a knot at her belly, jeans shorts, torn fishnet stockings, black motorcycle boots. Her belly-button is pierced.

"I'm moving out," she says. "I guess I'm moving in with my boyfriend. I can't afford this place anymore. Not since I stopped doing porn."

The place is tidy. April pushes open a door off the living room. A StairMaster stands in the middle of a sea of clothing, luggage, miscellaneous porn-star paraphernalia. It's like the second bedroom has been devoted to all of it.

"I'm selling that," she says, nodding at the exercise machine.

"I have some pretty cool stuff—do you want costumes?" April stares at the pile of

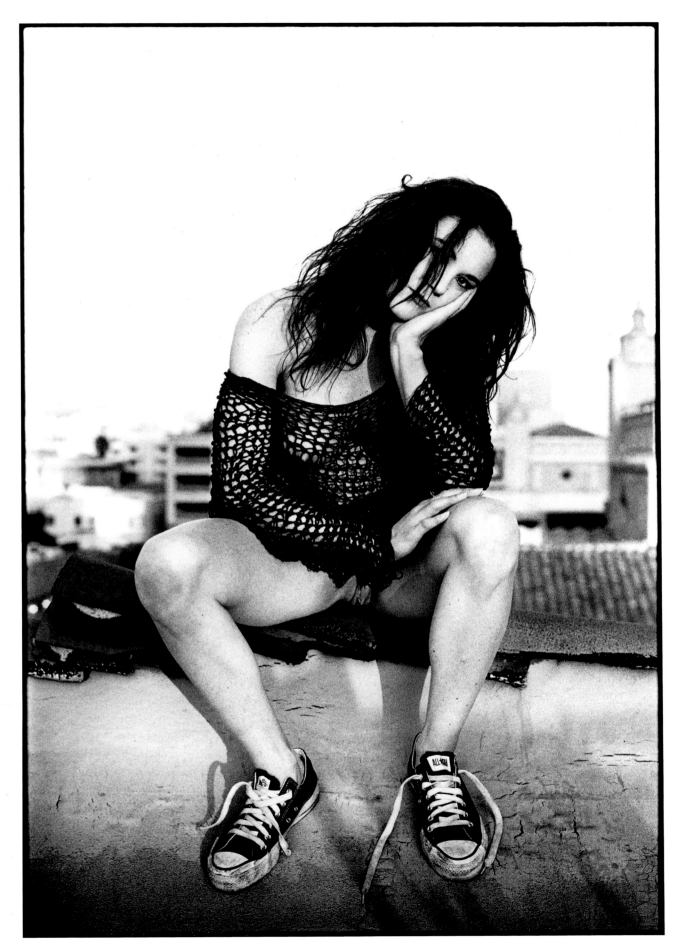

April Rayne

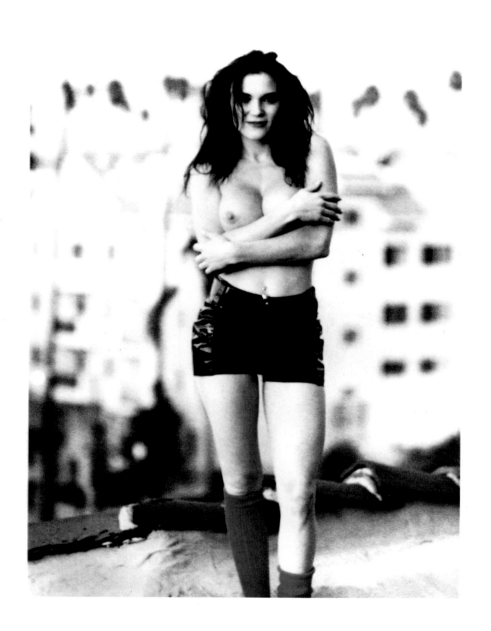

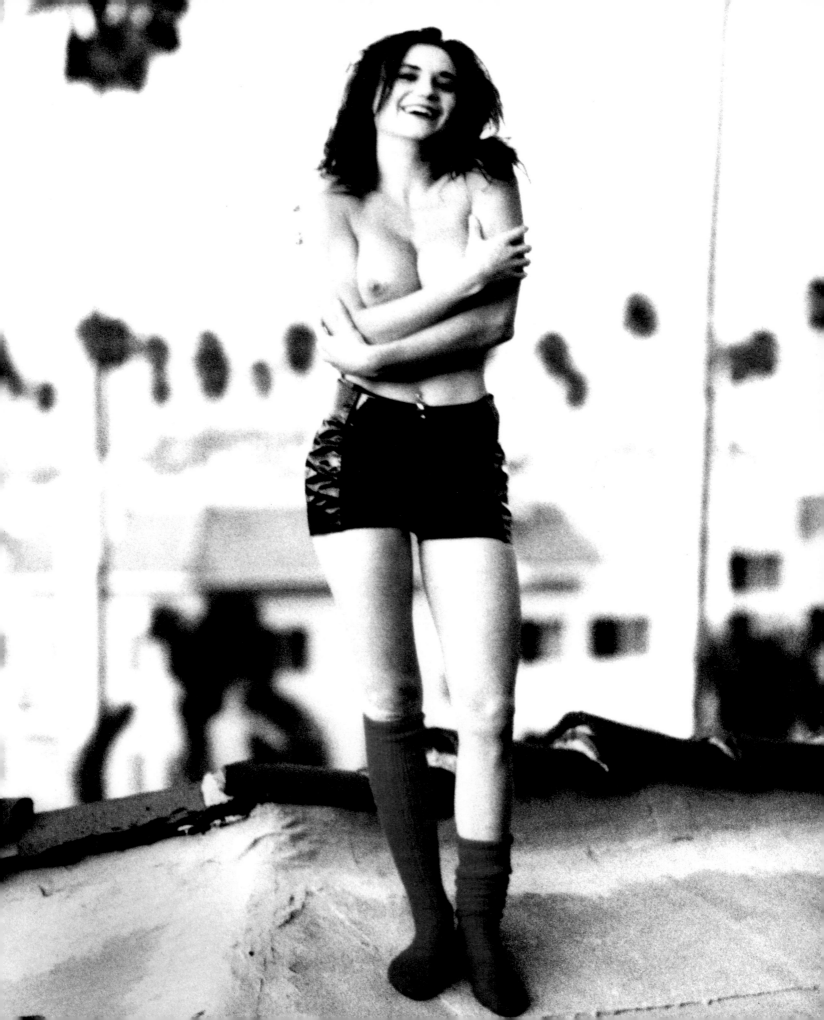

glittery getups. "Or just normal stuff, y'know, what I wear out and stuff. You can look in here if you want."

She opens a neatly organized closet filled with shoes, designer-shredded rocker outfits, leather vests, a hanger with thirty belts—the kind of stuff groupie chicks love but usually can't afford. MTV stuff.

It doesn't even occur to me to shoot her here when there's a big empty studio in Hollywood. April fills a knapsack with some outfits she likes.

"JEANNA TOLD YOU I'm not doing fuck films anymore, right?" she says. "I got a part in an independent feature. They're gonna show it at Cannes. I'm gonna try and act more and you can't get parts if you're doing X. It's like a union thing."

April smokes a Camel filter. We're at a red light on La Brea.

"Anyway," she continues, "after doing fifty videos the thrill was gone. Three months in this business is long enough."

I look at April when she says this, but she turns her head the other way, down Santa Monica Boulevard.

April is impressed with the studio, as if she's never been in a place like this. She checks it out, snoops around, then puts her bag on the makeup table. She takes her shirt off. April's chest is a shock. Her tits jut out from the top of her torso, scream out. She's only five-foot-three or -four and really skinny, which makes it more freaky. There's no give to the flesh, and the shape is boxy. The scars under her nipples are red, fresh.

My first reaction is panic. There's no way to hide those scars, and no budget for retouching every picture of a porn star with a tit job. The scars are the first place she applies makeup, though, and I kind of slow down, go with it, try to get into that April is topless, that I'm in Hollywood alone with a topless porn chick, which feels cool. Rocked out.

She poses on the roof. April has style, and charisma. She connects. When she smiles, April makes you believe she's happy. When she's asked for a scowl she turns nasty. She's a natural, the first one, of the girls I've shot so far. The clothes look cool, and April knows what to do to hide her tits, or flatter them.

On the way here she seemed depressed. Now April exudes confidence, like she's centered. I go with what I see in front of the camera, over anything else, because that's the kind of image I want to believe and show the world. The Southern California sun begins its descent. Towering palm trees sway in the distance. April is a star.

When the sun is gone April poses inside the studio. There's a spotlight on a stand in the corner of the kitchen, so I shoot her there. April's in a flowered dress. She starts with it on, but a minute later she's showing me her tits again, and this time because I ask. April gets up on the sink, leans against the window and spreads her legs wide. She giggles, then smiles a big smile. It's dirty. She's a skinny little girl showing me her pussy, and it looks really, really good. April is the first porn star to truly flash me hard-core like this, slow and deliberate. Seeing her vagina, just shaven, bare and open—being alone with it—is different, more sexual, much more.

I stop shooting, let the camera hang by its strap, and just look. She doesn't mind. When I glance up at her face she's still smiling, wicked. These are not pictures I'll use. I know that.

I step close to her. She looks down, and stops smiling.

"I don't think so, I mean . . . No. OK?" April says. "Is that all right?"

She says it sadly. It's almost like April is apologizing for my coming on to her, or for her saying no. I back away and April's smile comes back, good as new, like she's just as into posing as before.

When the roll is finished she gives me a long hug.

While packing, April talks about her boyfriend's band, Dumpster. She says they opened for Guns n' Roses at the Whiskey.

"He's a skinhead type," she says. "I guess you could say I've been supporting him. Or I was, until recently. Y'know, since I stopped porn. They're about to sign with Warner Bros."

April writes down her telephone number for the studio manager. He'd kept out of sight the whole time, until I disappeared to take a leak.

"I'm into modeling," she tells him.

NEW YORK. HEATHER HUNTER WHISPERS.

"Hey. Yeah, I recognize your voice, from the machine. I've been meaning to call you, been very busy, y'know. Madison gave you my number? That's cool. Madison is cool."

She's barely audible but at least it's her voice, live. It's a guy's voice on her machine. I wasn't even sure it was the right number. You can only leave so many messages.

Heather's apartment is in the basement of a building on Mulberry Street, just off Houston. The place is dreary—especially since today is one of the first warm, sunny days of spring—but it's big enough, and in a hip enough area, that Heather probably pays two grand a month to live here.

Heather is black. She was already a regular guest on Robin Byrd's show, on cable in New York, way before she got into doing hard-core. Mascara, long eyelashes, bright red lipstick. She has curly hair extensions that hang down her back, almost to her rear end. And she's tiny. She is attractive and she's managed to become a pretty big porn star, which is not easy for a black girl to do. Heather even has a contract with Vivid Video.

Her refrigerator is covered with color snapshots, a lot of them pictures of Heather with other porn stars. There's an oil painting of Heather's head and shoulders leaning against the wall near her sofa.

"A fan of mine did that. Isn't that so sweet?" she says.

The painting is primitive but it captures her dreamy eyes. Heather says the guy who did it has sent her a lot of his art, all dedicated to her image, but that this one is the best.

She lights a half-smoked joint and takes a couple hits. Heather coughs a deep one as she exhales then laughs a little. Her eyes water.

Heather is finished with porn and adds she has no regrets. Another one getting out. Now she has a recording career that's "much more gratifying." Heather says she's on Tommy Boy Records. She says she cut a dance single. Heather is tapped into the dance scene. Besides the snapshots, there are all kinds of invitations to parties she's thrown at places like Tunnel and the Roxy taped up in the kitchen. "Jellybean spun that night," she says, pointing at an old invitation for a party at Palladium.

The buzzer rings. Heather whispers into the house phone and a few seconds later a group of clubby kids file into the apartment.

"These are my friends," Heather says.

They're in awe of Heather. She has money. She's traveled. Heather has her own apartment. Heather is famous. That goes a long way. These kids haven't seen much more than the dance floors of local discos, just from the way they look. Street kids, homeless maybe, much younger than she.

Heather follows them into her bedroom and closes the door. She comes out a long five minutes later by herself. Her friends are coughing and laughing in her bedroom. The apartment is getting cloudy.

"They're really great," she says, kind of like a big sister.

Plans are made to do a photo shoot—she says she's excited about it—then, a week later, Heather's number has been disconnected. No further information available.

SHOW WORLD FOLLIES. SHARON MITCHELL IS ON HER BACK, LEGS SPREAD, AT THE END of one runway, a couple of balled-up dollar bills near her—literally two singles. The song ends and she gets up and dances. It's hippie-ish, a throwback. Sharon Mitchell is an "erotic dancer." She has a serious expression.

There's a row of booths with curtains in the back. Two flashy guys noisily file into one, along with four house girls. A hostess shuts the curtain behind them then someone delivers an ice bucket with a bottle of champagne, passing it in. It's the middle of the afternoon.

After the show I knock on the dressing room door. Mitch shouts for me to come in. She's naked, standing in between two on-duty New York cops.

"Hey, honey!" she says, hugging me.

Mitch looks high. The cops acknowledge me with nods.

"Baby, would you do the honors," she says, handing me a Polaroid camera. Each cop poses with Mitch for a picture, then she autographs them.

"Guys, I've just gotta get ready for the next show, OK? Thanks for coming up," she says, like a pal, ushering them to the door. She gives each one a hug and a kiss on his cheek. The second one squeezes her butt.

After they're gone Mitch confides, "As long as you look like someone's sister, aunt, or mother you'll always work in this business." She lets out a big laugh then says earnestly, "Those guys are great. It's so great being back in New York, y'know? It's home."

She pulls on a tank top big and loose enough that her tits still show, and lime-green terry short shorts. Mitch is dark, like she's been in a tanning booth. Her face is crinkly and old looking, but she's the cheeriest porn star I've seen and acts the youngest. Her big nose scrunches up when she smiles. Her friendliness makes her pretty. Mitch is considered the ugly-duckling porn star but her body is toned; she's sexy. I tell her she looks good.

"Thanks so much, honey. I work out, y'know, every day, I work it all out."

She takes my wrist, pulls down the waistband of her shorts with her other hand and pushes my finger into her crotch. My hand might as well be a block of wood, or frozen. Mitch squeezes three times.

"See, I'm just completely in control of my body," she says. "In this business you have to be."

It'll be years before I recognize the parallel between Mitch's move—or Jeanna

Fine's ordering me to feel her tits—and the cock-rock posture I cultivated in high school. It's beyond parallel. "Touch it, don't be afraid," I remember semiaffectionately daring a girl in a cafeteria while pushing her hand into *my* crotch. The girl *wasn't* afraid, and I wasn't ready for that. But anyway with the porn stars I'm on the other side of it, which I'm not used to. Mitch looks into my eyes with her heavy-lidded ones for some response or a sign—something that will verify that her vagina/stun gun has rendered me limp, a nonthreat. It's all about control.

I mumble "yeah" like an idiot. I'd set out on an innocent research trip, and now my finger has been in the Porn Star's Pussy.

As she's leaving the club, a guy in a suit, maybe the manager, says, "Miss Mitchell, you only got forty-five minutes, so don't get lost, OK?"

"Aw, honey," she answers, "You know I got it all under control. I'll be ready early."

He's not satisfied. When he glances my way it's not a tough guy look, not even distrustful. His expression seems to say, "Please, buddy, make my life easy, save me a headache. Get this lady back in time."

Mitch takes the side stairs directly to the street. She practically dances as she walks, hopping and spinning, playful. She says hi to strangers who may or may not recognize her. The guys behind the counter at Colony Records definitely recognize her and they all try to help her find the cassettes she's looking for, ones for her act. She calls them "baby" and "honey" and "sweetheart" and they all have big, shy smiles. Mitch makes each of them—a Nigerian, a Pakistani, and a balding Jewish guy at the register—promise to come see her show before the week is over.

Mitch sits at the bar of a dark, empty, rundown Mexican restaurant off of Seventh Avenue. She orders a glass of Kronenborg.

"I don't do anything anymore," she says. "I'm clean, baby, really. No dope."

Mitch is relieved when I change the subject. I want to believe everything is "OK" even more badly than *she* wants me to. But her tone is more serious than before.

"Honey, I don't think I look good enough to do pictures this week," she says. "I look so tired. I wanna do them when I'm *up,* y'know? You understand, don't you? I wanna feel good. It means a lot to me."

SHE'S NOT LATE but it's close.

"Five minutes, OK?" the manager says. He looks over his shoulder at the DJ booth, where three more guys in suits, older guys, are watching the exchange with solemn faces. They weren't here before.

"No problem, baby," Mitch says.

"Give me your music, I'll cue it up," he offers.

"Oh, I've gotta make the tape. It'll just take a second, just a minute."

"Your music's not ready? Oh, Jesus." He drags his hand from his forehead down to his chin. "What about the one from the last show?"

"No, no. I have something particular in mind," Mitch says. "Gotta do it."

"OK, OK. Hurry up, just move it. We can't keep 'em waiting too long."

He lets her pass into the dressing room, but not before shooting her a pissed-off look. Mitch hands me a beat-up Walkman, a pink Sanyo tape recorder, a tangled wire to connect them, and headphones. She marks choices on her tapes with a Sharpie, then hands me *Thriller, Like a Virgin, Dirty Mind,* and *Tattoo You.*

It's my job to cue up her choices then copy them onto a blank cassette in the right order. The tense suit pops his head in the door every few seconds.

"What's up? Come on, do it fast," he says.

I tell him the tape is rewinding real slowly. He takes it out of my hand.

"What the fuck is this? Oh, shit. OK. I'll be back in a minute."

As he leaves again he mutters under his breath, "This is why they fuckin' booted her ass from the Triple Treat."

Mitch's Show World Follies gig is a demotion. This place doesn't get half the traffic as its flagship sibling Show World Center. The potential for Mitch to cash in on extras beyond her guarantee isn't good.

"What'd he say?" Mitch asks, looking at me in the reflection of the dressing table mirror.

"I didn't hear him," I lie, and watch the tape spin to a stop.

The guy comes back. He hands me a bag of AA batteries. His receding hairline is dotted with sweat. One of the older guys leans in behind him.

"Who's that?" the older one asks, two feet from my face.

"Uh, this guy's making her tape," the nervous one says.

"Tell him he's gotta hurry it up."

"You gotta hurry it up, OK?" he tells me.

Mitch turns around and hollers, "Please guys, get out, get out, get out! I can't get ready for my show like this!"

The door closes, and Mitch smiles at me. I haven't even gotten one song on to the blank cassette, but the new batteries help—a little. My shirt is stuck to my back. Mitch says to put two Michael Jackson songs on the tape and skip the Stones if it'll make it go faster. Then the nervous suit sticks his head in.

"OK. Gimme what you got. I got a guy out here who can do it on the big system, fast."

Mitch stands. All she has on is a red-and-black leather G-string.

"Make sure he gets it right, OK?" she tells him. "It has to be in the right order or my pace is fucked, understand?"

The door closes without a response. Mitch takes a look at me.

"You poor thing," she says, and we both burst out laughing.

Then it's quiet again.

"Thanks so much for coming to visit me," Mitch says.

Mitch hugs me. That's what it turned out to be—a visit—and the good-bye is definitive, like we won't see each other until some unspecified future date, not again on this trip.

Someone knocks.

"Ugh, these fuckers won't leave me alone," Mitch whispers, then, "Door's open!" louder, in a mock-friendly voice.

It's not one of the suits. It's a stripper, a house girl. She has a pretty face, big green eyes. She's in a red sequined bathing suit with half-inch straps that cover her nipples. Her body is pale and skinny. She looks half Mitch's age.

"Miss Mitchell . . . ," she starts.

"Who are you?" Mitch says, warmly.

"Uh, Sapphire, I mean y'know, that's my stage name."

She glances at the floor, then back at Mitch.

"I saw your last show last night," she continues. "I just wanna tell you I think you dance really great. I think you're really great and it's an honor, you being here. That's all, I mean, sorry to interrupt."

"Aren't you just the most darling thing," Mitch says.

She clasps her hands around Sapphire's waist, resting them in the small of the stripper's back.

"You are such a sweetheart," Mitch says. She kisses Sapphire on the lips. The kiss lingers for a second then they touch tongues. Sapphire blushes.

"I better get out there or they're gonna kill me," she says.

"OK, honey. I'll see ya later after my show, OK? You'll watch?"

Sapphire nods yes, smiles, and leaves. Mitch looks happy for a minute. "She's a really cute kid," Mitch says, " What a sweetheart."

I make my way down the side stairs as the nervous one introduces "Miss Sharon Mitchell" over the distorted PA and the star takes the stage.

THERE'S AN ARTICLE ABOUT APRIL RAYNE IN *INTERVIEW*. IT'S CALLED "AN ACTRESS WHO Likes Taking Chances." The article refers to April by her real name, Andrea N———, and *Interview*'s film critic raves about Andrea's performance in *Hold Me, Thrill Me, Kiss Me*, an independent feature, the film Andrea mentioned the day she posed for me in Hollywood. The film's director says he discovered her while watching *Personalities*, a hard-core video. In the corner of the photo in *Interview,* there's a designer credit, "Dress By Morgane Le Fay." Then *The New Yorker* publishes an illustration of Andrea by Robert Risko.

Andrea's success outside of porn and her mainstream recognition are a vindication of my original vision for this book: like, "see, these *are* real stars, and their lives aren't all hopelessly negative."

I telephone Andrea to congratulate her, but her number has been disconnected.

Tom Byron's hasn't.

"I hear she's turning tricks," he says. Tom doesn't have a new number for Andrea. He says the last he heard, she didn't have a place to live.

"WHERE THE FUCK IS SKIP?"

Someone points to the bathroom then gets out of Savannah's way.

Los Angeles. Every few years, a porn actress comes along whose fame raises the visibility of the entire industry. This time it's Savannah.

Savannah's the girl who in a tabloid interview rated all of her rock-star boyfriends' bedroom techniques on a scale of one to ten. The most recent story is about Savannah giving Slash, the Guns n' Roses guitarist, a blow job at Scrap Bar, a Greenwich Village metalhead hangout. Howard Stern went on and on about it, finally interrogating Slash. The rock star denied everything over his cell phone from a beach in Hawaii. He said he and Savannah are just friends, but since then a lot more people know Savannah's name.

She looks heavy, bloated. She carries her large tits like they're a burden. Her pale face looks washed out with no makeup. She doesn't look anything like her pictures.

Savannah ignores Jamie Summers and Tom Byron, who're laying in each other's arms on the futon. The anal beads are on the floor nearby. No one picked them up when the crew moved on to the next setup.

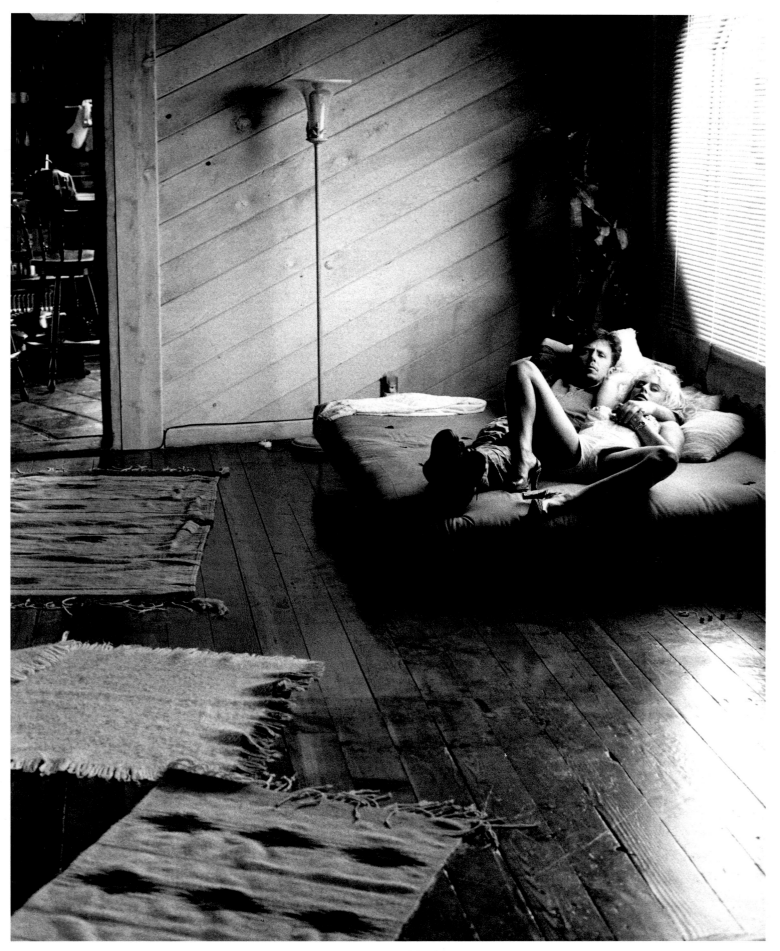

Tom, Jamie, anal beads.

Paul Thomas—PT—rushes in to greet the star. The director treats Savannah like a princess, apologizing for bad directions, the distant set, for anything he can think of that'll make her feel very, very appreciated for being here, even though she's three hours late. He leads her to the bathroom, to Skip, the makeup artist.

Forty-five minutes later PT emerges from the house with Savannah on his arm. She's transformed, radiant in a flimsy sundress, her blonde bangs shimmering. She looks like a totally different person, and sexy. Savannah tippy-toes along with a big smile, maybe because she knows now everything hinges on her, and she likes that. It's forty yards from the house to where the crew is, and the whole way everyone just stares at her.

Savannah sits in a hammock, waiting. PT promises ("I promise, promise, promise") it'll only be a minute more. Everyone's busy, so she's just sitting there by herself.

"Hey, can I take your picture?" I ask. Savannah nods and lies back in the hammock. She spreads her legs, no panties.

After two or three clicks she says, "Who are you?" Savannah sounds like a curious adolescent, a little kid, a girl from the Valley. Her voice, her attitude, the way she looks now, are all designed to be a turn-on. She just assumes she turns everyone on.

Savannah doesn't wait for an answer. PT helps her out of the hammock and walks her to a red fifties Chevy pickup parked right outside the gates of the property. Jamie is leaning against the cab. PT introduces the two actresses.

Jamie gets behind the wheel of the pickup; Savannah sits next to her in the passenger seat. Jim Waters, the cameraman, shoots the girls pulling out as an actor named Marc Wallice chases the truck. They run through it three or four times. Each time Marc is left in a cloud of dust as the truck disappears around a bend.

PT is satisfied. The pickup is parked around the bend and down the road fifty yards. Two PAs carry a twin-size mattress from the house and lay it in the truck bed. The AD remarks that they should've put the mattress in the truck when it was parked by the house. The two PAs stare at him with blank expressions. Their day is twelve hours old.

The view off the edge of the road, a cliff, is breathtaking. The sun is setting over a series of jagged mountains that lead to the Pacific. The light is yellow, glowing, and intense. Movie-star light.

The bright-red truck and the two bleached-blonde California girls climbing into the back look glamorous, in a late-night cable kind of way. They're here to do dirty stuff, but the whole thing has an airbrushed feel to it. It's my first day on the set of a porn movie and this works, this benign vision is all the reconfirmation I need that doing a book of *Interview*-style portraits of porn stars is a conscionable pursuit.

Jamie and Savannah kiss and touch each other's breasts, half-undressed. Skip steps in to touch up Savannah's face. Waters shoots standing, circling the back of the truck. Ron Vogel shoots stills. PT cues Marc to join the girls. The actor hops in, shirtless. PT stays fifty feet back. Despite running shorts, nonbrand-name sneakers, and tube socks pulled up near his knees, the handsome director looks successful, has that kind of aura. He was once a porn star, too. PT has a blissful expression.

"I really love what I do," he says. "I really love making movies. I really love it." PT gestures at the vista and the actors with a sweeping motion of his arm.

Savannah kneels. She opens Marc's Levi's and puts his dick in her mouth. She looks pretty, and bored, doing it. Savannah and Jamie take turns. The actors spend seven or

eight minutes trying different positions before arriving at the final setup.

Jamie stands with her back against the truck cab, while Savannah is on all fours with her face pressed into Jamie's crotch. Marc is on his knees behind Savannah. Every few seconds Marc stops moving, pulls out, smacks his erection with the backs of two or three fingers. A couple of times he even smacks himself in the face, all to keep from coming. No one laughs.

PT calls out, "Whenever you're ready, Marc."

"OK. Here goes," Marc says.

He checks to make sure Waters is on him, pulls out, and stands. Marc's arms are at his sides as he comes on Savannah's ass and back. He strokes himself once or twice and the orgasm is over.

PT says, "Cut. Thank you."

The girls are handed towels.

"THAT WAS FUN," Jamie tells Savannah.

They're in the bathroom, at the makeup table.

"Yeah," Savannah says. "It would've been even more fun without Marc."

She smiles at Jamie.

"*Definitely*," Jamie says.

Marc steps into the bathroom and directly into the shower. The girls both giggle then finish packing their stuff into identical flowery, embroidered duffels monogrammed with their real initials. Porn-star bags.

SAVANNAH PULLS INTO THE PARKING LOT OF GLADSTONE'S IN A RED MIATA, TOP DOWN, forty-five minutes late. She's changed her mind about doing pictures several times in the four days since *Sleeping Beauties*.

"Now, *where* are you taking me?" she says.

I say, "Paradise Cove."

"You follow me," she says.

Savannah pulls out before I start my car, turns left, and heads north on One. She drives too fast, passes everything in her way. She's six or seven cars ahead. The entrance to the beach is twenty minutes past Malibu Colony. Savannah is tapping her pink fingernails on her steering wheel as I pull alongside the Miata. I go ahead and pay the attendant for both cars; forty dollars. Two large white trucks are parked at the edge of the lot.

Savannah is annoyed. I carry her embroidered, monogrammed duffel along with my camera bag. The beach is a series of alcoves at the base of the cliffs. There's a film crew in the first alcove.

A PA recognizes Savannah as she passes. He smiles knowingly. JENNY GARTH is stenciled on a tall director's chair. They're shooting an episode of *Beverly Hills 90210*.

Past the production the beach is empty. We walk a couple hundred yards and stop at a surfer hut fashioned out of palm leaves and bamboo. It looks like something from *Gilligan's Island*. There's a rusted lounge chair. The sand is littered with cigarette butts.

When the camera is on her Savannah acts friendly, seductive. When it isn't she acts like a spoiled kid. Savannah goes through a series of well-rehearsed stock pinup poses. She acts like a star, and dresses like one. She makes a pretty strong case for her stardom, despite forcing it.

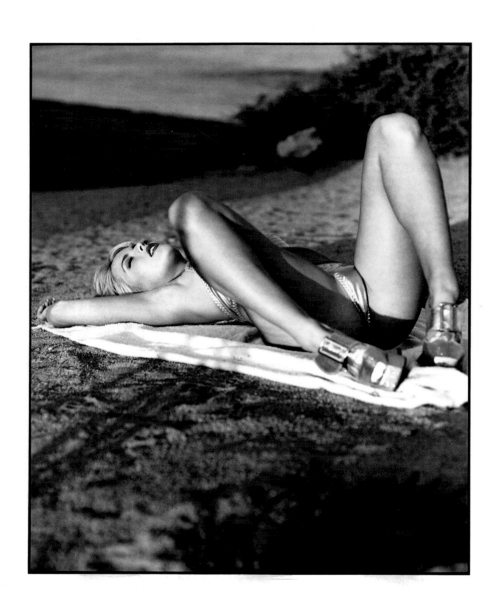

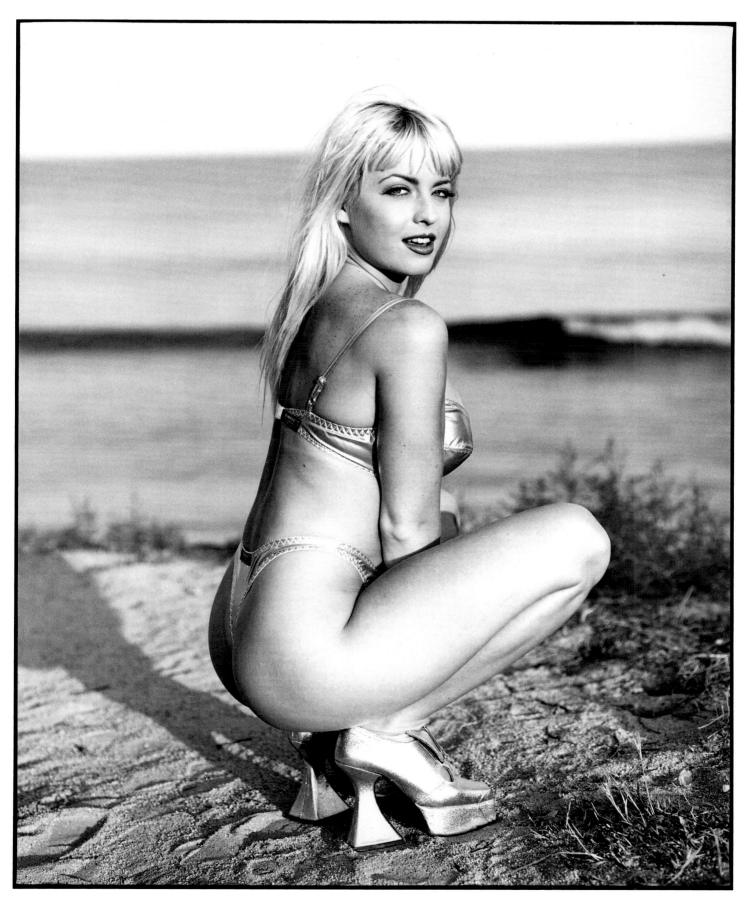

Savannah

After a couple of outfits Savannah strips and walks into the surf nude. I follow shooting, up to my knees in foamy water. The gaudy jewelry and rocked-out costumes are gone. For the first time Savannah looks really girlish, innocent even. She smiles like a little girl—and not like she's pretending to be one.

A skinny, sun-bleached surfer dude wearing a wet suit walks in our direction carrying a board under his arm. Savannah covers her breasts. Her pussy is still exposed. He looks at the sand, does his best to avoid looking at Savannah. She walks up to him.

"You're Savannah right?" he says. "My brother talks about you a lot."

She nods, smiling. The surfer can't seem to wipe the big, goofy grin off his face. Savannah looks like she takes pleasure in the effect her presence—her stardom, not necessarily her nakedness—has on the kid. I ask him to pose for a picture with her. Savannah puts her arm around the surfer's waist. She doesn't say anything, just smiles. He thanks her—she nods once more—then he walks away, down the beach and around the bend toward the parking lot, past the *90210* crew, with a story to tell his brother.

It's almost six. The sun has shifted over the cliffs. We follow a path up one of the steep inclines. The last rays blast past Savannah and over the sea. It's a glorious view. Savannah looks hopeful basking in the sun, but anyone would. Her bleached hair sparkles. She crouches at the edge of the cliff with the ocean behind her—a California dream girl.

Savannah can barely stand in her platform shoes. I lift her up in my arms and carry her back to her towel and bag. Savannah laughs as she pulls her silver panties over my head.

There's still light hitting the top of the hill, so I follow Savannah, who is now wearing my shirt, up a crude little path. She lays down on her back in the dirt and spreads her legs wide. Her expression is hard, raunchy. She plays with herself, and stares me down. The come-on takes me by surprise. I can't tell if it's for the camera or for me.

"Do you want to fuck me?" I ask, not as an offer but because I really want to know.

Savannah nods affirmative. She has a wicked grin.

Suddenly there are voices coming from further up the path. Savannah covers herself, stands up, annoyed, and walks back down the hill.

A woman and her maybe five-year-old daughter make their way down the path a few seconds later. The woman looks like a mom from the fifties. She offers a weak, perfunctory smile. Savannah is in panties. The mom shuttles her daughter past, down the path to the beach. The girl looks over her shoulder at Savannah as her mom pulls her around a bend and they disappear.

"What's she got stuck up *her* ass?" Savannah says, then adds, "Cute little girl."

Savannah changes back into the dress she wore to the shoot, a ruffled flowery thing. I pick up her bag and we start back to the parking lot.

"I better be getting dinner at Gladstone's out of this," Savannah says.

As she passes the *90210* crew, the same PA who had noticed Savannah before whispers something to another tech, and the two laugh. Savannah must know they're laughing about her, or at her, but she doesn't let on.

"I'm fucking starved," she says.

On the road I don't even try to keep up. When I arrive Savannah is waiting near the entrance, drink in hand. Gladstone's is a big seafood restaurant at the end of Sunset, on the water. It's jammed with college kids, couples on dates, all pounding down

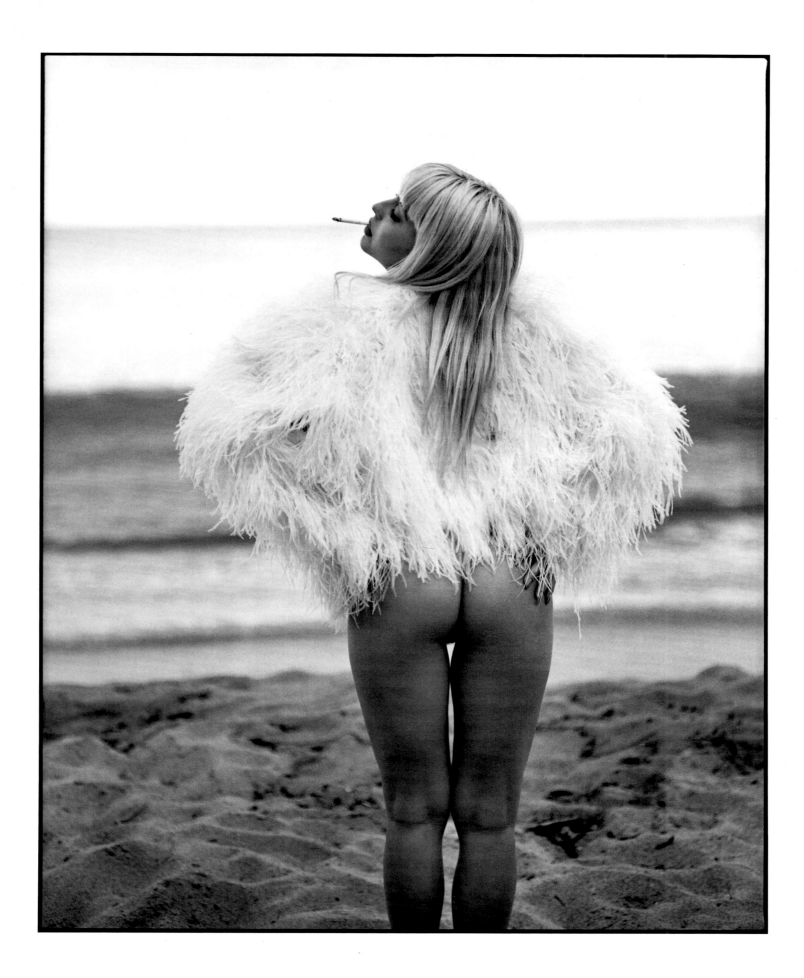

tall pink and blue drinks with flowers and umbrellas. There's an hour wait. Names are being announced over a loudspeaker.

I convince the maître d' that Savannah's famous. He buys it, half knowing who she is. Within five minutes we're sitting at a table overlooking the water. Savannah orders a frosty, colorful daiquiri. The drink is gone in three hard sucks on a swirly straw. She orders another, and seems cheery.

She watches three Jet Skiers traversing the surf in front of the restaurant. Spotlights illuminate the water.

Savannah says, "I gotta pee."

She comes back as the food arrives.

"I'm ready to go home," she says. "*Now.*"

Savannah doesn't look at the food, couldn't care less. She's come back from the bathroom a little harder, a little less cheery, maybe wired. As we're leaving the maître d' hands me his business card.

The valet gets Savannah's car first.

"Follow me," she says, then pulls over to the exit and waits. It's pitch black out, except for headlights and taillights. Savannah drives faster than before. It's stupid trying to keep up, but she wouldn't give directions or an address.

She zigzags through the freeway traffic, pulling way ahead. At seventy-five I'm still seven or eight cars behind. Each time I think I've lost her Savannah appears in the slow lane, laughing crazily, getting off on the speed, on freaking me out. This happens over and over during our thirty minutes on the freeway. I try to laugh about it, too, about the whole thing, how absurd, how vaguely pathetic, it is to be risking my life trying not to lose a porn star on a Los Angeles freeway.

Finally her right blinker flashes. Savannah's car slides from the left side across three lanes, then across another three lanes like it's nothing—at ninety—then down the off-ramp for Ventura Boulevard.

Savannah turns right onto Ventura, then again onto Valley Heart Drive. The curving, homey tree-lined street is a relief. It's a joke, almost, that all that terror should lead here. Savannah pulls up to a garage entrance underneath a small, white modern apartment building.

"Meet me at the elevator," she shouts, then pulls in.

THE THIRD-FLOOR APARTMENT is immaculate, hardly lived in. The wall-to-wall carpet is stark white. So are the bare walls. Savannah is proud of her home. There's a bar off the kitchen, lots of shiny appliances, six stools, an eight-foot L-shaped leather sofa, a smoked-glass-and-metal coffee table. Everything that isn't chrome is black. A Sony large-screen TV and VCR take up one corner. Five or six Savannah tapes make up her entire video collection. Four thirty-by-forty-inch Savannah posters, each in a fancy black-and-gold frame, lean on top of one another near the TV.

"I still gotta hang those up," she says.

In her office there's a gleaming StairMaster in one corner. Savannah laughs when asked if she uses it, like I must be joking, but I can't tell if that's a yes or a no. There's a neat row of shoe boxes filled with fan mail on her black desk.

"I have to answer those sometime," she says.

Savannah is being sweet again, like a kid who wants to share her toys.

The bedroom carpet is white shag. The bed takes up most of the room. The far wall is all mirrored closet doors. There's a fluffy black cat curled up on Savannah's comforter. I tell her I'm allergic to cats and she nudges it out of the room. I expected her reaction to be, "Deal with it, dude." Savannah flops down on the bed and grabs the remote control. She turns on a big TV in a black faux-bamboo shelving unit at the foot of the bed, next to the bathroom. I sit near her feet, then move up. We lie there watching some show where Sandra Bernhardt pretends she's Hugh Hefner. I click the set off.

I ask Savannah if she has a condom. She points to a small bedside dresser. I pull open the drawer. It's filled, ten inches deep and a foot back, with condoms and dildos and all kinds of sex toys, in every color, shape, size.

Later Savannah gets up to go to the bathroom. She's gone for a long time, maybe twenty-five minutes. She finally steps out in a long, frilly robe over an even frillier nightgown. It's not sexy stuff—just the opposite. Both have long sleeves. It's the kind of stuff third-grade girls dream of, the kind of bed clothes their dolls wear. Savannah's makeup and lashes are gone. Even though I saw her without it when she arrived at the set of *Sleeping Beauties,* it's still a shock. Savannah looks wiped out.

"I'm going to sleep," she says; no eye contact.

Savannah's out fast, in a minute or two, breathing heavy and steady.

In the kitchen, the cat is circling the doggie bag from Gladstone's. We share the salmon. There are Polaroids stuck to the refrigerator. In one, Slash is kissing Savannah. In another, she's kissing his cheek. In the third, Slash has his arm around Savannah's shoulder. They're smiling at the camera. Savannah looks happy, like she's in love. The pictures were taken in this room, on Savannah's black sofa. The last shot is of Steven Hirsch, the owner of Vivid Video, standing next to her Miata. Jamie Summers says Hirsch bought it for Savannah, and this apartment as well, in a "been there, done that" tone of voice, but one maybe tinged with jealousy, too.

The refrigerator is stocked with junk food. Artificially flavored puddings, fruit pies. I squeeze what's left of the doggie bag into a corner. The freezer is the same: ice creams and Popsicles, some named after cartoon characters I've never heard of. The cupboard is brimming with a ton of different cereals, all family-sized boxes, Froot Loops, Cap'n Crunch's Peanut Butter, and twelve-box convenience packs. Pop-Tarts, Fruit Roll-Ups, various Jell-O pudding mixes. It's the cupboard every nine-year-old dreams of. I turn out the lights and go back to the bedroom.

Savannah's bathroom counter is overflowing with toiletries. It's kind of like the kitchen cabinets, except this is grown-up stuff, expensive stuff. Makeup, fingernail polish, a Rembrandt tooth-whitening system. Savannah's teeth are very white.

I lie next to her back for a couple hours. At dawn I try to say good-bye but she's out cold, doesn't hear a thing.

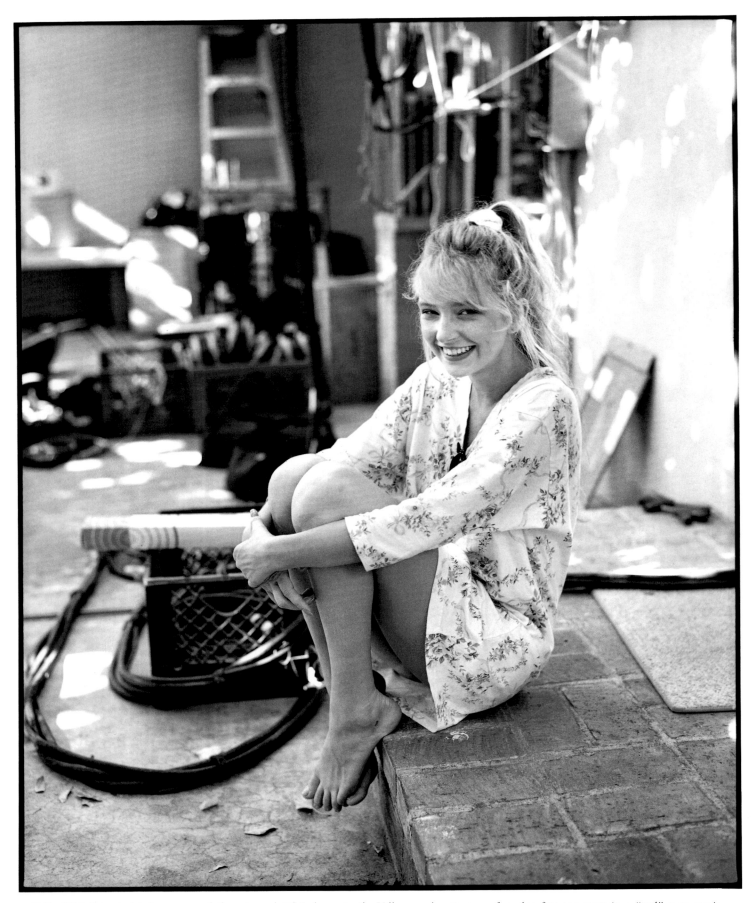

Kelly O'Dell, a starlet, hangs around the set—a dentist's house in the Valley—and waits to perform her first sex scene in a "real" porn movie.

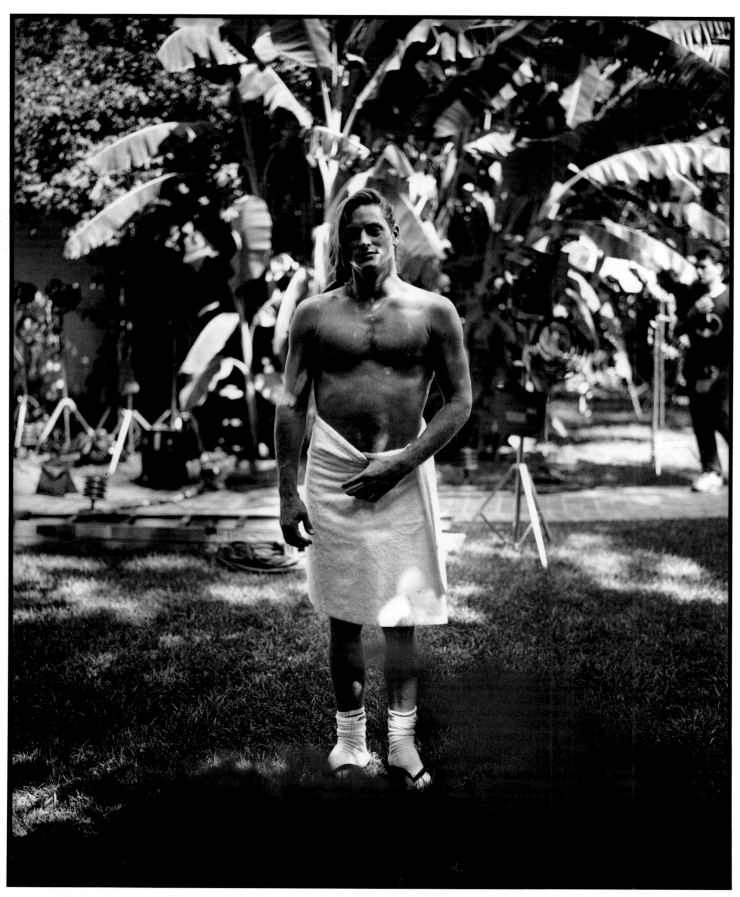

Marc Wallice, moments after his first scene of the day (the two thousandth or so of his career), will have sex with Kelly next. Marc admits he's a premature ejaculator and says the technicians, the lights—all the distractions other actors view as obstacles to a successful performance—enable him to function reliably.

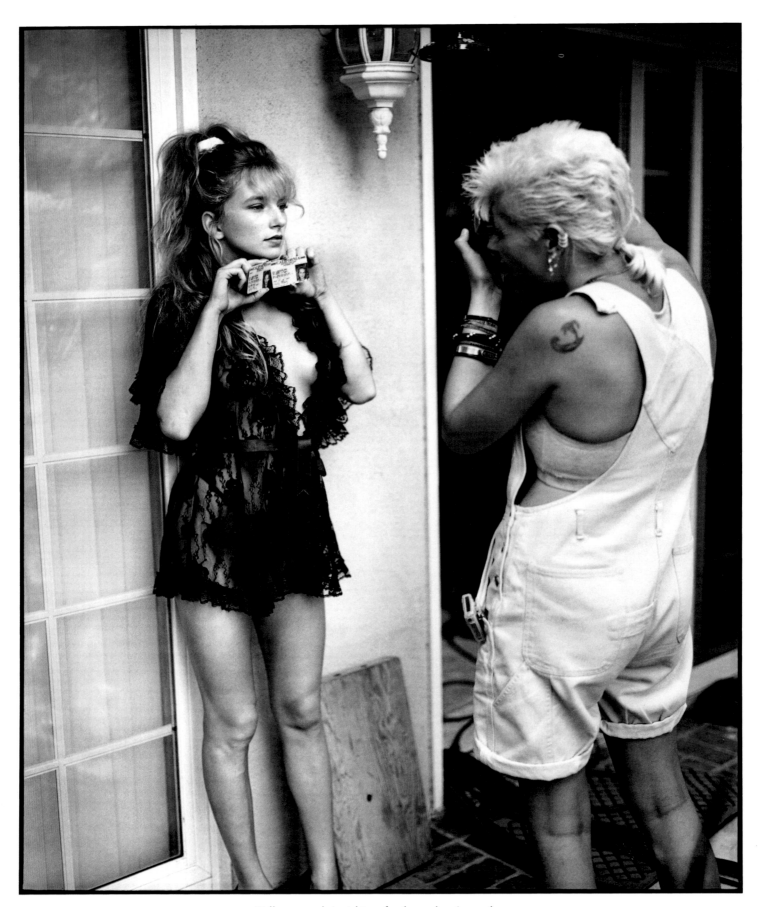

Kelly proves she's eighteen for the producer's records.

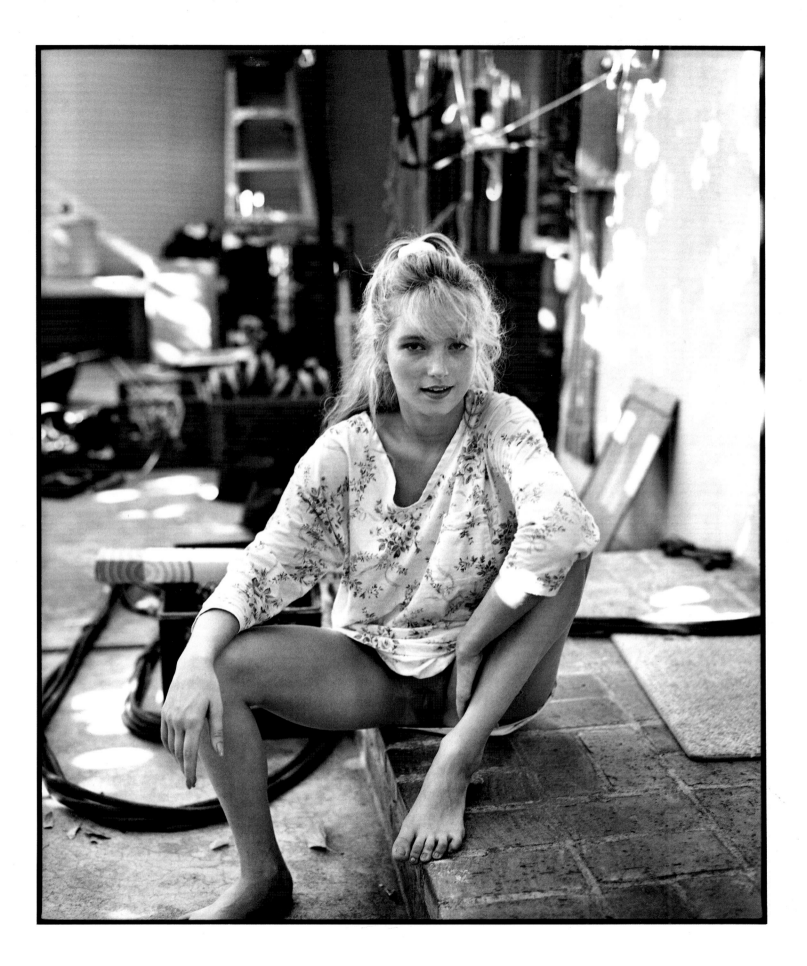

A soundstage dressing room.

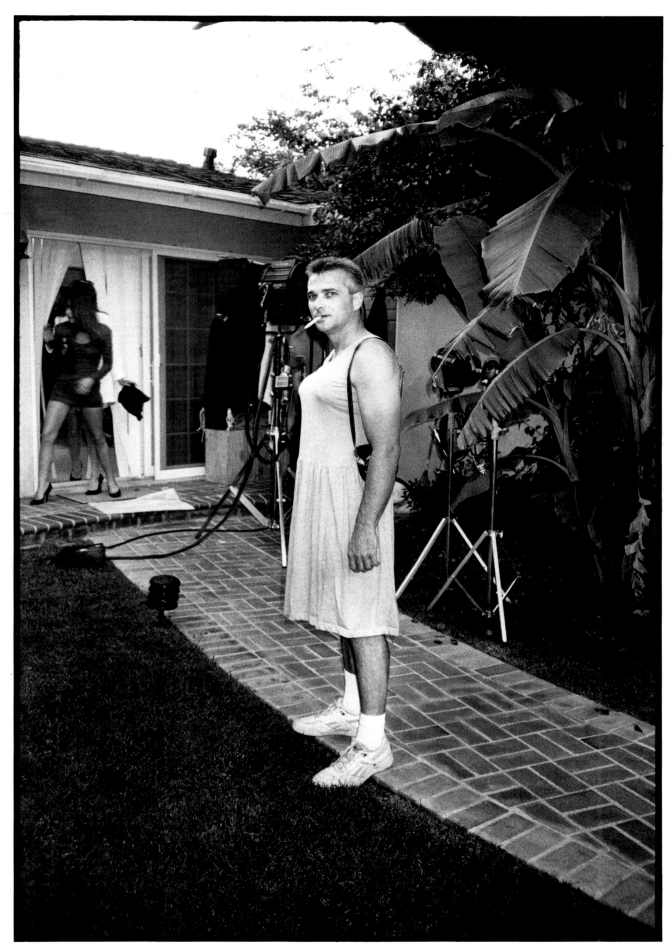

Director Jay Shanahan makes a cameo appearance in his video "Flesh for Fantasy."

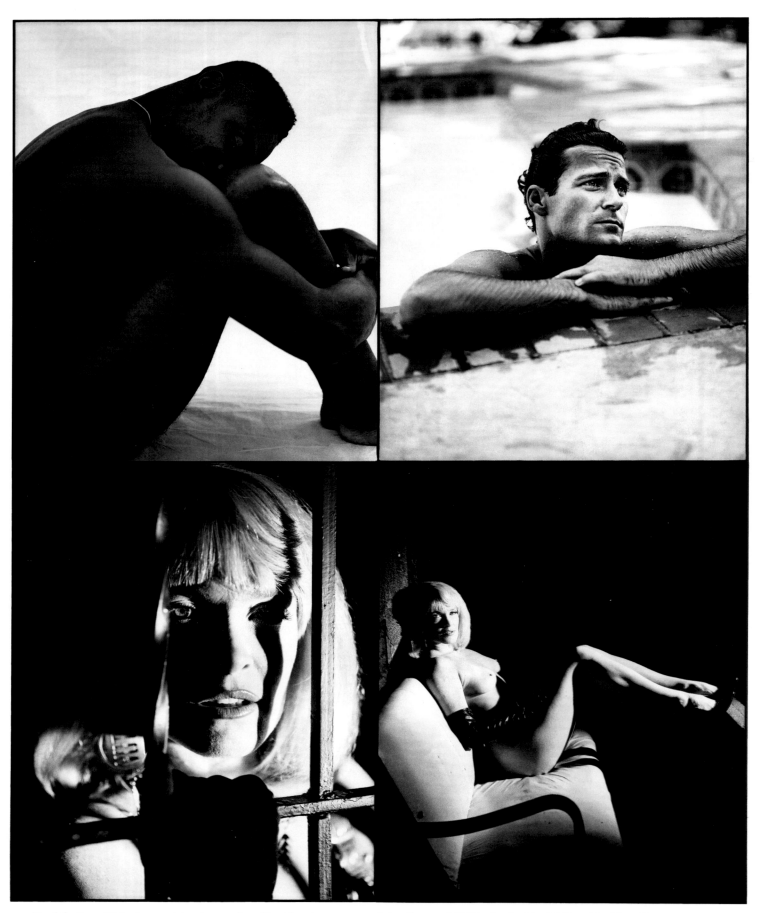

Top left: Sean Michaels, a registered nurse from Brooklyn, is an actor and the director of "Girlz 'n the Hood." Top right: Tom Chapman says one reason he acts in porn is to piss off his dad. Bottom: Instead of trying to compete with the constant stream of young girls entering the business, actress Porsche Lynn revitalized her career by coming out with her own line of S&M tapes.

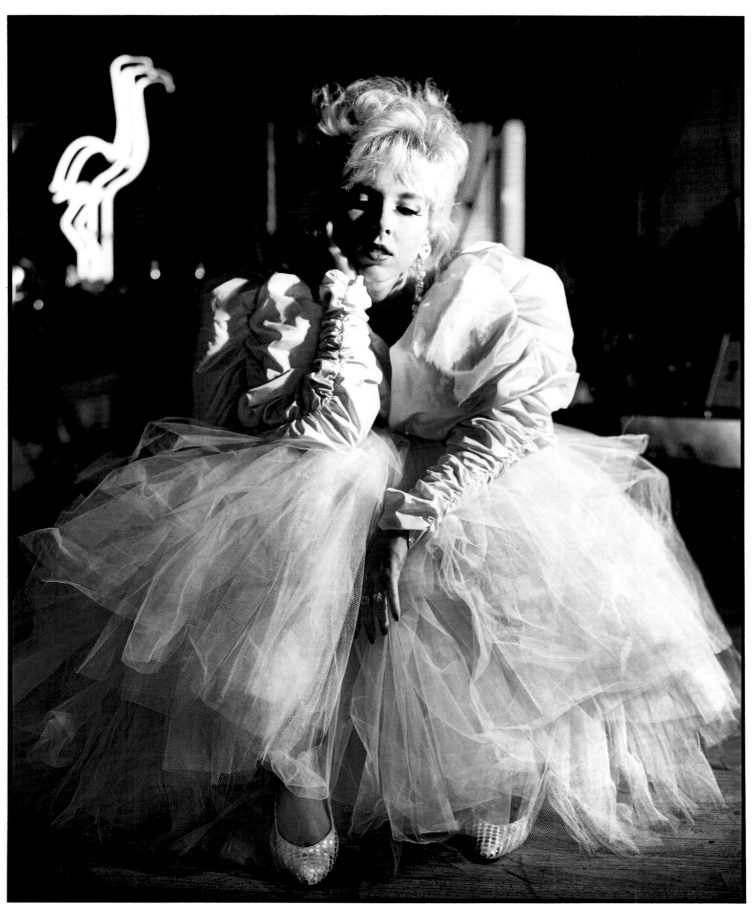

Once a rec center swimming instructor back home in Montana, superstar Victoria Paris (pictured in her tiny Hollywood bungalow) came to Los Angeles with hopes of becoming a sports nutritionist.

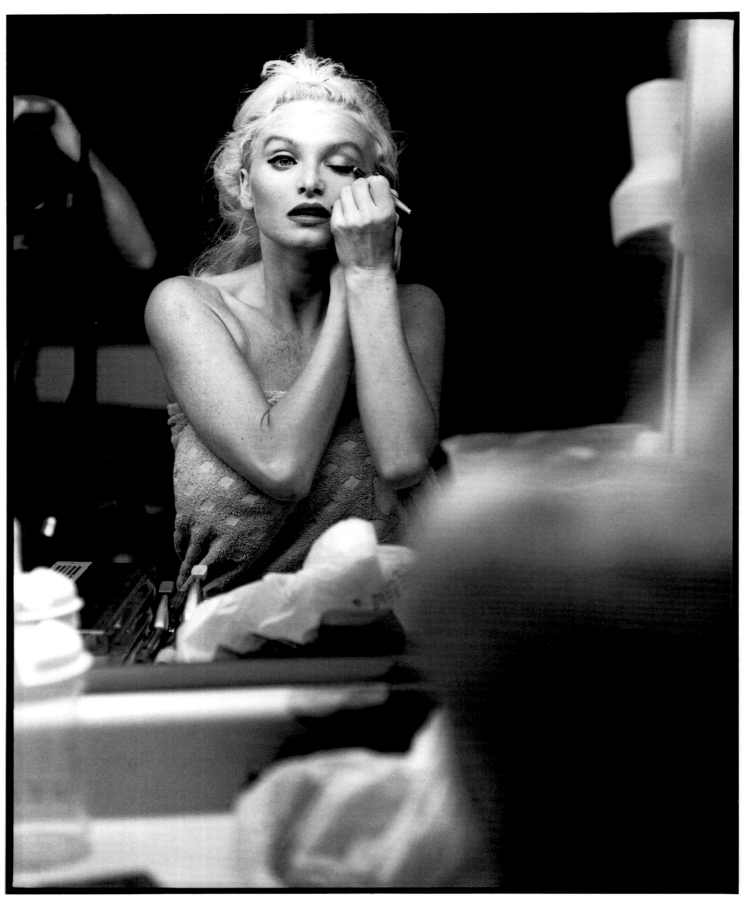

Taylor Wayne left her native England for Hollywood, where she has made a name for herself as a hard-core sex queen. Her fiancé is one of porn's busiest video-box-cover photographers.

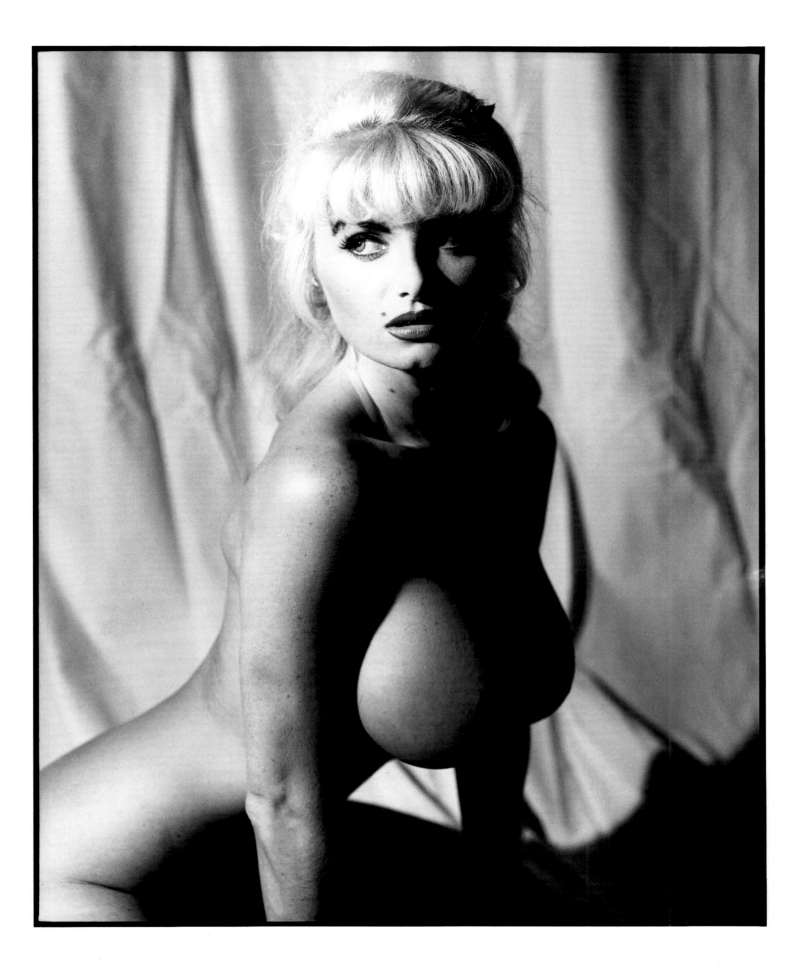

Bad-boy actor TT Boy.

Dominique Simone, one of the few black stars from her generation of porn, says the first time she had sex on camera it was "pretty bad," but that as she did more scenes "it got better."

Madison on her boyfriend's roof in downtown Los Angeles.

MADISON IS SHARING A SUITE WITH TIANNA TAYLOR AT THE TROPICANA. SINCE I PHO-tographed her at her place in Hollywood last week, she's taken me under her wing. She's even secured me a cut-rate room at the Tropicana for the four days of VSDA '92, the Video Software Dealers' Association convention. Madison likes being seen with a photographer from "outside the business" following her around. It's a status symbol—an affirmation of her stardom.

"If you want a lift to the Panty Auction at Pure Pleasures tonight," she says, "be at my room at eight thirty." Today was the first day of the convention, and this seems to be where everyone is going.

Madison dresses like a hippie rock star, with peace-sign medallions, octagonal rose-colored shades, tight black bell-bottoms, macramé halters. Recently that image—plus a bunch of plastic surgery—has helped transform her from an Atlanta stripper, a house girl, into a major porn star.

It is an image. Madison is likable, but she needs to move within the center of an entourage—this weekend it's Tianna, one of Madison's little errand boys, and a tall club DJ who looks like Morrissey. Madison bristles whenever her control is defied, no mat-ter how trivial the breach. Tianna is also acting in porn, but it's clear Madison is the leader of this gang.

When I arrive she's on the phone with Aaron, her boyfriend in LA, a rock drum-mer. He won't be arriving in Las Vegas until one thirty in the morning, and Madison is pissed.

Tianna checks herself out in a full-length mirror. She's wearing tight white bell-bottoms and a white vest that covers less than half of an enormous, painful-looking tit job. "Do I look too much like a slut?" she asks.

Madison's group arrives at the small, white two-story building at the same time as Scott St. James, a stills photographer. After brief hellos they follow him in. Downtown Las Vegas feels far away. We're in the pitch-black middle of nowhere.

Still, Pure Pleasures is a typical sex shop and video arcade. Magazines, videos, and au-tographed posters of porn stars line the walls. The fruity stench of Professional's Choice Spring Mist Odor Counteractant—used to mop down the booths—fills the air.

Two thugs in tuxedos stand at the back door. When they recognize Madison, she and the rest are waved on through into a large tent erected at the back of the building.

It's a steam bath. Three hundred, maybe more, are packed into rows of folding plas-tic chairs, which are arranged on three sides of a shabby eight-by-ten-foot stage. Press photographers and other industry insiders are sprinkled throughout the front rows, but the vast majority of the audience is definitely fans. Some look like they've traveled a long way to get here.

This is the premise: The fans have paid an admission fee for the opportunity to bid on the panties of their favorite porn stars. The stars, all girls, will be introduced and brought out one at a time. Each one will dance a little, maybe take a few questions from the crowd, and then the bidding will commence. The highest bidder for each performer wins a chance to join that porn star onstage and remove her lingerie with his teeth.

Bill Margold, a perennial presence in porn and this event's organizer, is the master of ceremonies. Margold has produced, directed, or appeared in over three hundred adult films. Each year, as a member of the board of directors of the Free Speech Coalition,

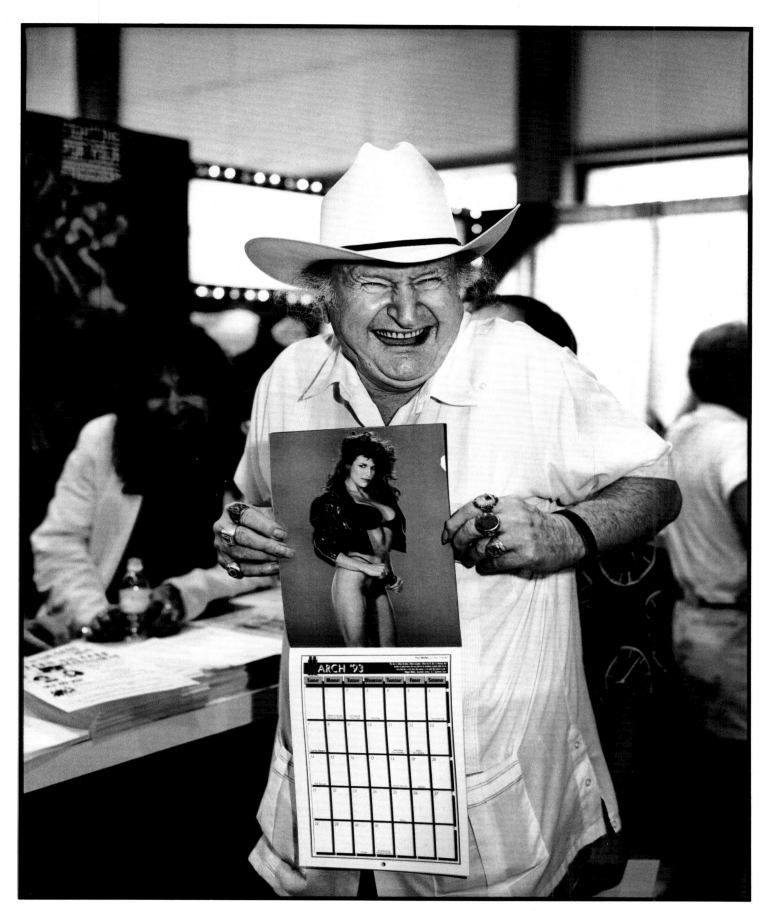

Grandpa Al Lewis

he throws this event in order to raise money to fight lawsuits involving censorship issues. The Panty Auction is a porn-world fund-raiser.

"Ladies and gentlemen, may all your wet dreams come true tonight. First of all, our thanks to Pure Pleasures for hosting, one more time, with me and the rest of the Free Speech Coalition board of directors, the VSDA opening-night Panty Auction! There are some very beautiful ladies in the house—I mean tent—tonight. I know you'll know most of them pretty well, but there are also a few girls I'm sure you'll want to get to know even better!" With each name the applause grows. After Nina Hartley's name is mentioned the applause is intense.

"Now you know the rules. I bring out a hot, sexy, curvy, lovable, fuckable porn star . . . and all you guys eat your hearts out! In fact, one of you lucky guys may get to say those very words tonight. It all depends on just how deep your pockets are. On a more serious note, it all depends on how much you value the right to purchase and use the materials of your choice in the privacy of your own home. That's what this is all about. We need your help. If you want to keep stroking it to the stuff we're putting out, *you* need your help. So tonight, dig a little deeper. These girls are ready to make it well, well worth it."

More cheers.

BACKSTAGE, NINA HARTLEY is laughing while holding her bikini bottom to one side. Michele Capozzi, a short Italian Hachette press correspondent in a linen suit, and one of three journalists surrounding her, is down on one knee giving her a gentle, reverent kiss, as a peasant may have kissed the foot of a queen.

The makeshift backstage area is an unfinished extension to the small cinder-block building. Some sections of the walls reveal insulation, others sheets of bare drywall. A single eight-foot fluorescent tube lights the space.

Someone has unrolled crepe paper across a six-foot table and laid out Cheez Doodles, potato chips, and a couple bowls of ice with soda cans floating at the top.

Sharon Mitchell is sitting on the end of a folded ladder, nude except for knee-high leather boots, assessing herself in a small mirror leaned against the wall.

The rest of the girls who will be performing are hanging out, mostly undressed, sipping Cokes, comparing tit jobs, looking nervous, acting bored.

"You're my hero, totally. I'm honored to meet you." Madison introduces herself to Nina Hartley. Nina has huge, friendly blue eyes. She responds with a warm smile. Nina is still surrounded by journalists, but she welcomes the attention from a new girl.

MADISON IS THE FIRST star to hit the stage. There's applause for the tiny stripper from Atlanta, but also that peculiar laugh you hear from porn fans—the one with the superior, judgmental tone.

She's in fire-engine-red, thigh-high, patent-leather stiletto-heeled boots and a red suede fringed bikini, and carrying a matching seven-foot bullwhip.

She cracks her whip, dancing provocatively to a couple of songs, then Margold rejoins her onstage. They joke around. He pretends to fuck her from behind while she leans over the sound equipment—a brown Radio Shack–type stereo.

"Let's get down to business," commands Margold.

"Yeah, who's got what it takes?" Madison shouts, grabbing the mike from Margold

and flicking her pierced tongue lewdly, the tiny barbell glimmering in the spotlight. "Who's ready to make a real political statement and get down on their knees and bite my panties!"

More cheers and laughs.

"Do I hear twenty dollars?" Margold crows. "That gentleman in the third row says twenty. People, people. Do I hear thirty? Yes."

Madison prances around the stage cracking her whip as the bidding climbs, grudgingly, up to seventy dollars.

The highest bidder is a Mexican man who seems happy and a little confused. Now that he's bid highest, he actually has to get up on the stage and perform. Madison waves him over, cracking her whip.

"Life in the Fast Lane" is playing, and before the man can figure out where to begin, Madison is lifting his shirt over his head. Moments later he's on all fours, with Madison, topless, riding him like a mule, pulling on the waistband of his underpants and using it as reins, her fringed bra draped over his face.

Madison's assault peaks with the man flat on his stomach, his arms and legs splayed. She's still straddling him, clenching her fists, gritting her teeth, and shaking her fake breasts violently from side to side.

The humiliation is almost complete. Madison allows the man, back up on his knees and visibly shaken, to sniff and snort his way through the ordeal of removing her G-string from behind with his mouth. He's led off the stage, shirtless, G-string in hand, with a puzzled expression that seems to say, "Everyone is cheering and laughing, so I must be happy."

Madison's performance sets the tone. All of the bigger names are intent on making laughingstocks of the males, while the lesser-known performers resort to kinky high jinks to try and prove themselves. A girl called Heidi Kat sucks off the director Seymore Butts while he films the act on a hi-8 with his outstretched arm.

The tent stinks of sweat. The faces in the crowd look beat. The auction has already passed the two-hour mark, and the fans are ready for the main attraction. They want Nina Hartley. Some have begun chanting her name.

"All right, everyone." Even Margold is worn down. "A legend—Miss Sharon Mitchell!"

Mitch slithers out to the stage, a real junkie grind. She looks wasted but her charisma is undeniable. She's one of tonight's most veteran veterans.

After a hard-core lesbian act with Alex Jordan, a new girl planted as an audience member, Mitch's routine ends with a tall Texan in his Jockey shorts wearing Jordan's bra.

"NINA! NINA! NINA! NINA!"

Now all three hundred–plus sweaty, exhausted men are chanting her name.

The rows and rows of token-booth peep shows on Times Square seem light-years away; the racks of porno magazines on display at the corner newsstand a memory. Dozens of minimum-wage laborers assembling videocassettes at plants in the San Fernando Valley, annual grosses surpassing $5 billion: these are abstract ideas.

The spotlight targets a door thirty feet to the right of the small stage. Now the crowd is up and stomping feet in time with the chant.

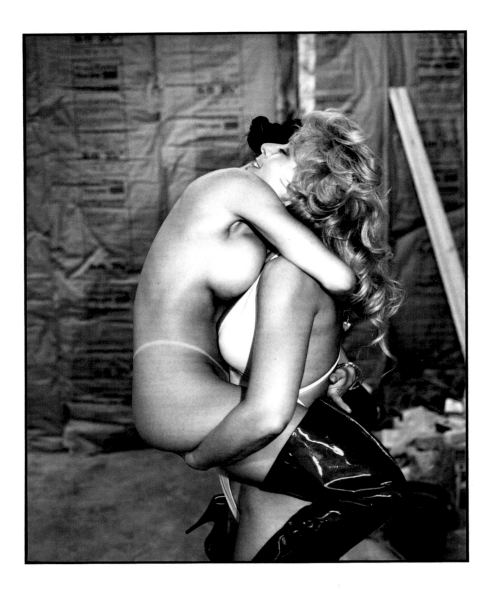

It has come down to the essence: a large tent behind a seedy sex shop a few miles west of downtown Las Vegas and three hundred fifty sweaty, exhausted men chanting her name.

Bill Margold says the following:

"Please let this wonderful lady, this marvelously sexy creature, know how much we love her. Ladies and gentlemen, a living legend . . . NINA HARTLEY!"

As Nina Hartley makes her way to the stage, the chant erupts into applause. Margold hands her the microphone and steps aside.

Nina stands in the small area between the stage and the first row, her compact frame clad in a lime green G-string bathing suit and black pumps. She's wearing an electric smile. The applause continues. Ten or twelve press photographers are straining for position, their flashes popping.

The star of *Young Girls in Tight Jeans* and *Female Aggressors* (among hundreds of other titles) stands before her fans, her arms at her sides, listening to the applause, taking it all in for a full two minutes before raising the microphone to speak.

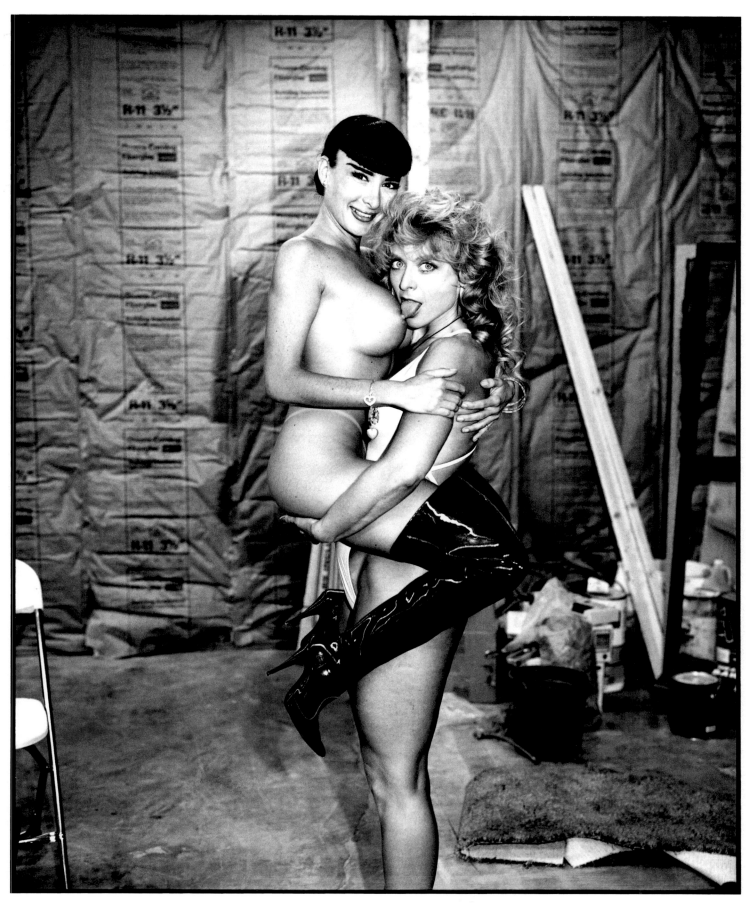

Madison and one of her idols, Nina Hartley, are introduced backstage at Pure Pleasures.

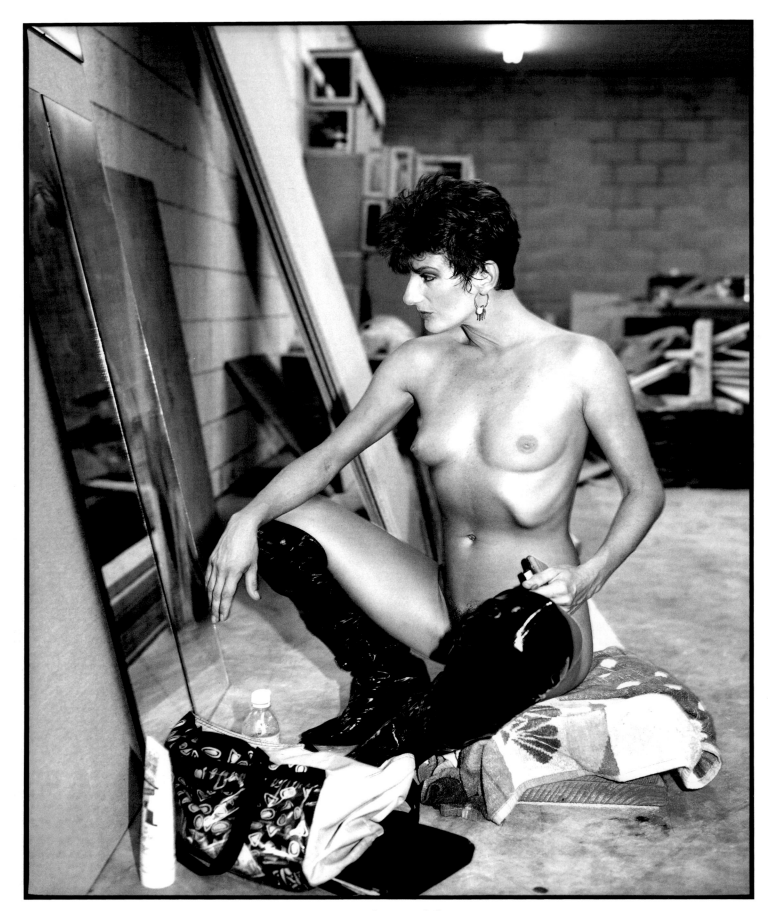

Miss Sharon Mitchell

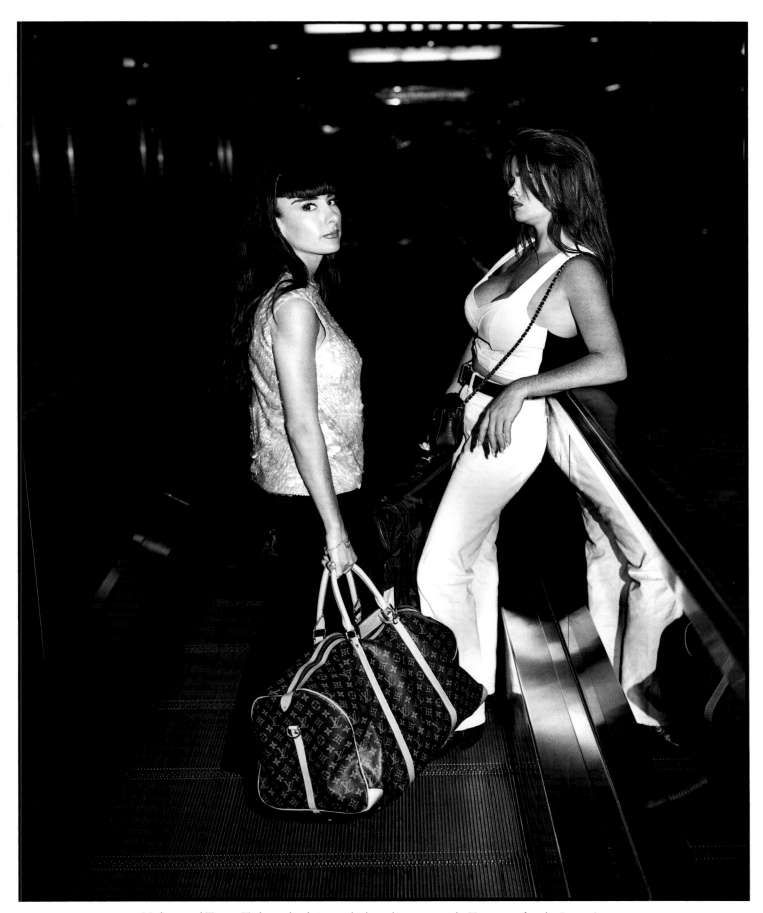

Madison and Tianna Taylor make their way back to their suite at the Tropicana after the Panty Auction.

"Thank you so much. It really means so much to me."

Another burst of applause.

"That's so sweet. I love you, too." More cheers. Hartley continues: "Hey, all the ladies have been just fantastic tonight! Thank you for coming out tonight for such a great cause. Thank you, Bill. And I can't tell you what it means to me that you guys stuck around to see me. I love it."

Now the crowd is on its feet again.

Nina is taking questions, wedding proposals, "I love you's" from her fans. The audience is transformed, focused. The snickering, the mean laughter is gone. Her gaze is direct, her voice clear and deliberate.

There's an iciness about her presence, a quality in her posture that implies a limit—and because Nina's eyes are so forgiving the men calm down. They honor that boundary. They show her respect.

The audience has finally found someone who knows why they are here, and who doesn't hate them for it. Her eyes tell them, "It's OK, I understand."

A young man in the back tells Nina that his father doesn't believe how close he's standing to the legendary porn star, and asks if she would help convince him.

"Where is he?" she asks.

Laughter sweeps across the audience—Nina's laughing, too—as the kid, maybe twenty-one, answers, "Right here!" and passes a cellular phone toward the stage.

"Hello, this is Nina Hartley. Who am I speaking with?"

Nina winks at the crowd, and now her fans are howling.

NINA HARTLEY LIKES THE IDEA OF DOING A SHOOT AT JOHN STAGLIANO'S HOUSE IN Malibu. She's famous for her rear end and he's famous for worshipping rear ends. The actress doesn't have a place in Los Angeles, so we have to figure out something. I call the director. Stagliano hesitates. He's in the middle of editing his latest *Buttman* video. It's my last chance to photograph either one of them before returning to New York. Stagliano finally says yes.

"No guy turns down a chance to spend the day with Nina."

John says this for me, or for the mythology of it. It's been a while since he has used Nina in one of his films. He concentrates on new girls, not legends.

Stagliano sniffles preemptively and says, "I have the same cold everyone else picked up in Las Vegas." If he can pull himself away from the editing console, he says he might pose, too.

John gives a tour before Nina arrives. Most of the living room has been converted into a ballet studio: John once had dreams of dancing professionally. One wall is mirrored and has a balance bar; the other wall is all windows with a view of a swimming pool, sun deck, and beyond that a couple more houses, then the Pacific.

Stagliano's bedroom is sparse—a bed, a large TV, and a collection of his movies on a fireplace mantel. He lends me a copy of *Buttman's Ultimate Workout,* an early feature he's proud of, on the condition that it be returned. Recently Alexandra Quinn's real age was exposed. The actress was underage at the time of Stagliano's shoot, so her scenes had to be edited out of all subsequent copies of the video.

"That's a collector's item," Stagliano says.

In a small room at the back of the first floor, there's a professional-looking video-

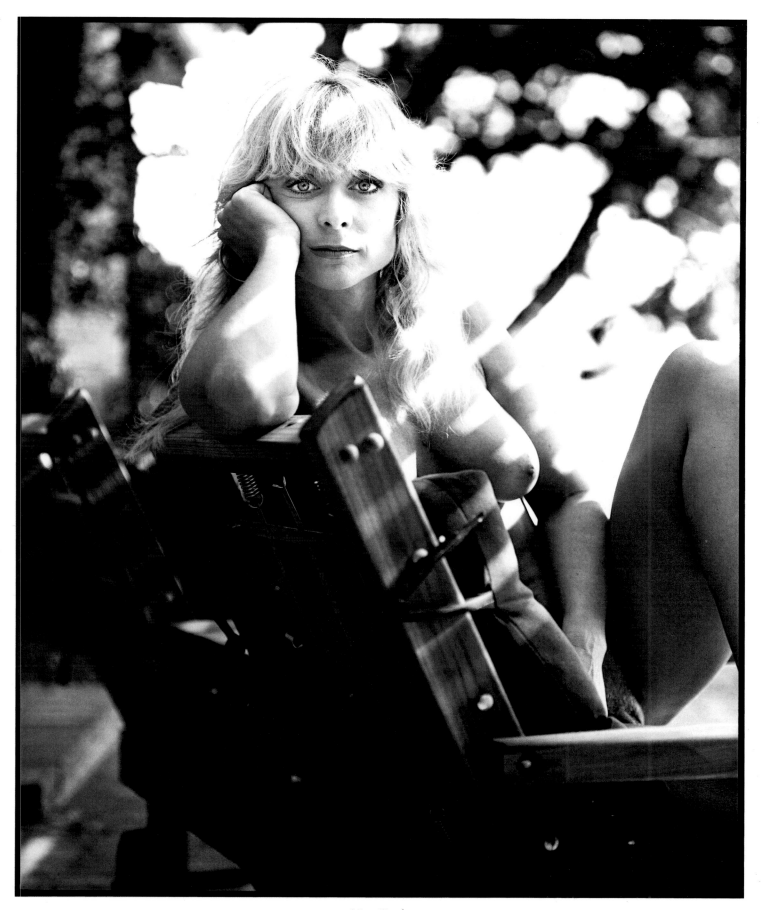

Nina Hartley

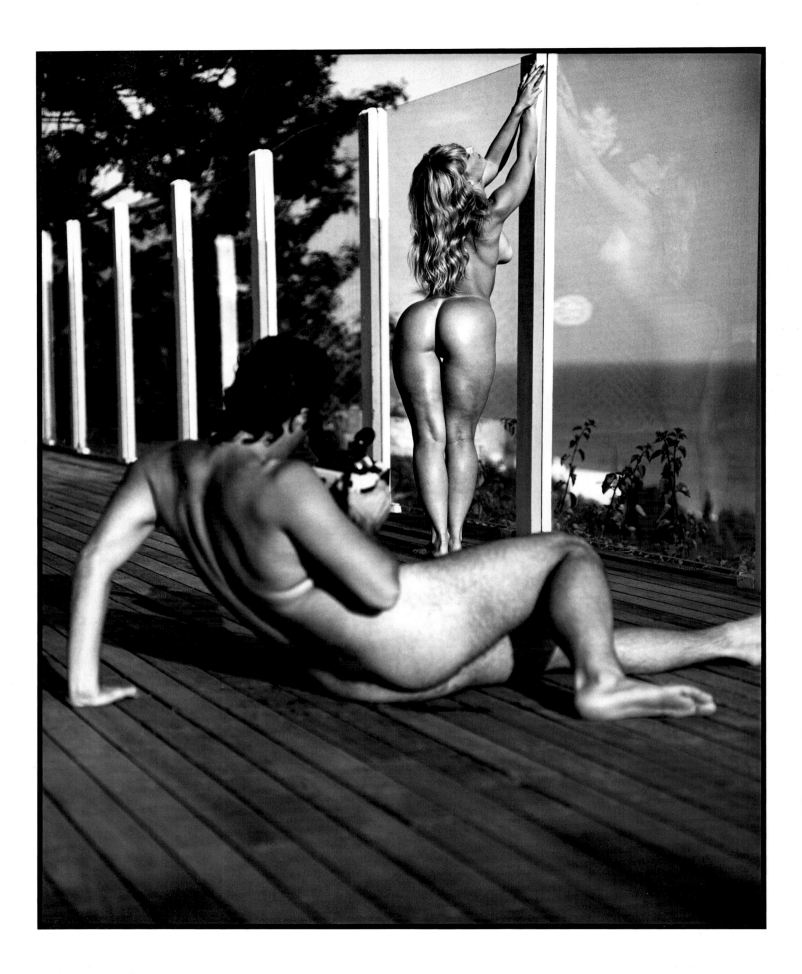

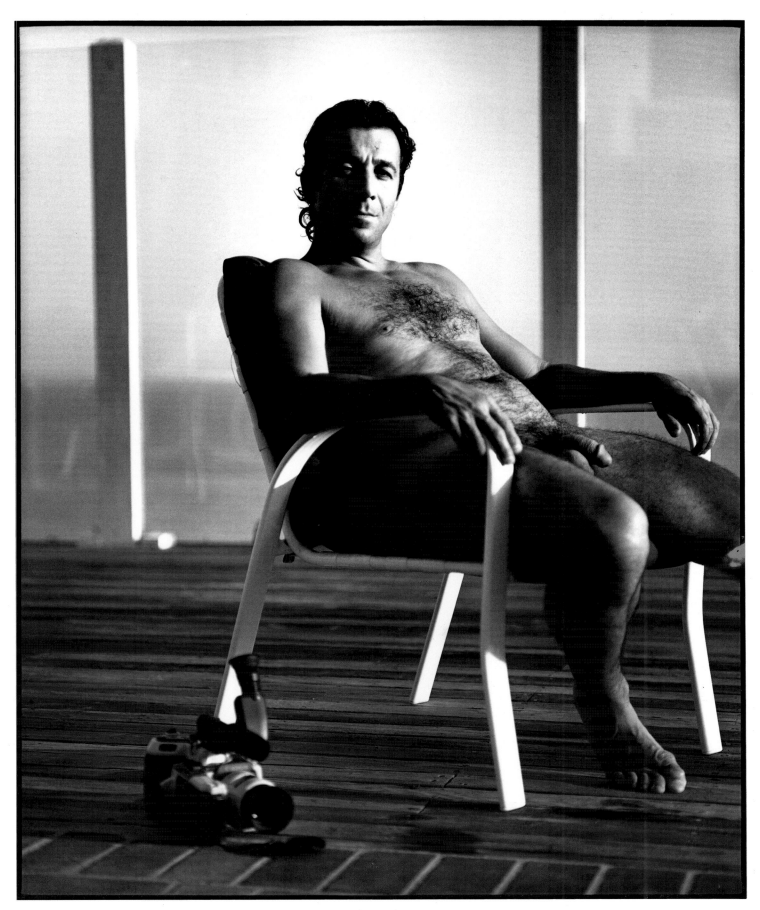

John Stagliano

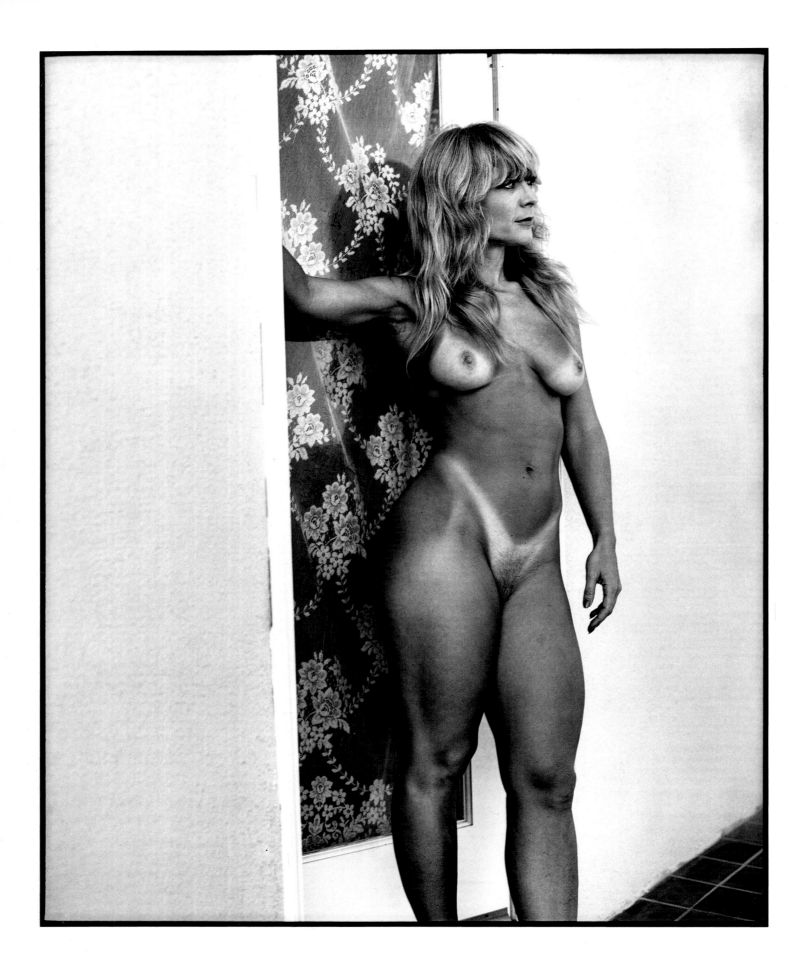

editing console. Someone works on footage of Rocco Siffredi having sex with a young woman whom I don't recognize. John lifts a slide sheet off a light table and hands me a loupe. He says he wants to show me something that "as a photographer" might interest me. The sheet is filled with close-up images of a woman's hands spreading the cheeks of her own ass, exposing her pussy and asshole. John points to three shots in the bottom corner, the only ones where she's covered, sort of, with a tiny string bikini.

"One of those will probably be my next box cover," he says, without a trace of irony. "What d'ya think?"

The doorbell rings and Nina breezes in. She hugs John and kisses him on the mouth. He tells her he's fighting something, but Nina doesn't act like she's afraid of catching a cold.

Stagliano returns to his editing. Nina sits cross-legged in front of the ballet mirror nude except for a G-string, "putting on her face." She looks like she's in her late thirties, maybe older than her years, too. I was still in college when I first saw her in a video clip on cable TV.

Nina is a certified superstar of porn, frequently described as a legend. She has a commanding presence. Nina calls herself a radical feminist. When she says she's thirty I avoid her eyes.

She poses for pictures behind the house, then on the upstairs deck outside John's bedroom. Nina is kind of an earth mother, beautiful despite her not seeming to really care. She isn't stylish. Her recent, very slight breast enlargement operation and maybe even her saying she's thirty (if this isn't true)—these things seem more like concessions to the business than contradictions.

Nina's nudity is almost sexless. She doesn't try to use her sexuality to control my perception of her, like all the younger actresses do. She's just naked. Nina fiddles absentmindedly with the string from her tampon while I reload the camera.

Stagliano joins her by the pool. He undresses. Nina goes inside while he's photographed. A few minutes later she joins John in front of the camera and starts kissing and fondling him. He protests weakly, is reluctant, sounds stuffed-up. He mumbles something about having a fever. Nina persists.

She begins sucking his cock. She's on her knees. He has half a hard-on and looks weary. He goes along, managing a smile here and there. John plays with Nina's tits. He's still not fully hard, but Nina squishes down, gets him inside her and rides him a little.

Nina is like a mom briskly toweling off her little boy. Vigorous, upbeat. John is the resigned little boy. It's not passionate sex. This impromptu performance may be Nina's way of trying to remind John that she's still viable, still a good casting decision, her way of proving a point. Does John remember what he said on the phone? He goes along, sick, maybe out of respect for her, rather than reject her in the presence of an outsider.

I go in the house as Nina climbs off John and begins sucking him again. Inside, a few minutes later, Nina has a mischievous—but still sweet—smile. John looks the way he did before the sex; just half an hour later. I hand Nina a model release form and begin explaining it to her.

"Do you have any idea how many thousands of those things Nina has signed?" John snaps.

He may not be into doing her but he wants to make sure I don't forget Nina is a star. A legend.

JULY 11, 1994

THE TELEPHONE RINGS, LATE—OR EARLY. IT'S STILL DARK. I'M ASLEEP.

"It's Jamie."

Contact with Jamie Summers has been sporadic. She retired from porn and moved to Fort Lauderdale with her boyfriend, a talent scout for strip clubs. Jamie is still in touch with some of her friends from the business, like Tom Byron.

"Tommy just called me," she says. "Savannah killed herself."

"When?" I say.

"Like a couple of hours ago."

I want to feel angry and sad but I just feel detached, and confused about how to process the information. It's two years since I photographed her, slept with her, and a year almost to the day since the last time I interviewed Savannah, since the night she drank saki bombers at Sushi on Sunset then purple penises at Bar One with Corey Feldman, the ex–child star, at a birthday party for someone from the cast of *Beverly Hills 90210.* Savannah's face was puffy and blemished; beaten up from hard living. She'd gotten a second tit job, gone real big, and it made her look more like every other porn actress. She said she was still heartbroken over Slash's returning to

his ex-girlfriend and getting married but then she grinned and mentioned she'd recently been dating Marky Mark. Savannah bragged about doing a gang-bang video. Hearing that was saddening, in a more simple way than news of her death: It meant her career was seriously in decline. Her career was all she had.

The night after interviewing Savannah, I saw Madison at an art opening on Santa Monica Boulevard. Madison hadn't spoken to me in a year, not since storming out of my Greenwich Village apartment after receiving what may've been the only truly *non*sexual hug I'd ever given a porn chick. The night of the art opening she looked wasted too, like Savannah.

Most of the stars I'd been photographing were fucked up, or fucking up. Most had hinted at their revulsion with selling their bodies for a living. I'd shrugged it off but it was finally getting through. The heroin or booze or whatever they were using—even the sex itself—that was a symptom; they were numbing themselves. And my hanging around with them was a way of numbing myself, or trying to, a way of remaining safely alone. I still identified strongly with the porn stars, but as I began to learn more about them, it became less clear to me why.

I'd avoided asking about their childhoods, except for a few instances in which I'd questioned them, reluctantly, in a way that must've come off like I didn't really want to know. I didn't—I knew it would complicate things. Keeping it on a surface level worked. The girls protected me or my image of them by saying, "No, I wasn't abused." I needed to hear that. But I didn't believe them anymore. It took me far longer than most. Half of the women I knew outside of porn had been sexually abused as little girls, so it only stood to reason that the statistics might apply in porn as well. One study of the general population claimed it was two out of three. The puzzling refrain I'd begun hearing from porn outsiders: "There are plenty of people with histories of sexual abuse who didn't grow up to be porn stars." That's missing the point: The ones who did become sex workers *were* abused. All of them, that's my guess.

A woman who is taught as a little girl to barter with her sexuality, taught the value of that—by a sexually abusive parent, relative, neighbor, baby-sitter, teacher—who then goes on to live her life with that lesson as a foundation gets pretty good—expert—at being a turn-on, despite how fucked up that sounds. The abuse is what cut them out for this job in the first place. And knowing they were fucked up didn't make the porn actresses less of a turn-on to me. That was *why* they turned me on. I wasn't ready to be close with anyone. Flesh was my way of filling—or at least disguising—that void.

DOMINIQUE SIMONE wanted to see the pictures I'd done of her, and I was interested in seeing her again. We flirted over the phone, but the people I was staying with had one rule: No porn stars in their house. Dominique said she was living out of her suitcase, that she was currently "in between" places to live, so our meeting never happened.

Sharon Mitchell said she'd finally kicked heroin—after sixteen years—and looked like she had, but Mitch's run-down apartment building in the Valley was disheartening. A grimy, sunburned janitor lay asleep next to an empty swimming pool. I wondered if all the young porn girls would end up in places like that. A Mexican woman and her four-year-old daughter stood in the hallway staring silently through a screen door as Mitch, weathered but beautiful, posed for pictures in her tiny living room. I

was determined to prove to the world that Mitch was beautiful. I hadn't let go of that goal. But a bondage shoot the next day nixed any possibility of my perpetuating my shallow illusions.

In a smoky living room, Mitch, the fortysomething porn star, paddled the ass of a roped-up and gagged young actress while the girl's boyfriend, in another room, sat in front of his computer screen with an electric guitar in his lap. There's always a humorous component to these stories, but the scene in that house, three doors north of bustling, sunny Melrose Boulevard, was an undeniably depressing way to spend the last Saturday afternoon of that short trip to Los Angeles.

RATHER THAN PURSUING this book—rather than facing the fact that a happy, tidy book about this sad subculture would be impossible—I retreated into my life in New York for a whole year, only occasionally making visits to Show World to say hi to porn stars I knew, or more likely, to get a small dose of titillation, a fix. Those encounters were depressing, too.

The world of XXX had blown the lid off any remaining hopes I had of using it to validate my own ideas in support of a lifestyle with sexual adventurism as its core. Sex had ceased to be a viable refuge. I was discovering how fragile the emotional landscape of my own sexuality was and beginning, for the first time, to see that the most prolific, single-mindedly sexually active period of my life was also my loneliest and most unhappy. My sexuality had always been like a badge or a shield, like someone else might cover himself with tattoos; my identity. An "honest" or "revealing" posture is an extremely effective way of keeping people at a distance: sexuality as self-defense, as a weapon, as a way of fending humans off, dodging vulnerability. It took a serious adjustment to first accept that that wasn't who I wanted to be anymore, to acknowledge that it was a front, an armor against any threat of intimacy—I'd been starving myself—and then decide how, if at all, I could proceed with this book.

I was deflated but in a way relieved. There was a feeling of liberation in relinquishing, in no longer having the burden of trying to manipulate or temper the evidence to fit my narrow thesis. No porn star ever asked me to manipulate anything. If I were to go out to Los Angeles again, it would be with a less specific agenda. Ugliness, or beauty, would have to stand on its own legs.

I'd used the few porn sets I'd already visited as a way to meet and then shoot more stars. The action—what they were actually doing there—was peripheral, something I'd shied away from, successfully avoided. I was ready to explore it. If there was truth or meaning in any of this, it would be found in the sex.

Yesterday morning, full of anticipatory dread but also hopeful that the trip might somehow still be a turn-on—an escape—I cashed in my frequent-flyer miles. I secured a ticket to Los Angeles and chose a departure date—less than a week away—that left no time for backing out.

Then came Jamie's call.

SAVANNAH'S SUICIDE plays bigger in the LA papers than it does in New York. She was out partying with a kid who works for the band House of Pain. Late that night she crashed her Corvette into a fence near her house. She wasn't seriously injured but her face was bloodied. She called her manager in a frenzied state. While the

The beautiful Miss Sharon Mitchell.

House of Pain kid was downstairs assessing the damage to her car, Savannah shot herself in the head.

The porn industry tries to defend itself, arguing that Savannah was unhappy *before* she got into the business and that there are *lots of happy people* working in porn. With my help, *Rolling Stone,* then *GQ* and *Esquire* jump on the story, sending reporters to the San Fernando Valley within days. The press thinks Savannah's death is somehow emblematic of the porn world. That idea isn't something I let in easily but it does resonate, especially because of the timing.

"HEY. NOW YOU HAVE two in memoriams," Tom Byron says.

I ask what he means.

"Well, Savannah and Andrea—April Rayne. She OD'd like a month ago. No one wrote about that. Anyway, I'll see ya later."

THE VALLEY

TOM BYRON IS RENTING OUT HIS NEW HOUSE ON BALBOA, IN THE VALLEY, FOR PORN shoots. Melanie Moore, a retired porn actress and today's production coordinator, calls Joey Silvera to let him know it's time to shoot his scene. Ten minutes pass and the actor shows up. He's taller in person, and he looks younger. He smells good, clean. He's shy but he has a presence, charisma. The room is buzzing as soon as he arrives. Galatea offers, only half joking, to be Joey's fluffer—to keep him hard during breaks. It sounds rehearsed, like something her agent told her to do. Joey Silvera has been acting in porn movies since 1974 but he's still overwhelmed by all the attention. He ignores Galatea's comment, looking at his feet as he quietly speaks.

"Where are we shooting?" he asks Melanie.

"In Tommy's bedroom," she says.

Joey asks if everything is ready, then goes upstairs. Melissa Monet is already up there with Ron Sullivan and his crew. Melissa is a thirty-year-old New Yorker. This will be the second scene of her two-week-old career.

Ron introduces the actors. Within seconds they're sprawled across the comforter. Their contact is gentle and affectionate.

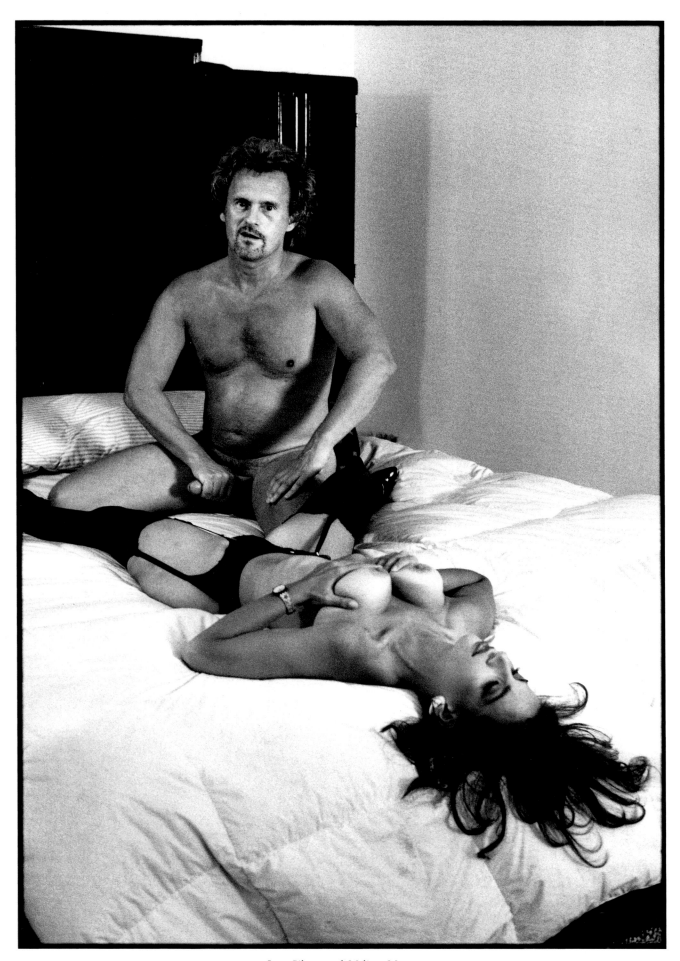

Joey Silvera and Melissa Monet

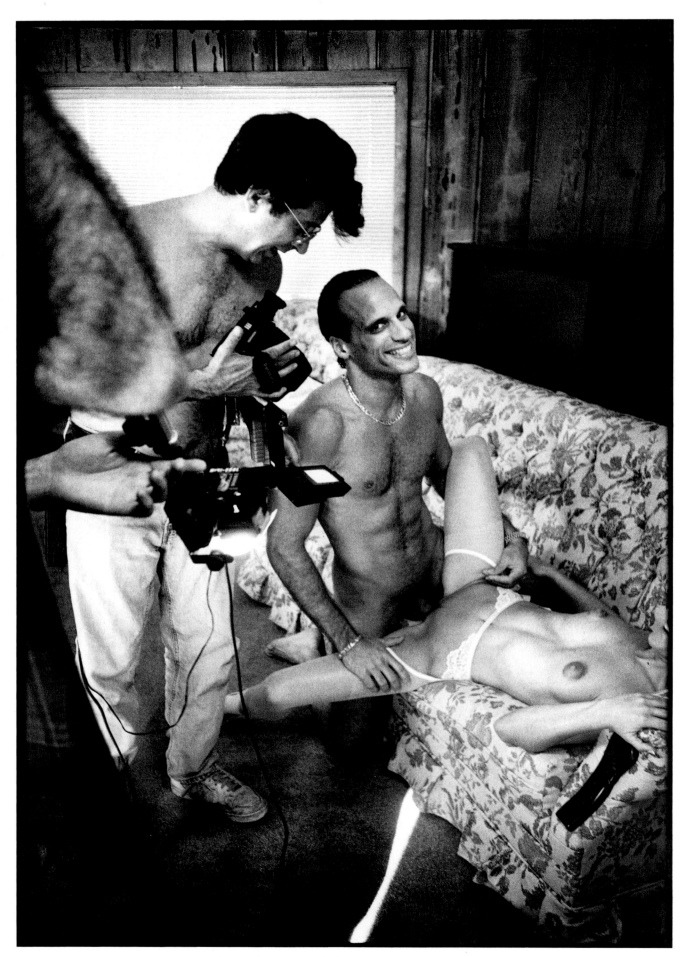

Shooting loops—sex-only footage—at Tom Byron's house.

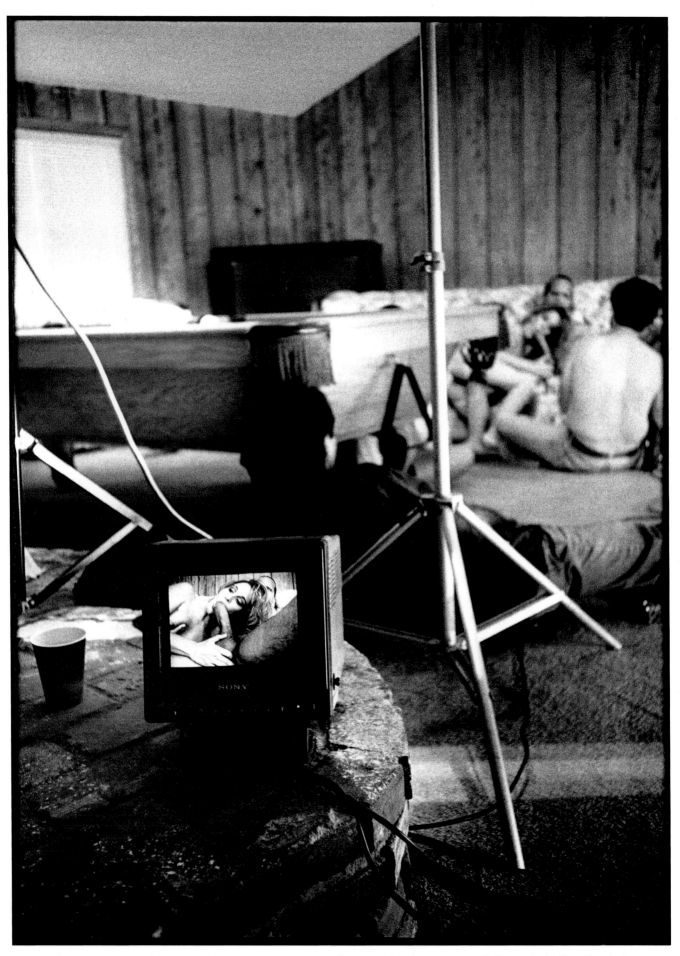

Following pages: In a classic slice of porn Americana, Ron, the director, and Galatea, a new girl, flirt unabashedly and with clear intent while actor Goldie readies himself for the scene's finale.

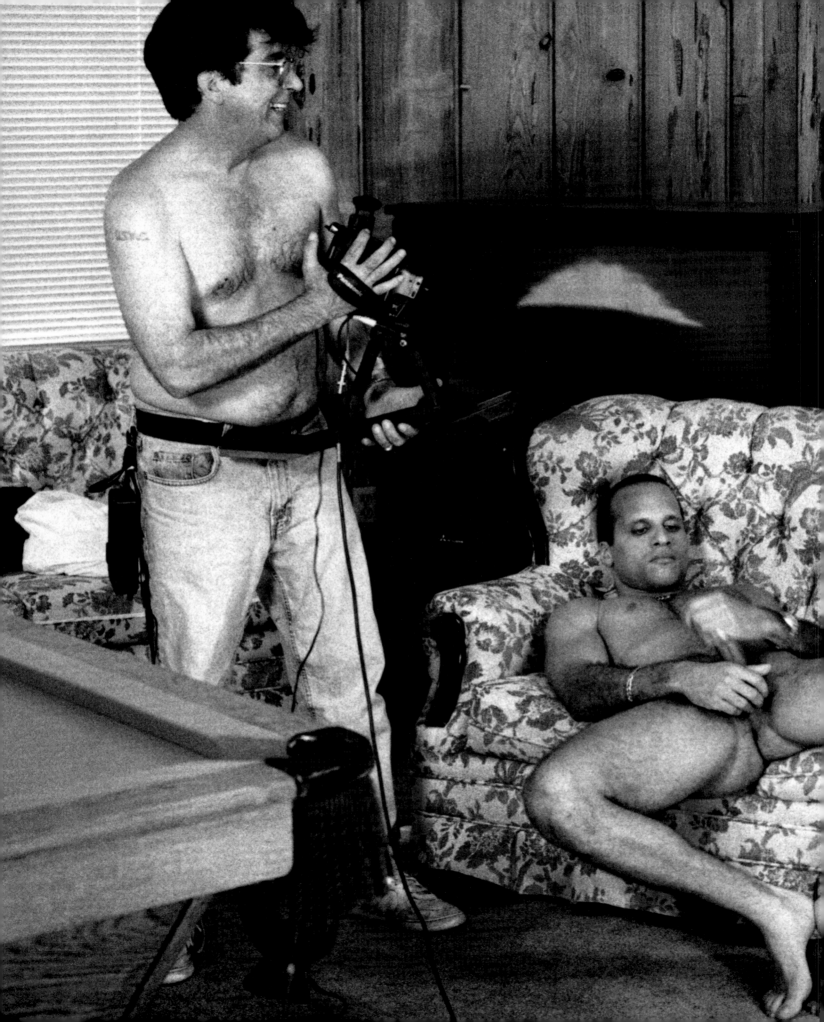

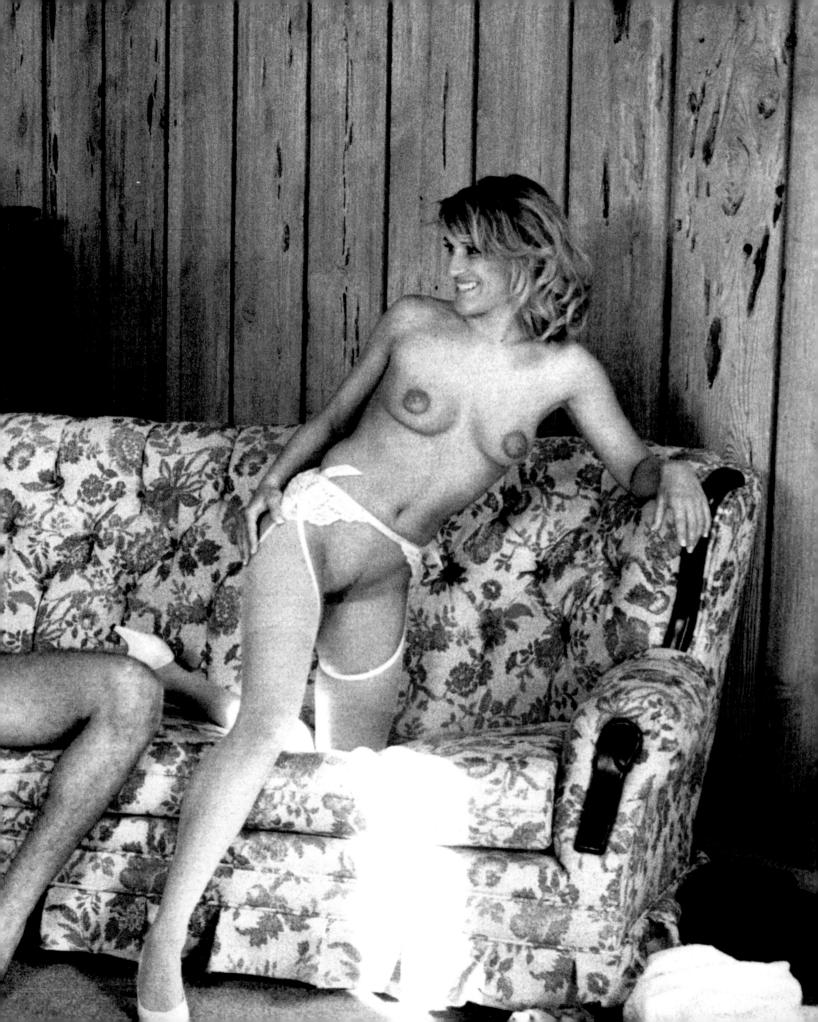

"I'm ready when you are, Joey," Ron says. Then, "Shit."

There's a problem with the camera. A minute turns to five. Joey gets annoyed.

"C'mon Ron, let's *do* it."

He looks around the room like he thinks the crew is all amateurs. Melissa has Joey's dick in her hand. She strokes it, casually, oblivious to the commotion around the camcorder. They get it running.

Joey and Melissa fuck for the next twenty minutes, trying a series of positions. The bedroom is sweltering. Two hot lights are burning, one set up on each side of the bed, as well as two stands with umbrellas and strobe heads for stills. Joey suggests an ending.

"How about if I fuck her tits and come on her around here," he says to Ron, gesturing with a circular motion above Melissa's neck and chin. Her head is hanging off the edge of the bed.

"That's great, Joey. Do it whenever you're ready," Ron says.

"Is there any lube? I need lube," Joey says.

The PA hands Joey the Astroglide. Joey spritzes Melissa's cleavage. He straddles her chest. She squeezes her tits tightly around his dick. Three or four minutes later:

"Here it is, Ron," he says.

Joey huffs and grunts.

"*Do* it, kid," Ron says.

Joey does it just like he said he would. His body is shiny from sweat. Melissa's chest is shiny from Astroglide and Joey's come. They lie in each other's arms while the crew packs.

JOEY COMES DOWNSTAIRS after a shower.

Melissa approaches him.

"I just wanted to say thanks," she says, "and also to ask you how I did. Y'know, see if you have any suggestions."

Joey blushes.

"God, you were great, really. Thank you. Just do what you're doing . . . don't change anything at all."

Melissa hugs him, thanks him again, then leaves.

Tom Byron sits next to Joey.

"Tommy, that girl just asked me for *tips*. She was so hot, y'know? What could I tell her? Nothing," Joey says.

"Tell her to be herself," Tom says. "If that's possible."

"These new girls are so great until they start doing things how they think they're supposed to," Joey says. "God, I hope she doesn't get her tits done."

"She will," Tom says.

I ask Joey who he thinks I should shoot.

"Man, Rocco definitely. Do you know him? He's phenomenal. He's a true star. He won't be back in town for a while. Do you know Patrick Collins? He's a must. I mean Patrick is larger than life. There has to be a shot of Patrick in your book. I'll hook you up with Patrick, no problem. Y'know, if he's into it."

"What about female stars?" I say.

"I don't know, man . . . I mean I couldn't really say, y'know?"

"Are you friends with—"

Joey cuts me off.

"I just try to, y'know, I don't push it with the girls. I mean I really respect them, so I try to just give them space, y'know? I don't really pursue them—outside of work. I guess it's kind of a delicate thing. But Patrick—he's a guy you should meet."

A FORTY-FIVE-MINUTE DRIVE FROM HOLLYWOOD INTO THE VALLEY. A QUIET STREET with modest homes. A brown horse grazes in the front yard of one, a dusty tractor is retired behind the toolshed of another. The family that lives on the corner might have a teenage son; there's a red Trans Am on blocks in the driveway.

Nikki Sinn and her boyfriend, Ron Sullivan, live on this street. Their home is modest too, though the living room has recently been refurnished with a couple of slick, black leather sofas. A thirty-six-inch TV sits in a corner. A copy of Helmut Newton's *Sleepless Nights* rests on a large glass coffee table. The room is neat, almost sterile.

Off the kitchen there's a glassed-in extension. This is Ron's office. X-Rated Critics Organization plaques and *Adult Video News* trophies—porn's Oscars—line the windowsill, framed photos show him at different stages in his career. A poster of Nikki, nude, hangs above a small bookshelf with forty or fifty of the tapes Ron has directed over two decades working in the business. From behind his desk there's a clear view of their swimming pool. Nikki is younger than Ron, by fifteen or twenty years. She's tall, big boned. She wears black to match her elaborately set jet-black hair. She drives a white Corvette with plates that read SINN. Nikki had trouble with one of her implants, and it had to be removed. Until she sees her plastic surgeon in Palm Springs next month, she's reticent about revealing her grossly imbalanced breasts.

Nikki apologizes about a room off the hall that leads to the bedroom. She's embarrassed. It's supposed to be her dressing room. In sharp contrast to the rest of the house, it's a complete wall to wall mess, literally a foot deep with dildos, fan-club flyers, broken-framed baby pictures, lacy underwear, boxes of thigh-high boots and stiletto-heeled shoes. The closets are so full that the sliding doors won't shut. A dress hangs on the frame of the window blinds. Rather than attempt to clear a spot in front of the dresser mirror, Nikki does her makeup in the hallway bathroom.

Nikki has a warm smile, and it's warmest when Ron gets home from work, from his office at Caballero Video. They invite me to stay for dinner. Ron offers to go do the shopping and leaves again.

Nikki dresses. She wants to straighten up the spotless kitchen before Ron returns, so she sits me down in the living room to watch a rough cut of the next feature to be released with her face on the box cover.

"It's pretty cool. I want you to see the DP. Steve Hatcher, me, and a new guy. Do you know Steve? He's great. It's really fun working with him."

As Nikki wipes down the sparkling-blue metallic Formica counter along the sink, the glow of the large-screen TV fills the dark living room.

The tape is lit harshly. Large skin areas—Nikki's bottom, Hatcher's chest—are overexposed, blown out. There's no music. The three actors are having sex on a bed. The room is so unremarkable that it must've been built, cheaply, in a soundstage.

The action progresses quickly to Nikki's double penetration, her DP. The new actor's face is obscured. Nikki is on top of him. Hatcher is standing at the side of the bed, entering her anally.

When the back door opens and Ron enters the room, the actors' midsections are filling up the entire screen. He stands behind the sofa I'm sitting on. Ron has a resonant Lee Marvin drawl and a square jaw. His haircut and faded tattoos are leftovers from a stint in the military. The next shot is a close-up of Nikki staring into the lens, moaning.

"My girl is really something else," he says, smiling, then heads for the kitchen and grabs a beer.

Nikki prepares the meal. Ron brought back a deep-dish pizza from one of the chains. Nikki chops up fresh mushrooms and peppers. She adds those, then covers it all with grated mozzarella and puts the pie back in the oven for a few more minutes. There's a liter of Pepsi on the table.

Nikki straddles a high chair at the counter and looks admiringly—respectfully—at Ron as he talks about his life and the industry. Ron started out in Greenwich Village in the late sixties, when a career as a legitimate actor refused to take off. It was porn or carpentry. Ron's son Jason, from one of a series of failed marriages, is among the busiest cameramen in the porn business today. Ron says that that makes him proud. When he pauses, Nikki tells a little bit of her story.

"I guess I realized pretty recently that I was sexually abused. Y'know, the memories are starting to come back."

Since coming to the conclusion that all these porn girls must've been victims of childhood sexual abuse, since accepting that, all the "nos" in response to the abuse question have miraculously turned into "yesses," like the actresses can tell I'm ready to hear it. Nikki says from the time she was three to six and a half, her family traveled with the circus.

"So I don't really have a clear idea who it was that did the abusing."

Ron continues from there with his own diagnosis.

"Everyone in this business has some kind of damaged psyche—no kid dreams of growing up and working in porn, for God's sake—but this business, the world of porn, is a place where a lot of damaged souls can coexist, prosper, and find some sense of community they weren't able to bring to their lives before."

Nikki smiles at Ron. She likes her boyfriend's way with words.

Then she says, "Once, I was doing a scene with two guys. It was building up to a DP. Ron was the director and Jason—his son—was the cameraman. *That* was kind of strange."

ARROW STUDIOS IS A RUN-DOWN SOUNDSTAGE IN THE VALLEY. TODAY'S EIGHT ACTORS and actresses share a seven-by-ten-foot dressing/makeup room. Most of the cast is the same as yesterday, but there are additions: Alicia Rio, an actress who Jonathan Morgan, an actor, quickly points out used to be his girlfriend, and Tom Byron. Tom's long hair is being sprayed silver-gray. He's playing a sorcerer. Today Tom will have sex with Ariana, a tattooed actress whose husband dropped her off at the set. Napoleon, a midget, has a speaking part. He won't perform sex anymore. "It began fucking with my head," he says.

The studio is busy. While Jay Shanahan's crew lights the next scene, Steve Drake, a porn actor who's begun directing his own videos, confers with Arrow's master carpenter about the sets for his shoot tomorrow. The skinny black carpenter looks familiar. Drake leaves, then Ron Jeremy arrives. He's in baggy shorts, Air Jordans, and a Mötley

Nikki Sinn and Ron Sullivan at home in the Valley.

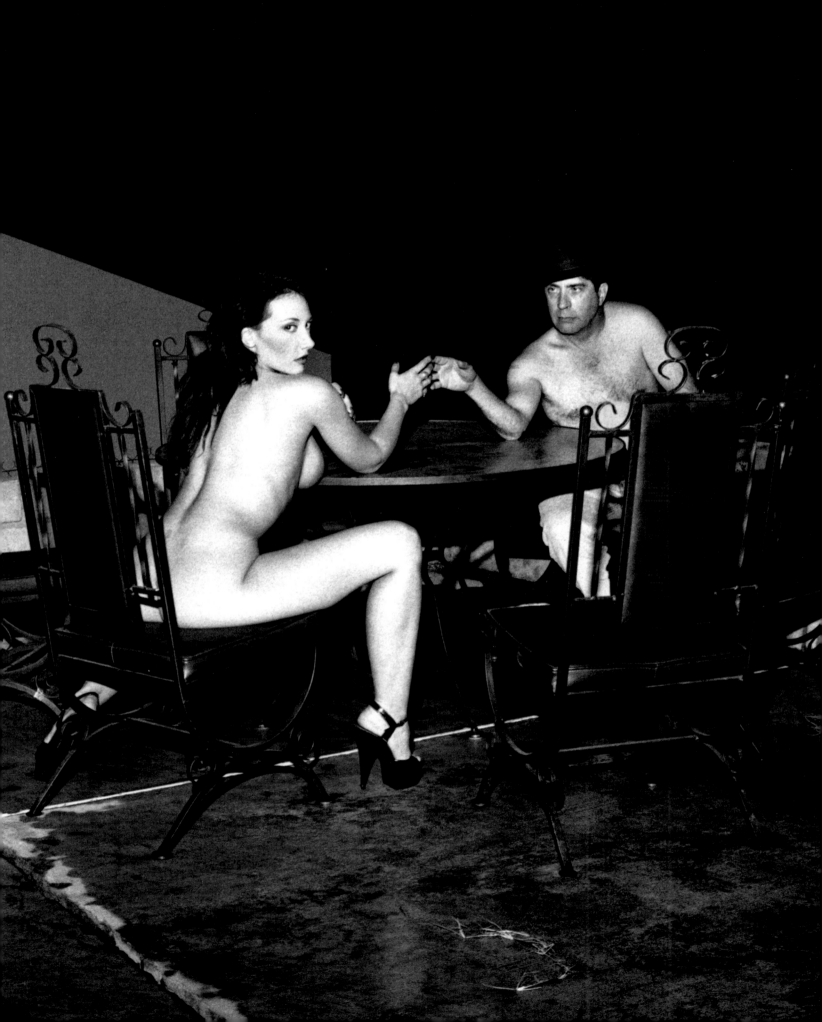

Crüe T-shirt. The actor is trying to get a check out of Shanahan. Shanahan gets annoyed. He's able to convince Ron that the check will be cut by someone else, and eventually Ron leaves. The carpenter nods and says, "Hey, man," but I still can't place him.

"He was in all those *Porky's* movies," Melanie Moore says.

It comes back in a flood of late-night HBO memories.

Bud Lee, the ex-husband and ex-manager of a porn star named Hyapatia Lee, arrives through the dressing room. Lee is a big, tall guy, maybe forty-two or -three, with long gray hair and a mischievous glint in his eye. He's looking for a bag he forgot on the set yesterday. He introduces himself, then extends an invitation to the set of a movie he's producing for Vivid Video. Tomorrow they're shooting at "the last house Orson Welles ever lived in."

It's three in the afternoon. Billy Rocket, a PA and aspiring porn actor, opens a bottle of rum and passes out Styrofoam cups to crew and cast members in the lounge. He and Melanie get serious when they see a camera. "You can't show that," Melanie says.

Tom seems to have fun with the acting part of his scene, the dialogue, then acts bored by the sex.

THE HOUSE AT FRANKLIN and Stanley, at the base of the Hollywood Hills, is beautiful. *Easy Love* is a "big-budget" production—sixteen-millimeter film; "period" wardrobe. The director, Michael Zen, takes himself very seriously, like a Beat-era fey Shakespearean drama coach. *Easy Love* will take seven days to make, not one or two like one of Shanahan's videos.

The stars are girls I've never heard of. One named Leena, another—Bud Lee's girlfriend—called Asia Carrera. The male lead is Stephen St. Croix. St. Croix hands out a "straight acting" business card with a picture of him wearing an unbuttoned vest and khaki shorts, sitting in front of a cheesy studio backdrop. The card says he's "Benjamin Banks."

Paul Thomas sits in the shadows of a canopied deck on the second floor. He's interviewing Jason Sullivan, who must've been shooting out at Arrow for Shanahan until three this morning. Sullivan is a potential cameraman for PT's next film. Bud Lee, as producer, answers to PT, too. Downstairs, Bud sits at a large oak dining-room table, poring over a four-foot-wide chart—the shooting schedule and scene-by-scene production budget for their next film. Lee is proud that the chart resembles ones used "to make real movies."

These guys see themselves as the link between porn and the mainstream. Among people in the porn business, the fact that PT is planning to direct an R-rated feature, his first, is a very big thing. PT leaves once the meeting with Jason Sullivan is over, offering me one of his not-unfriendly "who are you and why are you here?" expressions as he goes.

The premise for *Easy Love*: Asia Carrera watches old romance movies on television. Late one night, fed up with her own unromantic love life, she wishes she could switch places with Leena, who plays the golden-era silver-screen goddess. Leena—responding from inside the TV set—agrees to do it. Leena is sick and tired of love scenes that end before she actually gets fucked.

Although PT isn't directing this one, the crew is composed of the same guys who were on the set of *Sleeping Beauties* two years ago.

The PAs, two in their early twenties and one, a Bosnian called Vladi who looks older, take their orders from Ron Vogel, the stills photographer. The house is a difficult location, with a lot of equipment being moved up and down narrow stairways and into tight bedrooms. The lighting makes the rooms superhot, and the day lasts a long time.

The screenwriter is Raven Touchstone, a woman in her forties wearing big sunglasses. She says she's written hundreds of porn screenplays. Touchstone is taking behind-the-scenes pictures, too. Her work is unremarkable, verging on snapshot photography, but there is one interesting picture in her portfolio. It's of an actress holding her open script, casually discussing her dialogue with a director (not shown) while a sweaty actor whose face is obscured waits—still inside the actress from behind—to continue fucking. The actress is Debi Diamond.

"Debi's great," Touchstone says, like someone on a fashion shoot might talk about a famous model. And of course, like everyone else I've asked, Raven Touchstone has no idea how to find Debi.

A sexy makeup artist who refuses to be photographed ("I've done all that already") blends away Leena's tan lines for the last scene, sex with Stephen St. Croix.

Touchstone says Leena is the industry's big new star. Leena doesn't mind being photographed having her makeup done, undressed, whatever. Her boyfriend, a struggling rock musician called Jimmy Swan, hangs out until it's time for his girlfriend's scene, then leaves before it begins.

Leena likes attention. She acts like a star, kind of affected—like how she thinks a star should act. But she seems normal, no apparent eccentricity, which under these circumstances, on the set of a porn movie, seems oddly dull, like Raven Touchstone and her pictures. No perspective.

Savannah. Madison. Jamie Summers. Even Dominique Simone. Definitely April Rayne. Those girls all had something, a quality of self-invention that can't be premeditated. It made them seem authentically starlike, more so than anything they could do—did do—to act like stars. Maybe it's because *my* perspective has changed, but that quality is missing on the set of *Easy Love* and has been missing on every set I've visited in the weeks since returning to Los Angeles.

But Leena is hot. Bruce Springsteen once said he performs for the one person in each audience who's never heard him before. I've never heard Leena moan and shout before. She snarls, grits her teeth, continues passionately straight through nonshooting intervals while the techs switch camera angles or adjust lights. She performs for me. Everyone else in the room has seen it a million times.

St. Croix has a perplexed—but satisfied—grin. He's game. When Leena urges him to push into her ass—this wasn't planned as an anal scene—the actor doesn't hesitate. They go like that for a while, but Michael Zen needs more straight intercourse. St. Croix pulls out. The recent *Baywatch* extra has no problem with being photographed washing his unflagging erection with a bar of Ivory in the marble bathroom sink. Back in the bedroom St. Croix and Leena finish their scene with his come on her face. It's almost ten o'clock.

There's one more shot to do tonight. Leena has to float on the surface of the lima bean–shaped swimming pool in full costume, like she's drowned. It takes forty minutes to light it and five to shoot it, then the crew begins to break down for the night.

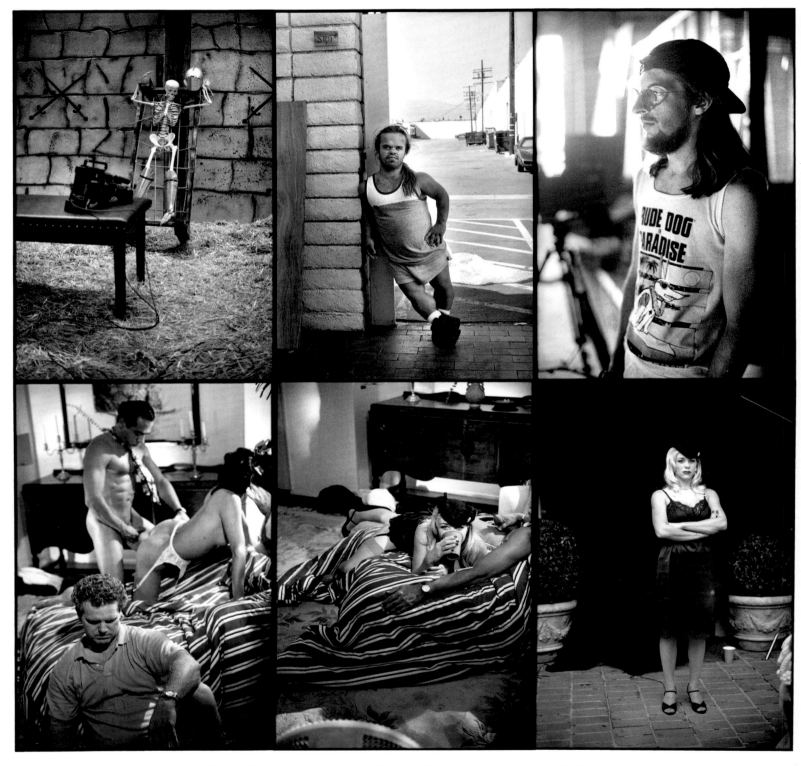

Top row, from left: Arrow Studios; Napoleon; Ron's son, cameraman Jason Sullivan.
Bottom row, from left: Sex in Orson Welles's bedroom; Kaitlyn Ashley; Kaitlyn shortly before shooting.

Opposite: Starlet Lisa Ann takes a break during the first scene of her career; it's TT Boy's second scene in an hour. From the edge of the gazebo, techs point out the Batcave from the sixties TV show, as if to prove that landmark and what the porn crew is doing here are all part of the same thing, all connected. Show business.

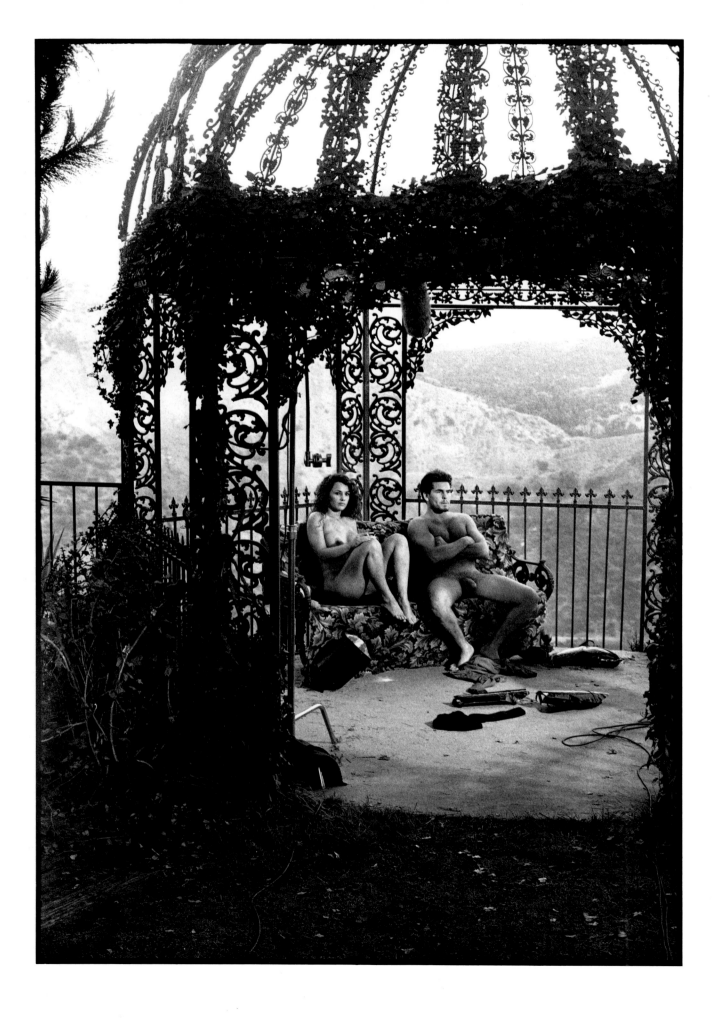

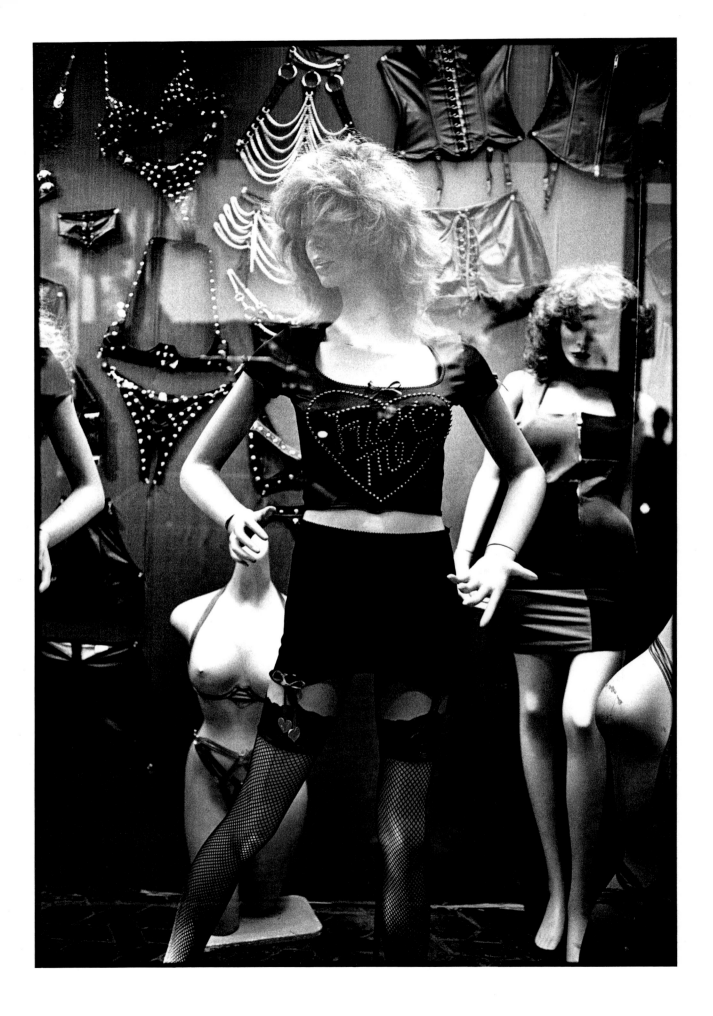

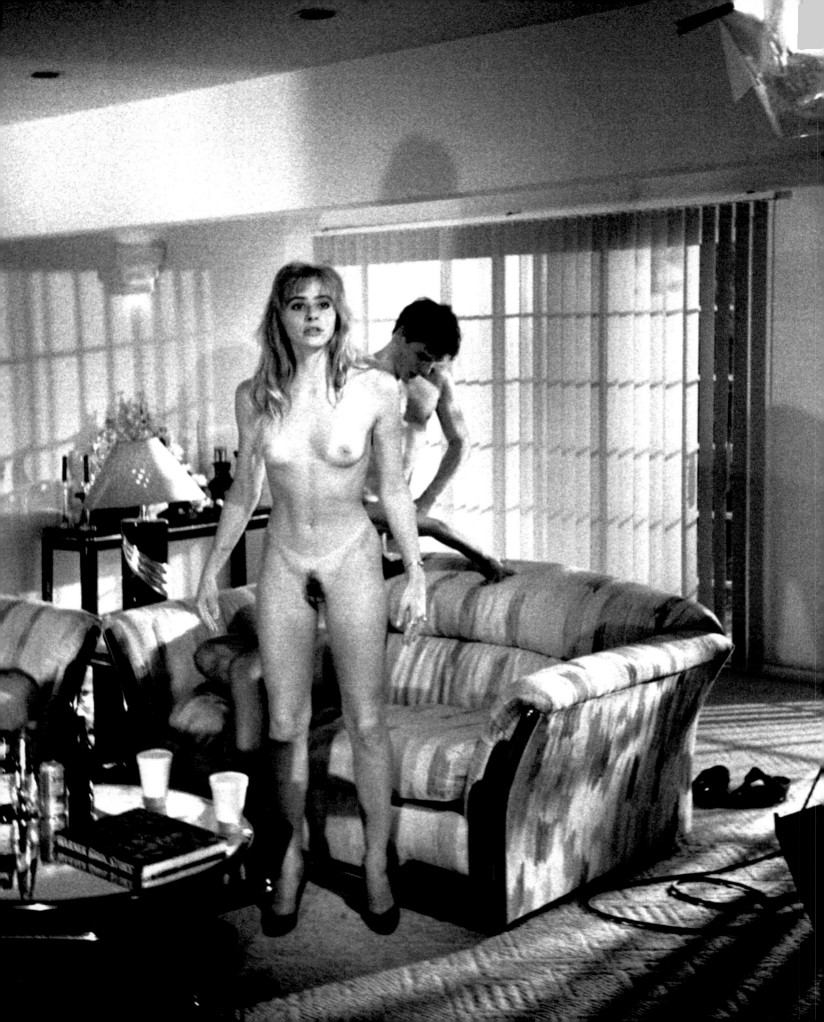

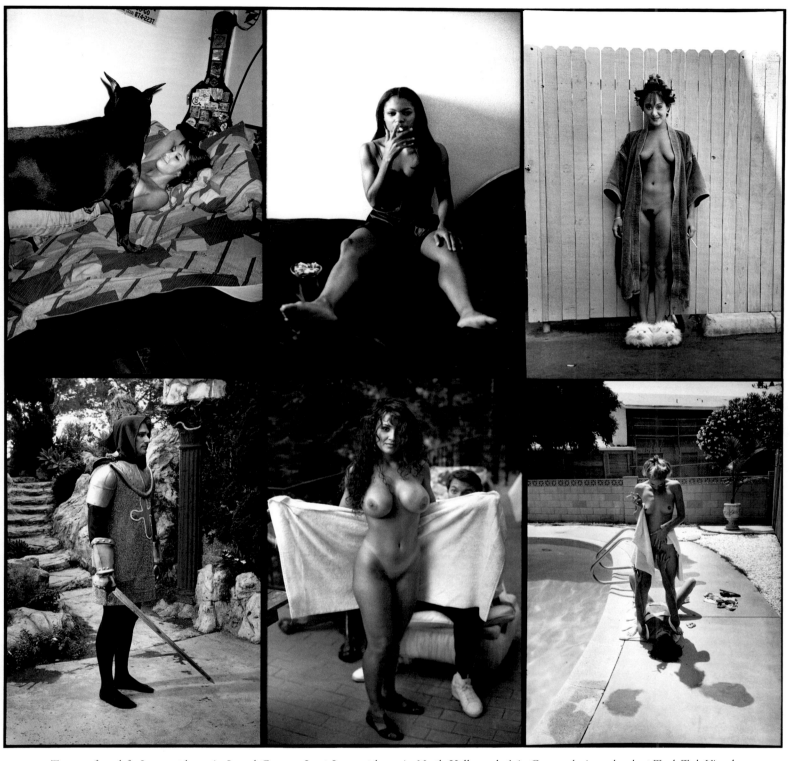

Top row, from left: Leena at home in Laurel Canyon; Janet Jacme at home in North Hollywood; Asia Carrera during a break at Trach Tech Visuals.
Bottom row, from left: Jay Shanahan in another cameo; Lisa Ann and actor Jonathan Morgan; starlets flirting off camera.

Opposite: Despondent over being paired in an orgy scene with an unknown actor she's uncomfortable with, Amber Woods, one of many girls with an on-again, off-again relationship to porn, hears her boyfriend's voice—he's arrived early to pick her up—and searches past the hot lights for his face, and comfort.

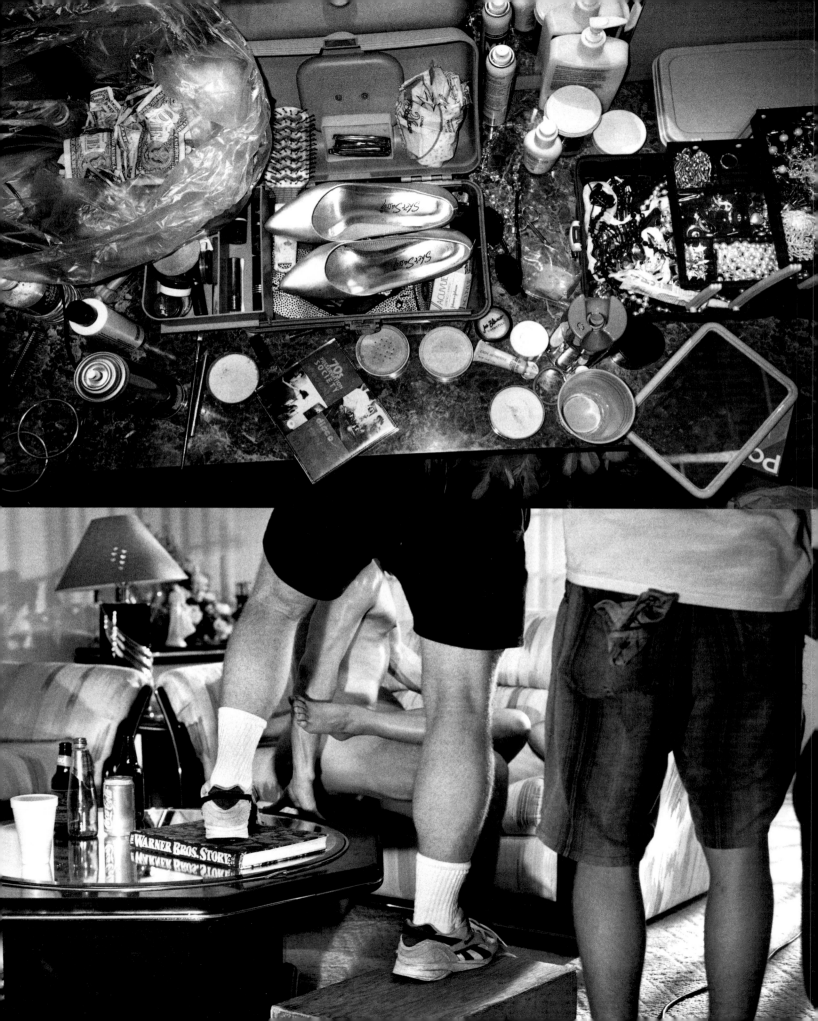

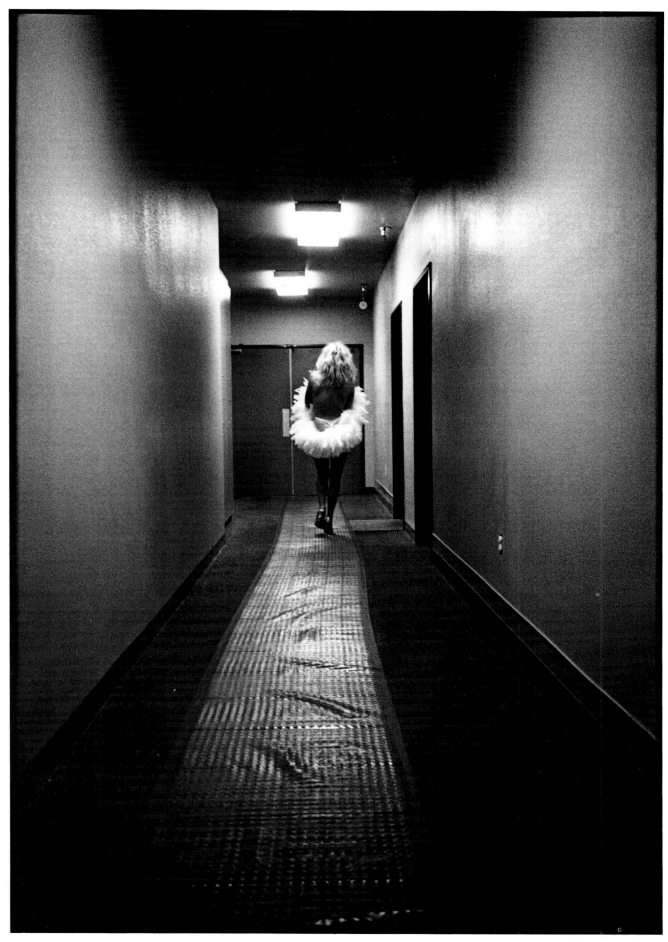

Rebecca Bardoux's gear; Michael Zen's crew; Bardoux making her way to the stage at Bob's Classy Lady, a strip club in the Valley.

Michael Zen apologizes for his grim demeanor throughout the course of the day, explaining, unexpectedly, that he's "waiting to pass a stone." It's dark by the pool, so Zen doesn't notice me cringe.

"I hope you'll join us again tomorrow," he says.

NEXT DAY. Asia Carrera has very reluctant sex in Orson Welles's bedroom with an unknown actor called Guy Da Silva. Her boyfriend, Bud Lee, sits downstairs with his budget during that scene. Asia makes Guy stop every two or three thrusts, and literally never makes eye contact with him. She gives Michael Zen just enough for the director to edit together later. Kaitlyn Ashley, another new girl—"a trouper" as one tech puts it—joins them in the end to get Guy off. Asia isn't on camera for the last ten minutes of the scene. Kaitlyn's husband, Jay, waits for her on the large deck outside the bedroom, under an umbrella. It's a porn social scene out there; actors, visitors. Jay is a porn actor too, but today he's just hanging out, schmoozing, while his wife works.

ON THE OTHER SIDE of Coldwater Canyon, in a nightclub on Ventura Boulevard, Jay Shanahan is already well into his next video. There's a film crew on his set doing a "lifestyles of porn stars" documentary for the Playboy Channel. Their cameraman stands behind Shanahan's cameraman—Jason Sullivan—and his stills guy. Shanahan's crew is filmed as they film Jonathan Morgan having sex in a tiny dressing room behind the stage with an unknown actress. There are ten or twelve more porn actors and actresses in the front section waiting for the "club scene." Brittany O'Connell sits at the bar, naked, chatting with a tough-looking friend who's come to visit the set. Alicia Rio is putting on a Carmen Miranda outfit. Her husband, a cop, is an extra. Tony Tedeschi, the Penguin from *Splatman,* adjusts a bow tie. Ron Jeremy. Other faces I don't recognize.

Shanahan has nothing nice to say about the PT-Zen-Lee crew. At one point he uses the word "elitist." Porn stars have been dissing one another since day one, but the rivalries between directors' camps is new to me. Someone on Michael Zen's set referred to Jay Shanahan as "that joker."

Shanahan films yet another sight gag centered around his bare ass. His sets are kind of silly, but people have a pretty good time, and Jay makes sure there's plenty for everyone to eat. Since *Easy Love* began shooting actors have been missing out on meals.

NEXT DAY. Zen's crew has relocated to a dentist's house in Woodland Hills, in the Valley. The dentist's wife sunbathes nude by the pool. The directors all use this place regularly.

It's ten hours of bad dialogue for Leena and Asia.

One of the PAs tells me he graduated from film school, couldn't find work, got dumped by his girlfriend, and ended up here six months ago. He's desperate for a connection with someone from the *outside.* He says he just began seeing a therapist, and I tell him that that's a positive thing. He seems relieved. He continues hauling light stands and reflectors.

Actors and actresses begin showing up for an orgy scene and end up spending the day by the pool, waiting around, getting to know one another. Melissa Monet arrives— she's the girl from the scene with Joey Silvera at Tom Byron's house. So does Lisa Ann,

the first-timer from *Flesh for Fantasy*. A Texan named Krista. Tony Tedeschi. Alex Sanders. He sits in a corner with a Toshiba laptop, working on a treatment for his own porn video. Sanders says he regrets he's here only to do dialogue. A new, very young-looking hippie actor called Ian Daniels plays Nirvana riffs on an acoustic guitar. Amber Woods, an actress with cat eyes tattooed on her ass, hangs out with her boyfriend. The boyfriend says, "We're a perfect couple: I'm not a sexual person at all, and she likes that."

He tells Amber he'll pick her up when the orgy is over.

There's one more actor hanging out, a skinny guy from New York with no immediately apparent qualifications, called Dave Dodge. Dodge stays off to himself, doesn't fraternize with the other actors at all. When it's finally time to shoot, Dodge is paired with Amber.

Five minutes into the scene, shot in the living room, Dodge approaches nude and says, "Please don't take pictures of me now. This is a difficult moment."

Amber doesn't want to have sex with him and doesn't have to. His shyness by the pool this afternoon has come back to haunt him. He returns to the uptight actress, who's sitting on a piano bench across the room. He gets down on one knee, puts his face between her legs. Amber stands up, walks over to the director. The scene could've been a break in the new actor's career, but Zen asks him to sit it out, then Dodge is dressed and gone. The PA called Vladi looks at me, smiles, and whispers, "Hooray for Hollywood."

It's a loud, lube-soaked, protracted affair. Zen doesn't involve himself in telling the actors what to do. Instead, he steers the cameraman from coupling to coupling, deciding "instinctually" what's worth filming and what can be left out. It's all going on simultaneously. The initial pairings give way, in a matter of minutes, to ones resembling the flirtations that went on out by the pool this afternoon, but it all ends up jumbled again. Ian Daniels and Tony Tedeschi have to utilize Krista, Amber, Melissa Monet, Lisa Ann, and Leena, as the girls all "do" each other as well. Asia doesn't participate in the orgy, but her boyfriend, Bud Lee, watches from the sidelines with a big smile.

There's no way to be in the room and stand more than five feet away from at least a couple of couples fucking. Sights, sounds, smells. The living room must be one hundred degrees.

At one point Amber hears her boyfriend's voice off the set, from the dining room, and kind of freaks out. He's back early. She stands, stares past the glaring lights, searching. She goes to find him and he calms her down again. She rejoins the group. The scene ends when the actors figure out an impossible position that connects them all in a heap of sweaty flesh. There's a lot of screaming and grunting. The girls either come, or pretend to, and the guys definitely do. The whole thing has lasted an hour and a half.

By the time Leena, Ian Daniels, and Lisa Ann have had their turns in the shower, there's no pizza left, just empty Domino's boxes.

It's past midnight. The set clears out. The cast gather their belongings and head home for the night. The "I'm not sexual at all" boyfriend leaves with two girls instead of one—Amber invited Melissa Monet to spend the night.

A SOUNDSTAGE IN COMPTON. THERE'S A HANDSOME GUY IN THE LOUNGE, TALL—LIKE six-five—in jeans, undershirt, boots, sitting at the modest buffet eating a carrot stick. I don't recognize who he is until he says his name: Jon Dough. He's better looking in

person than on video. Jon, like Marc Wallice and Tom Byron, is a veteran actor. Only Jon seems present, not distant and aloof. He's not like the other guys that way.

In a matter of minutes we know a lot about each other, kind of phase out everything around us. We're the same age. We've both been through painful breakups.

Jon divorced his wife of five years, the porn star Deirdre Holland—or she divorced him—almost two years ago. He agrees it's weird that that's when I broke up with my girlfriend of five years, too. Jon blames the failure of his marriage on his drug and alcohol dependency, says he misses Deirdre, still loves her, and that he's been sober since going into rehab shortly before she left him and moved back to Holland to live with her mother. I like hearing that he's sober. I know that it has something to do with why we connect. Jon says looking back, seeing his behavior, he can't even figure out how the marriage lasted as long as it did, that he was "so far gone, so out of it."

I suggest if he was any *less* out of it Deirdre might not have been able to handle *that,* and launch into a story about a girl with whom I had an intense rebound relationship, about how she found out her previous boyfriend—of two years—was a-junkie.

"How could she not know that," I say, "unless she chose not to?"

"Definitely," Jon says.

I keep going. The guy's junkie distance was a barrier against the girl's ever having to get too close, I tell Jon, and the part of her that couldn't be close with him, with anyone, was what enabled *me* to open up to *her.* I tell Jon there was no risk of any kind of real intimacy, which is the point, that for some tragic reason intimacy is something that terrifies people *like us.*

It's my trademark sermon about emotional availability. This stuff is all new to me, and I guess I want Jon to understand where I'm at as much as I want to make him feel understood. Jon nods "yes" all the way.

He says, "Man, you're a cool guy. You know, you definitely know. We have to talk more."

It might sound silly, but the way he says it in his deep, calm voice makes me feel grounded, less alone in this world of bored, inaccessible porn people. In three years, he's the first male star to tell me anything about his insides, to show his feelings.

I ask him, rhetorically, why his marriage failed right when he finally began to deal with his drug problem and not in the five years before. Jon smiles in a sad, quiet way, then lets out a deep sigh. He understands what I'm getting at, says that's part of it, but Jon says it was more complicated than that, that he wasn't ready to be close, either. He says even though he and Deirdre were supposedly only doing scenes with each other, he was sneaking off and fucking other girls in front of other cameras all along, and Deirdre knew. He says he was serious when he decided near the end to be faithful, but he never got to try that out—he has no way of knowing if he *could* be faithful. I tell him I know what he means.

Eleven or twelve minutes pass. It feels longer, like the conversation takes us away. The lounge becomes hectic around us. It's harder to talk.

Sarah Jane Hamilton, in nurse's uniform, stethoscope hanging from her neck, and a German actress called Lady Berlin sit nearby. Lady Berlin is in a police outfit, but with G-string, garter and stockings, pumps. It feels like a party. The caterer, Nicole London—a porn star on hiatus from doing scenes since testing positive for HIV—is setting up a

Mexican spread for lunch. Even though her test result has since been proven false, Nicole hasn't begun performing sex again. Nicole goes out with one of the PAs.

Norma Jeane, another actress, crouches near Jon's chair. She caresses the crotch of his pants, then pulls his dick out, strokes it. Jon has a hard-on in a second and it's huge, kind of on a par with all the big tits around us. The other girls are amused.

Norma Jeane stares down at what's in her hand then into my eyes.

"It scares me," she whispers, then winks.

I'm sure I blush. When she stands, so does Sarah Jane. She pulls Norma Jeane's top down, listens to her . . . tit . . . with the stethoscope. Jon zips his fly, says he has to change. Lady Berlin tells Bionca that she likes black guys, but not "suave guys like Sean Michaels." She likes "rough ones with broad shoulders and fat cocks who've spent time in jail." This in her German accent.

THE PREMISE of the movie: Jon and Norma Jeane are a married couple who have hit a plateau in their sex life. They turn to Bionca, a dominatrix/sex therapist, for guidance. She invites them to a party to loosen them up, to "initiate" them, and that party is the setting for all the sex Kelly Holland, the director, will shoot today.

Holland gathers her cast—minus Debi Diamond, who still hasn't arrived—on the dungeon set. She approaches me, says this scene has to feel crowded, that there aren't enough actors, then gets to the point and asks if I'd be willing to be an extra. I don't answer immediately, which makes me nervous.

Jon Dough is walking around in a toga and Birkenstocks. Norma Jeane is in a black bustier and thigh-high boots. Tom Byron is wearing brown plastic chaps, a matching vest, G-string, and cowboy hat. Bionca is in a rubber outfit. Nicole London, the caterer, is in plastic panties, a black mask, topless. She sits on the throne.

Others get involved, including Scott St. James, the stills guy. But they're all part of it, anyway: The studio's fiftyish carpenter/electrician has built a following doing cameos like this.

It's confusing—for me. It wouldn't be for someone else. A German couple writing a book remain on the sidelines, and they're friends of the director. Kelly Holland sees an opening in me. Maybe she noticed how I was with Norma Jeane earlier today, or maybe it's something in my eyes. I can't believe I'm this obvious. She holds up a leather mask, says it would completely cover my face, nearly pleads but doesn't have to.

I go blank, or maybe see red lights flashing—you know, warning signals. But a minute later, having received a disdainful glance from Marcy Hirsch, today's production coordinator, as I tore my shirt off, I'm standing at the edge of the dungeon panic-stricken—more from stage fright than any sense of right and wrong—in the mask and black nylon underpants from a cardboard box full of cheap shit for extras. That's it. The German writers stare at their American journalistic counterpart with bewildered expressions. Everything looks strange from the inside of a death mask.

Kelly moves about the set with a video camera resting on her shoulder, tethered by electric cables to nearby monitors. It's a weird sensation. For a couple of minutes the only people who don't stare at me like I'm a freak are the ones on the set, the performers. Then I come to, all of a sudden, and realize I'd better avoid Kelly's line of vision. The other extras really get into it, get physical with the girls, who let them now that the camera is running. Scott St. James tweaks Sarah Jane's nipple. She takes his hand

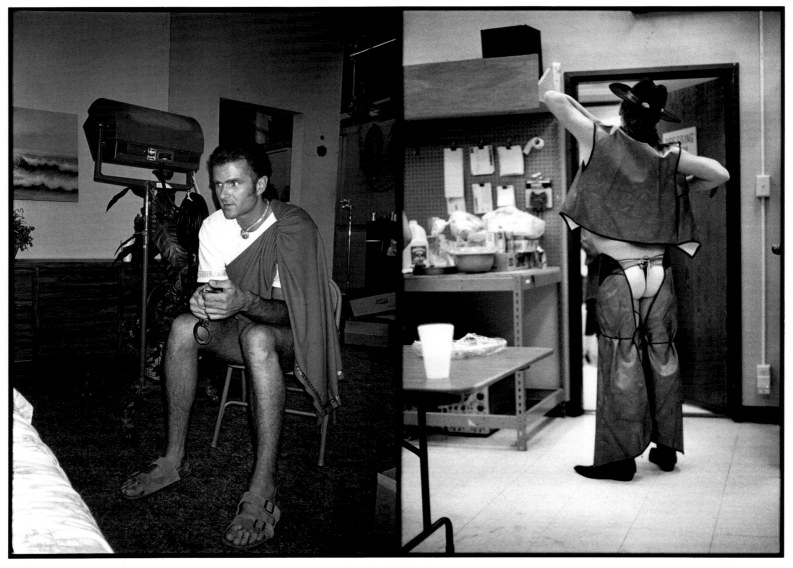

Jon Dough; Tom Byron

and puts it on her other breast, mumbling something about an infected nipple-piercing.

Kelly keeps going. I back away from the set into the darkness of the next one, pull the mask off, find my clothes, and go back dressed. I hang on the sidelines with the other outsiders, like I'm supposed to, like someone "from *Rolling Stone*" is supposed to.

Then the scene is finished—it took twenty minutes—and the cast disperses. Only Tom Byron, Sarah Jane, and Lady Berlin stay behind, to do the first real sex scene of the day.

It starts with Tom over Sarah Jane's lap. The nurse spanks his G-stringed ass with a hairbrush, soundly, well past its turning bright red. At one point he looks up, turns towards everyone watching the scene, and, smiling, says, "What can I say? I enjoy this." He gets a laugh, then says, only half joking, "I'm serious," and gets more laughs. Tom is relaxed in front of the camera, *on,* despite the absurd brown plastic cowboy outfit, or maybe because of it. It's not great acting or anything, but Tom comes off like an

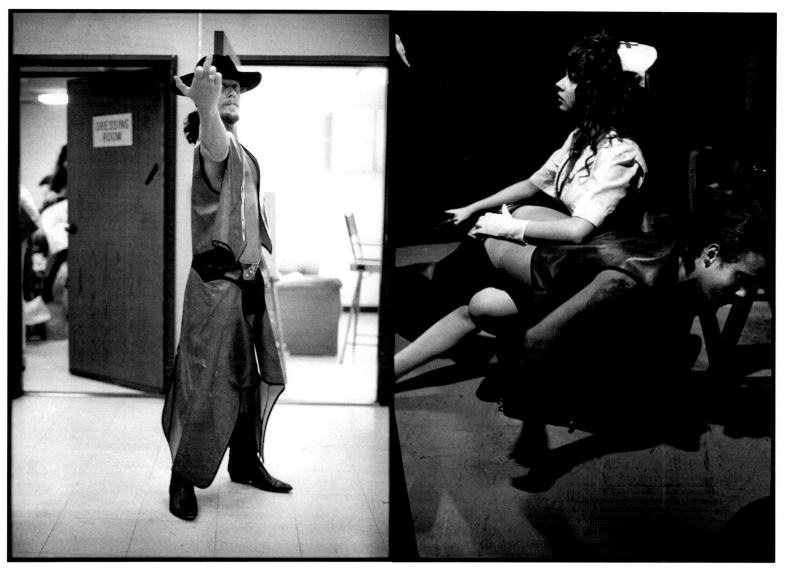

Sarah Jane Hamilton and Tom

experienced performer. He has a different, more-alive persona since Kelly Holland said "action."

The scene progresses. Lady Berlin, the cop, joins in. Both girls blow Tom, and it starts looking more like a typical sex scene. The moment where the woman was in control passed pretty quickly. Tom finishes the scene fucking Sarah Jane from behind. I can't see what Lady Berlin is doing, exactly, but it's secondary to the fucking. Then Tom comes and it's over. The actors pick up their discarded clothing and head up front. Sarah Jane takes longer, can't find her panties at first, and ends up last in line for the shower.

Norma Jeane is on the bed in the dark bedroom set, staring up at the ceiling. Jon is on his side facing her, not quite touching her. Preparation for their scene. They were only introduced this morning.

Nick East is in the lounge. He says, "Hi," like a teenager, friendly, buzzed. The PAs are more casual around male actors, and a couple have already gravitated toward him.

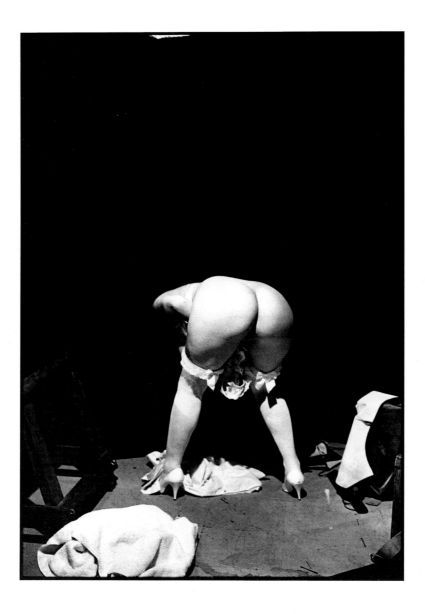

Marcy is going around the room handing actors model release forms. Scott St. James does ID—age verification—shots of whoever he can corner. The lounge is getting crowded. Nick slips outside.

He's sitting in the cab of his Toyota pickup with Rachel smoking a bowl of weed. Rachel—not her real name—is related to Marcy Hirsch. Since Marcy is Steven Hirsch's sister, and Steven is Vivid Video's owner, Rachel gets to PA on porn shoots during her summer vacation from college. Nick is hanging out, waiting to do his scene.

"You can't show that, can you?" he says as I snap him relighting up. He smiles, then blows smoke into the lens. Rachel laughs and takes the glass pipe out of Nick's hand and tokes away.

A silver, early-eighties Mercedes coupe swings into the lot and screeches to a stop. Not out of control, but maybe borderline, very fast.

"That's her, dude," Nick says.

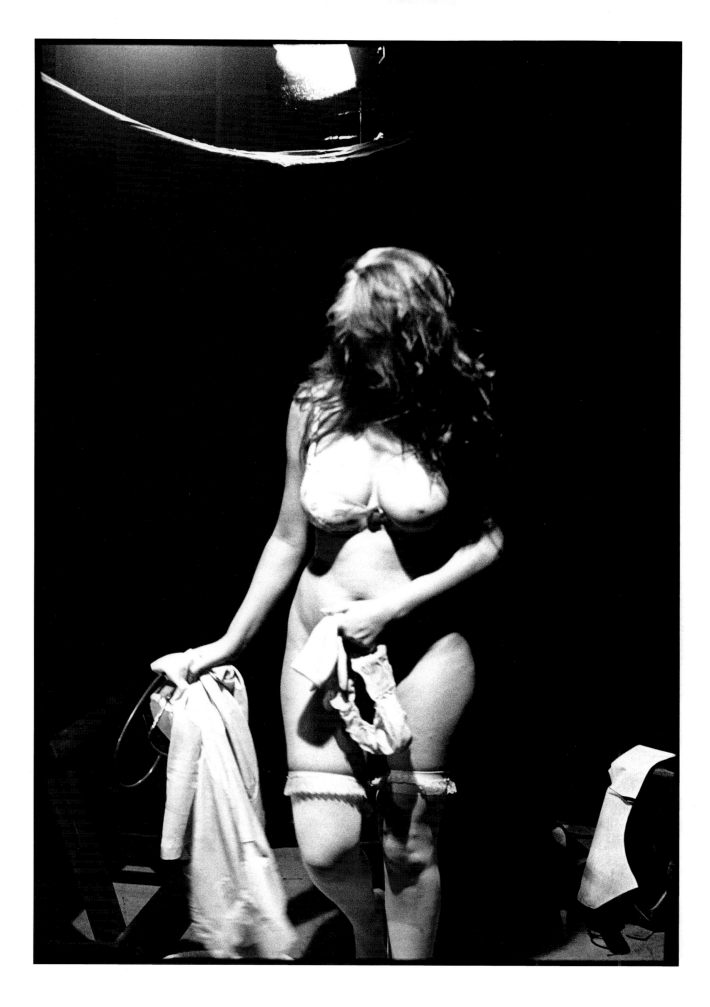

Debi fumbles with the lock of the trunk. She pulls out a garment bag and heads toward the entrance of the soundstage, across the lot in our direction. She's tall and really, really skinny. Her energy is intense, and I can't help it—I begin snapping pictures before I even introduce myself. Debi gives me—the camera—the finger.

"Who the fuck are *you*?" she says.

If Edward G. Robinson had been a girl from Southern California, he would've sounded like Debi Diamond.

Then she smiles.

Debi is six feet tall in black Converse high-tops. Her jeans are tight and faded, torn up and down the front. Her tiny striped T-shirt barely covers her flat chest. Debi's bleached-blonde hair is piled on top of her head, falling in front of her sunglasses.

"Who the fuck *are* you?"

This time the drawn out, sandy growl is more of a purr. She's still smiling. Nick tells her.

"Sure. You can take my fuckin' picture. But you should be a little fuckin' cooler, y'know? You could be some lunatic stalker trying to fuckin' kill me . . . God, I'm fuckin' horny."

Debi struts, bounds into the building, straight through the lounge, past everyone, and into the dressing room. She tosses her knapsack on a love seat and pulls her T-shirt down so it hangs around her waist. Debi raises a bottle of Evian high in the air for a long desperate suck of water. She unbuttons her jeans with her other hand.

By the time the bottle swings down and the actress gasps for air, she's surrounded. Marcy Hirsch hands her a model release form. Teri, the hair and makeup girl, is holding a hot curling iron. Bionca says, "Hey, baby," as she slaps Debi's butt with a black-rubber-gloved hand. They kiss with tongues. Bionca grins. She speaks Debi's language. The two of them hiss and growl like old-time movie gangsters or cat women.

"Change as quick as you can, honey," Marcy interrupts. "And I need you to sign that, OK?"

The form she handed Debi is already crumpled under the water bottle on the sofa. Marcy's pretty blue eyes twinkle as she forces a smile, but she looks nervous, and out of place in a dressing room with half-dressed porn chicks.

"Hurry, 'cause we're running behind, OK?" Marcy says.

Debi is three hours late. Marcy eyes me uneasily then walks out.

Debi talks nonstop, strikes poses, flexes, checks herself out in the mirror. She looks like a junkie, emaciated, and acts like she's on speed. She's beautiful, though, beyond harsh, and I know—instantly—that she's someone special, different from all these other people. I keep shooting, and not because it's what I decided my new approach should be, but because Debi is the first porn star I've ever met—the first star of any kind I've ever met—with a charisma that generates moments, images, every second. Her energy sweeps me along. After the search and the wait, Debi Diamond doesn't disappoint.

"Everyone thinks I'm doing drugs. I'll take a fuckin' drug test right now," she says. Debi brags about her thrice-weekly mountain-bike rides from Sunset up to Mulholland and back. "My trainer can't fuckin' believe what I'm capable of," she says. Then, softly, "I run on the beach with my dogs every morning. But one of them is getting old . . . so I have to work with him, y'know, slow down, 'cause that's how much I love my animals."

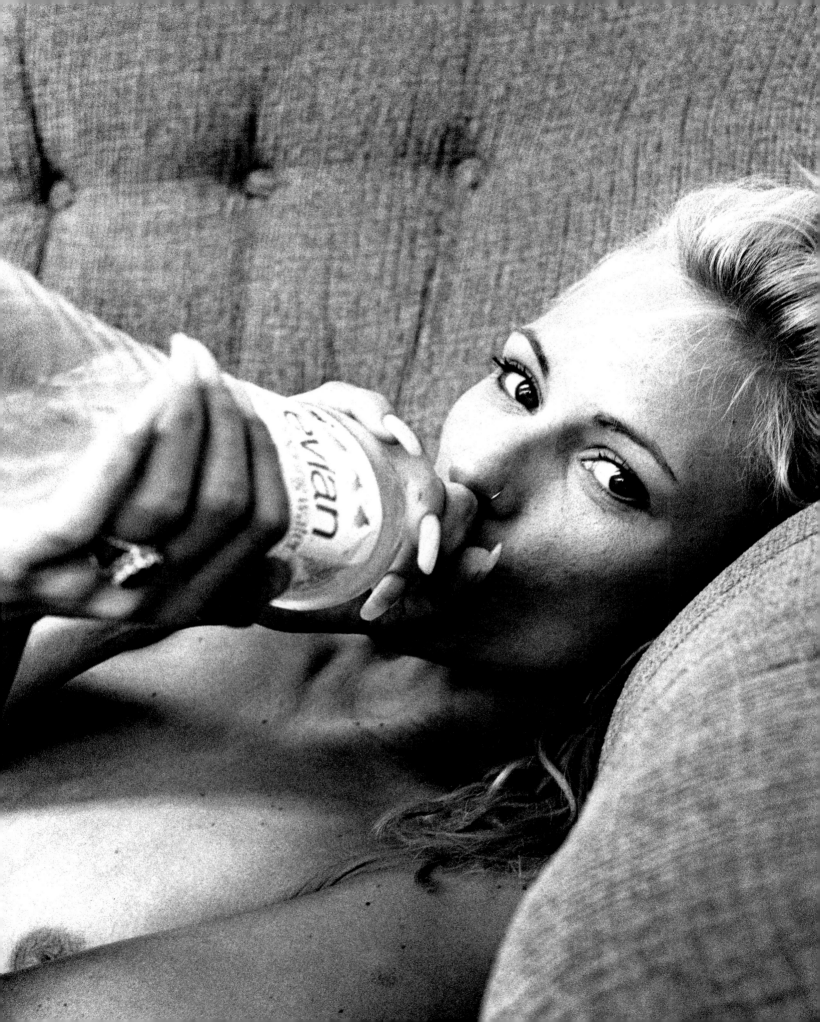

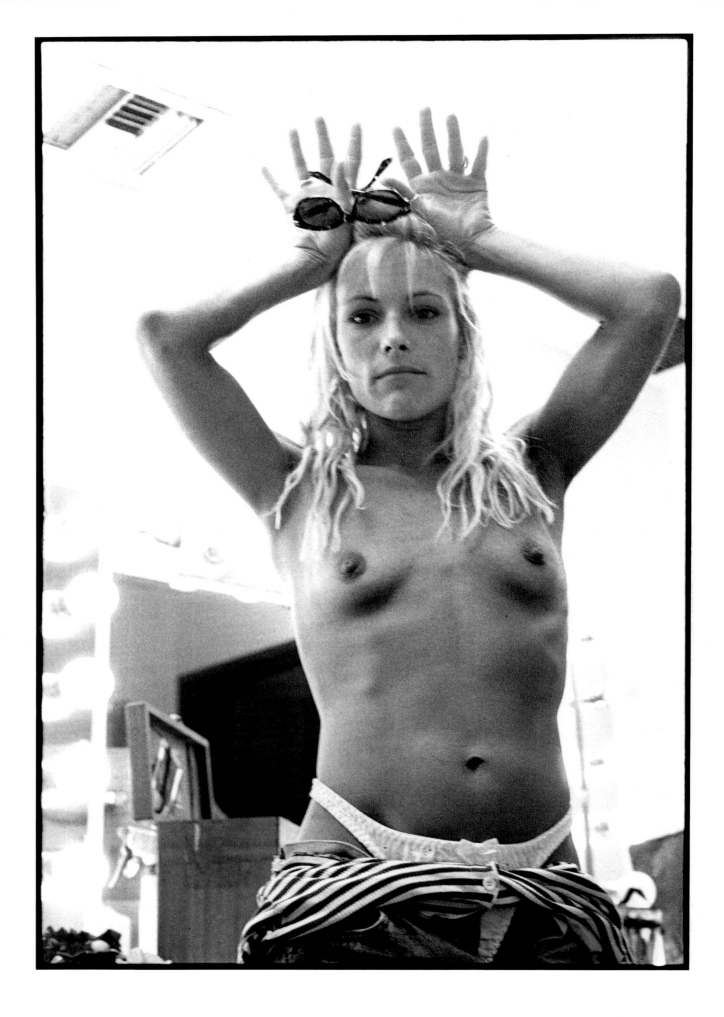

I ask her where she lives. Debi changes the subject.

She pulls a bag of Mrs. Fields cookies from her knapsack, munches on a chocolate chocolate chip. She says she was once legendary Hollywood producer Bob Evans's personal assistant, "a long, long time ago." She was nineteen, hadn't "really" started doing porn. Evans introduced her to Helmut Newton. He loved the way she looked. I believe it. Even now, ten or more hard-core years later, her body language is magnetic. Debi says Newton followed her around for days.

"I would crawl around on the floor, kick the air like Bruce Lee, bark like a fuckin' dog. Shit, I didn't know what to do. He didn't say anything—just, 'Great, fantastic, perfect.'

"So I heard he was having a show. I wanted to see if I was in it, so I went to the opening. The very first thing I saw—in the entrance to the gallery—was a four-foot shot of me. I stole some prints that Bob had in his office and went and had negatives made. I hear I'm in one of his books."

I tell her I came out today to find her and it was worth it. I know I already have a crush on Debi, can't help it, and the next time Marcy looks in to see what's up, Debi and I are holding hands, just sort of buzzing out on each other, and the words "I'm a fan" are coming out of my mouth. Debi's wild, and because I see it—get her—she acts wilder, but not in a forced way; just like she can turn it up as high as I can take it—I'm sure higher—and for me she doesn't mind doing it. But Marcy does. She's taken aback.

Nicole sits between Debi's legs on the sofa, and Debi wraps her legs around her. She offers Nicole a bite of her cookie. Nicole has a little tattoo on the back of her neck: SLUT. Norma Jeane comes in. Debi fondles Norma Jeane's tits and really digs a thin chain with tiny clamps that goes from one of Norma Jeane's nipples to the other. Debi asks to borrow the jewelry for her scene.

Debi keeps being outrageous. Teri begins working on her, but it isn't easy. Debi doesn't stop moving. At one point Teri has the curling iron out in the parking lot. Debi sits on the pavement between cars, retrieving messages from her voice mail, trying to figure out who's paging her, and returning calls on her cell phone. Teri mentions she does hair and makeup for Kenny Rogers.

Nick East is on his cellular, too. He's already in costume, dressed as a pirate—or a musketeer. Marc Wallice is inside putting on the same costume.

Alex Sanders shows up. Even though the building is in the middle of nowhere and a number of stars are hanging out smoking, and the lot is hidden from the highway, the actor wheels his red Ninja motorcycle into the lounge.

"This is Compton," he says.

As I pass Marcy on my way to reload my camera, she stops me.

"Do you have anything that says who you are? A card?"

I hand her a card.

She looks at it, frowns. "Nothing that says, y'know, that you work for *Rolling Stone*? I mean, this doesn't say *who you are*."

I *don't* work for *Rolling Stone*; my explanations don't satisfy her. Why should they? An hour and a half ago I was in a death mask and underwear. Marcy doesn't want to see a portfolio of the pictures I've done over the past three years, and I don't make her, which is a mistake. It would clarify that I'm who I say I am. Then she kind of brushes it all aside, like it's nothing, and sort of glosses over.

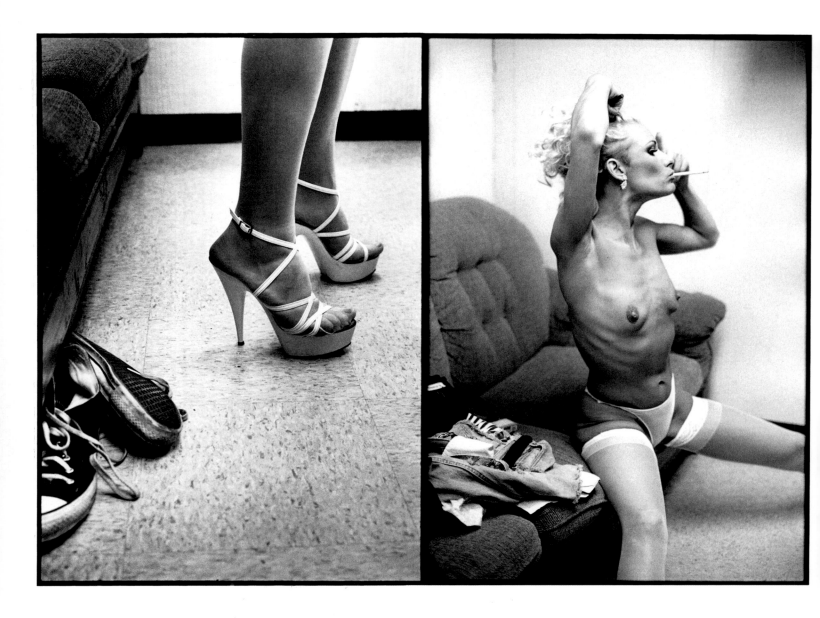

Debi's still in the parking lot. She's transformed. She towers atop platform sandals with six-inch heels. She's in a transparent white dress with ruffled cuffs, white panties, white stockings. Her hair has been puffed up into a big curly 'do. She's smoking a Marlboro, eating a cookie, and talking on her cellular. The ravaged, beautiful actress looks like a drag queen.

"That was my masseuse," she says.

I ask Debi to sign a model release. So far I've been more successful than Marcy at getting them this morning.

"Uh, can we talk about it after, OK?" Debi says.

She looks away from my eyes. A PA sticks his head out and tells Debi it's time.

Someone has lined the dungeon with votive candles in glass. The gray platform where Marc Wallice, Nick East, and Bionca will go at Debi is also surrounded. Each candle has an inch or two of hot wax at the surface already.

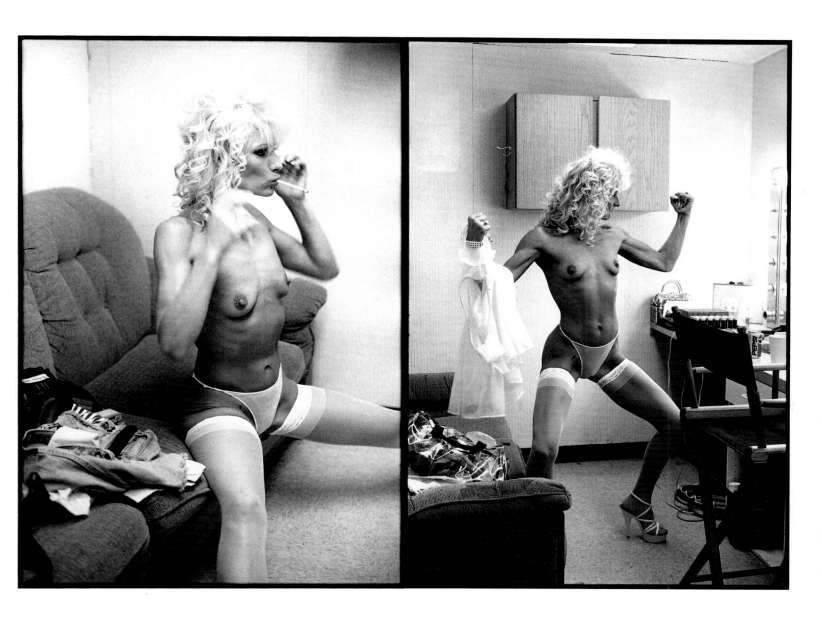

Debi is fired up from the word go. She hisses, writhes like someone possessed. She twists her body like a contortionist. Her acrobatics are extreme—at one point she's standing on one hand, completely upside down, sucking Wallice's dick and stroking it with her free hand while Nick, also standing, eats her out. The guys need Bionca, if only to steady Debi's frame while they tip the candles. Bionca pets Debi, tries to soothe her. Debi thrashes her head from side to side. The white dress is already torn away.

"In my mouth," Debi urges.

She's on her back. Kelly stops shooting.

"Are you OK, Debi?" she asks.

Debi nods yes, grunts affirmative, motioning with her hand for the director to keep going. Nick glances up at Kelly, sees she's shooting again, and continues. He pours wax into Debi's mouth. Debi flips her legs up and spreads herself with her hands. Nick turns to the director again, doesn't get a sign, keeps going. Debi takes the hot wax everywhere.

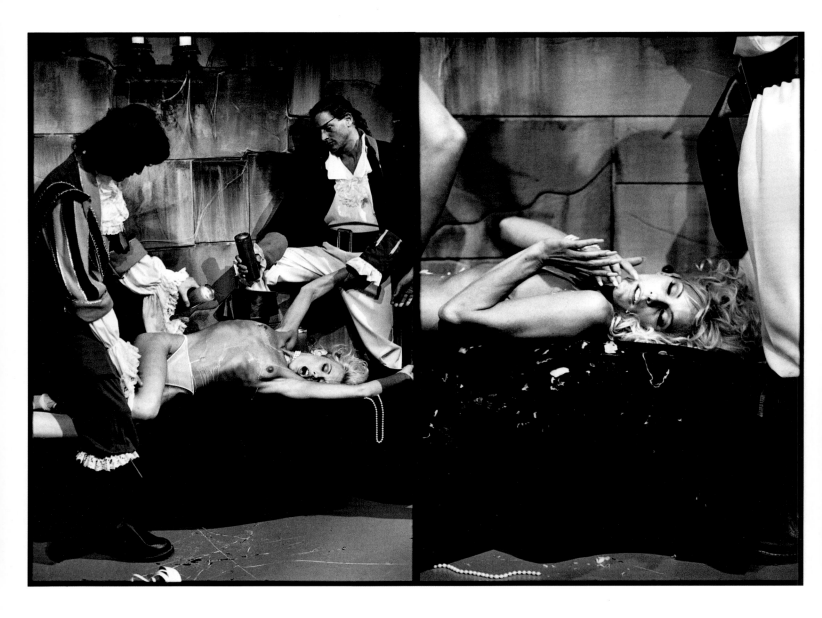

A minute later Debi makes a scissors motion with her fingers to signal "Cut." She says she has wax in her eye, that she needs to take out one of her marine-blue contact lenses. Her string of fake pearls is broken. One end dangles from her shoulder. Most of the beads are scattered around the actors' feet.

This was intended to be "light bondage," the central episode of a "couples oriented" Vivid Video release, but the scene has taken a turn for the super hard-core. Debi's oily, sweaty body is covered with strands of dried wax. It's been poured into her spread pussy, asshole, and open mouth. Both Marc, who's been acting in porn for over ten years, and Nick, a relative newcomer with four years experience, are having problems maintaining their erections. They weren't expecting the scene to turn vicious.

Debi's snarling demands for abusive treatment are intimidating, throaty, and real. If Marc and Nick had any control over the dynamic when the filming began, that control is gone. The five-minute break will help them. Maybe that's why Debi called

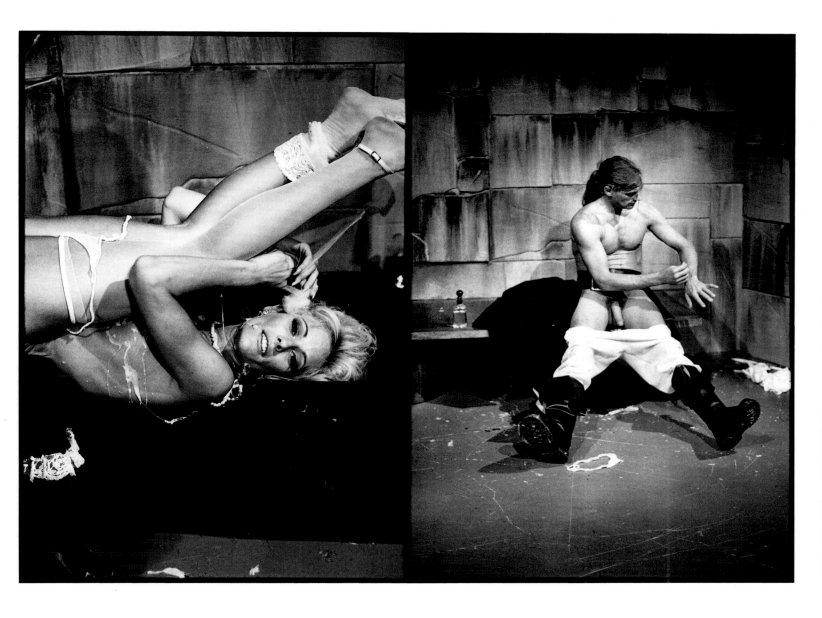

it. It doesn't matter whether she gets off or not: This scene's not over until these guys come.

Kelly steps back. Scott St. James moves in to shoot stills. I shoot too. With her legs high up above her head, Debi looks into my lens with the same expression she might've worn for her third-grade school portrait. "Help me" is what I hear. It's too much—not her need itself, but her willingness to make a connection with me, to really let me in. It's disarming. Debi is the brave one. I flinch, then look away.

Debi storms off toward the bathroom. She pulls Nicole London's boyfriend, the PA, in with her and slams the door. Nick paces around the set stroking his semi-hard-on. Marc sits, pants at his ankles, casually picking lint off his dick.

Violent sex noises emanate from the bathroom. Bumping, shouting. It lasts five or six minutes. The PA is left standing in the doorway, a frazzled, guilty smile pasted across his face like he's just been hit by a sexual tornado. Debi returns to finish the scene.

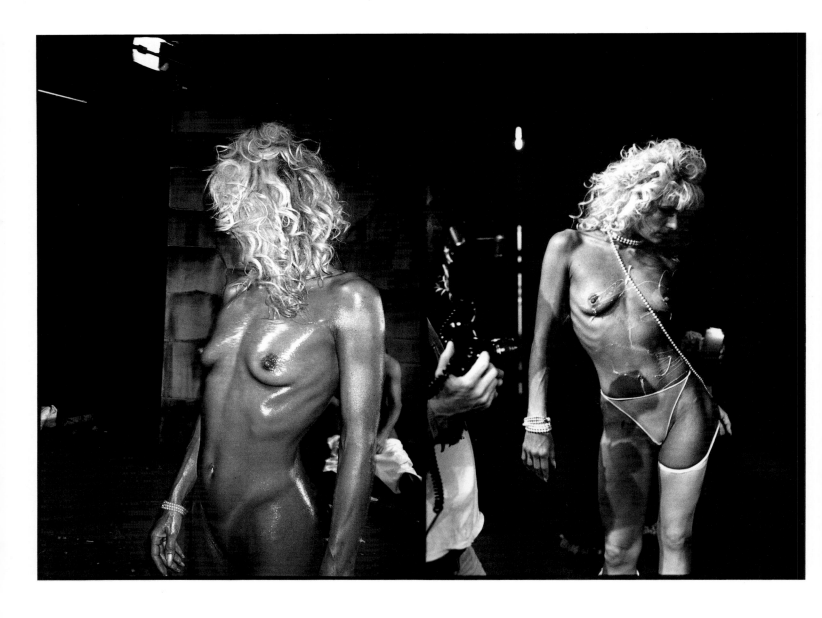

"DON'T WORRY about banging my head against the wall . . . really."

Debi is reassuring Marc as he enters her mouth. Nick East is at Debi's other end.

"It's OK," Marc says, "I can do it this w—"

"No, don't worry. You can bang my head against the wall if you have to."

"But if I just—"

"Bang my head against the wall, you fucker."

"We're still rolling," Kelly reminds everyone.

Debi, quickly demanding—hissing—one more time, says, "DO it."

Marc does what Debi says. Now the soundstage is silent except for a steady thumping—Debi's head banging against the wall of the set—and the hum of stage lighting and video equipment.

It ends with a DP. Marc tells Nick to get underneath Debi. This means Nick will have vaginal intercourse with Debi while Marc enters her anally, from on top. A flash

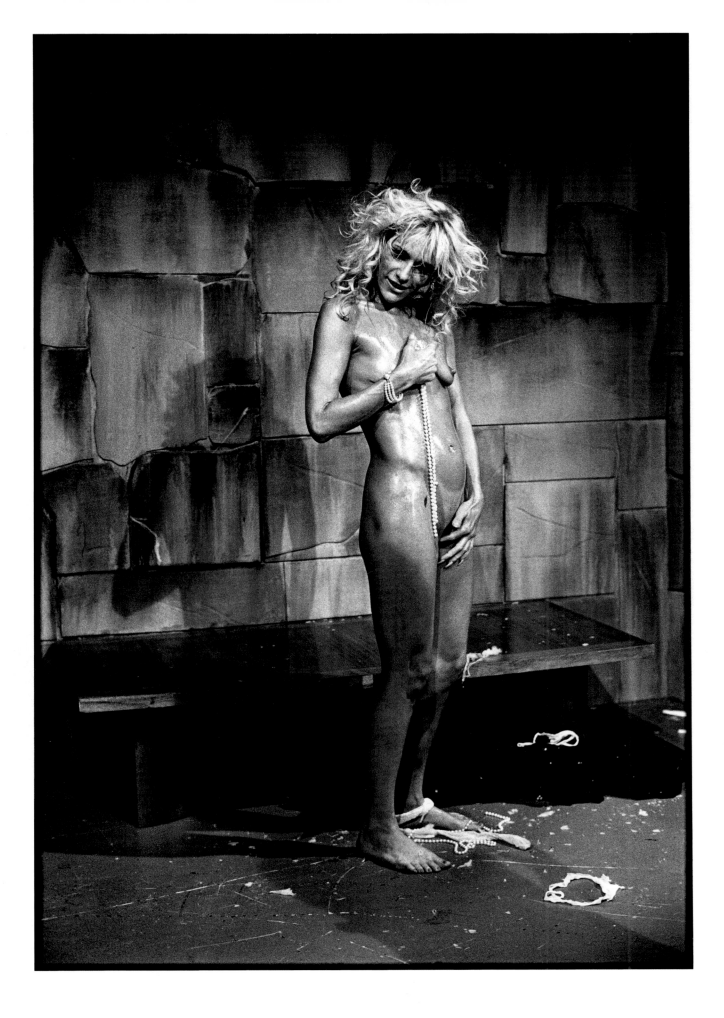

of disappointment crosses Nick's face but he goes along. It's as if Marc called "shotgun" first. Only this isn't Dad's car it's Debi's body.

When it's over Debi gathers as many of the beads from her necklace as she can find on the floor. Of all the scenes I've witnessed—some hot, others not—this is the first one that breaks my heart.

JON DOUGH ANSWERS HIS PHONE. HE'S STILL IN BED, IN TOPANGA CANYON.

"Man, you should've been there. That girl Norma Jeane and me ended up rubbing fruit salad all over each other. It's a hot scene."

He says he was surprised, that he "never expects much" when he works for Vivid. Jon says he'll arrange a get-together with Patrick Collins and Joey Silvera. "We're gonna hit some strip bars tonight," he says. "You have to hang out with Patrick. He's a trip."

FIVE THIRTY P.M., ENCINO. THE TEN-FOOT-HIGH ELECTRIC GATE AT THE EDGE OF PATRICK Collins's—formerly Tom Petty's—property swings open. A shining new black Mercedes—a big one—a blue minivan, a beat-up station wagon, and Jon's Land Cruiser are parked in the driveway.

Jon answers the door. In the den there's a pool table and a baby grand piano. Patrick Collins is standing near the piano, blowing a harmonica miked through a small amplifier. He has devilish blue eyes, short, very black hair, and a goatee. He's in jeans, sneakers, and a lavender Polo T-shirt that accentuates his beefiness. Shane, Patrick's long-haired assistant, backs him up on an acoustic guitar. Large, framed "erotic" posters hang on the walls, one a poster for a *Buttman* tape. John Stagliano manufactures and distributes Patrick's videos.

Jon crouches at Shane's feet, watching his fingers closely. Shane hands him the guitar. Jon fumbles through a couple of beginner-type strums, gets frustrated, then hands it back.

Because I'm a city kid, suburban homes always feel unlived-in, cleaner and newer than what I'm used to. It's like that here. Patrick turns his amp off and racks up the pool balls. At leisure, these porn guys are like kids. Patrick, at fortysomething, is the ringleader. He talks like a guy with plenty of experience hawking snake oil. Joey and Jon have both said Patrick was a con man before getting into the porn business.

I tell Jon I'm concerned about not having photographed enough male porn stars in the nude. For balance.

"Anything you want, man," he says. "It's no problem."

I ask if he thinks Joey would do it.

"Sure. I'll make him do it."

Joey Silvera arrives a few minutes later.

"Naked? I don't know," he says.

He's sitting, watching the other guys play pool. He scratches his head, thinks about it. It doesn't look good.

"I don't know if I'm, y'know, up for that—in the right mood . . ."

Very long pause.

". . . unless we do it outside."

Patrick is bent over the table, about to take a shot. He freezes, then just his head turns to Joey. Shane and Jon fall silent. They all have bemused, wait-and-see expressions

ENCINO

Jon Dough, Patrick Collins, and Joey Silvera

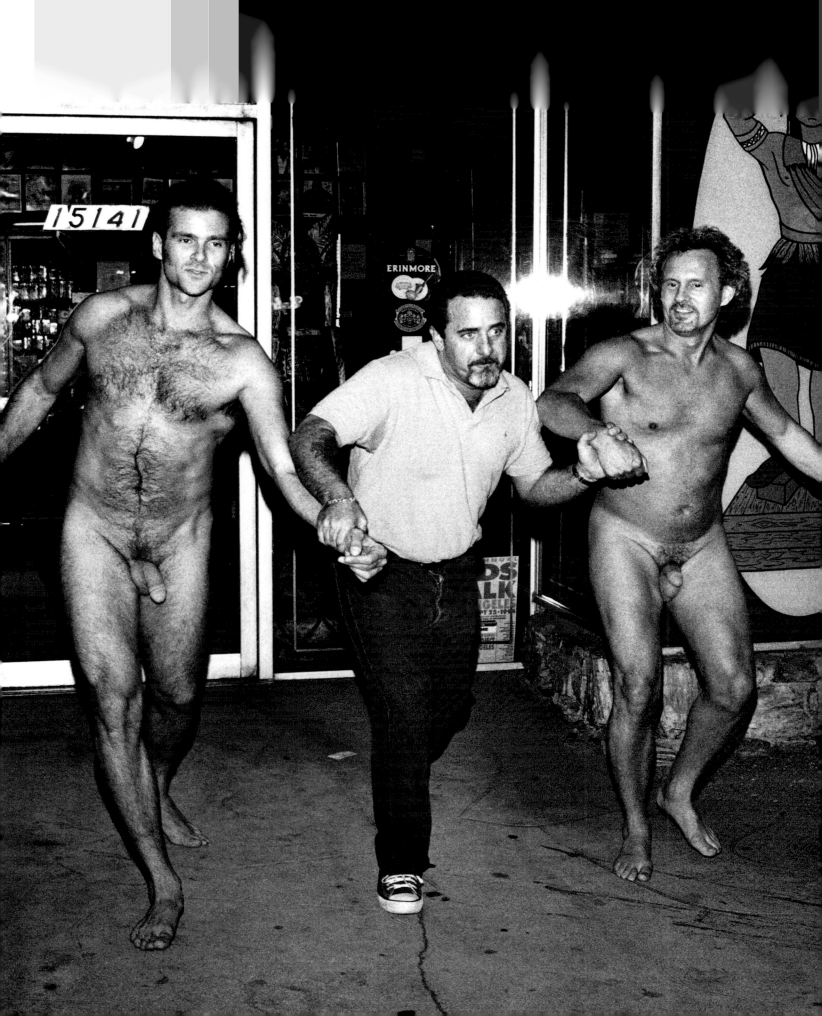

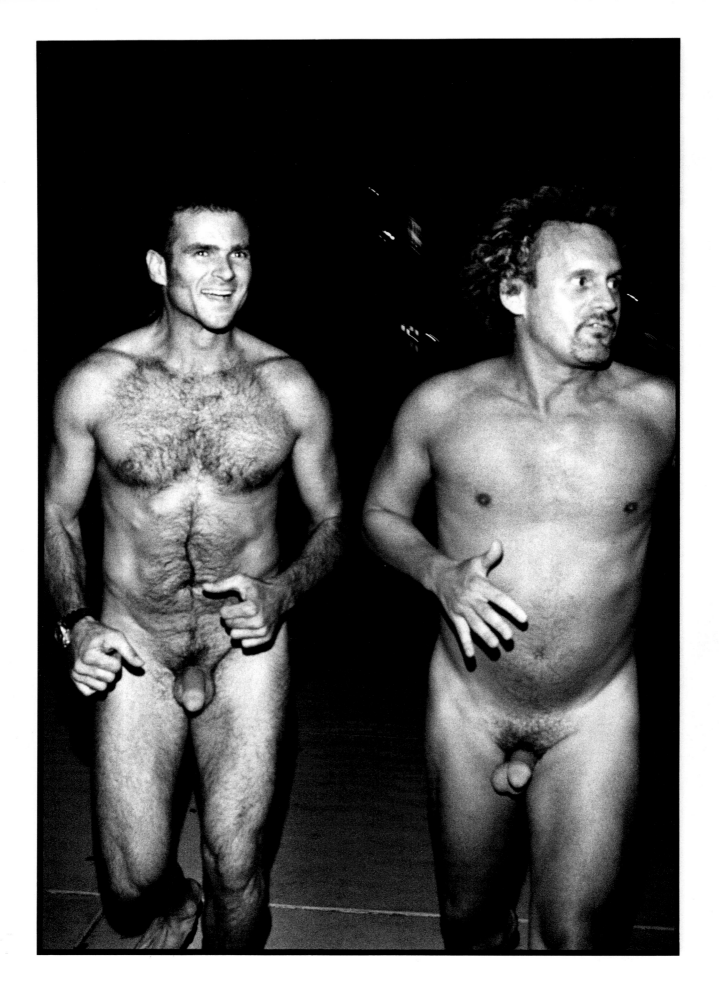

and the beginnings of smiles. None of them speaks. Joey squirms in a reproduction Louis IV chair, finally letting out a shy smile.

"I mean, that would be cool. I would do that," he says.

A minute later they're filing out of the house. Joey stops to peek in through the kitchen window, on his tippy-toes. There's a Guatemalan woman washing dishes. "This guy's got a thing for my housekeeper," Patrick says. He calls out her name. "Shh! Don't embarrass me, man," Joey says, waving and smiling when the plain-looking woman glances up. She smiles back. Patrick says his minivan is normally reserved for grocery shopping.

It's rush hour. He pulls to the curb near Ventura and Balboa, a busy eight-lane intersection. Patrick sees I'm nervous.

"Kid, if you *gunned someone down* around here it would take the cops forty-five minutes to show up. *Relax.*"

Horns honk. Catcalls and whistles zip by out the windows of passing cars. Joey and Jon walk down the boulevard fully nude, barefoot, laughing. They improvise, act out some unscripted drama, do their best to ignore their own nakedness. Patrick joins them, dressed, and plays the angry authority figure, taking the guys by their wrists and leading them away. Then he hops back in the driver's seat. Each time Joey and Jon try to get back in the van, Patrick pulls it up a little further, making them chase it thirty feet the last time.

"Fuckin' asshole," Joey says, out of breath. Jon grunts in agreement. They're in the backseat pulling on their pants.

"Don't be such babies," Patrick says.

Patrick asks if I got what I need. I say I don't know—the flash was fucking up again—I could probably shoot more to be safe.

Patrick says, "Then let's find another spot."

Joey says, "It's easy for you, Patrick. You're not out there naked."

Patrick Collins—director of *Sodomania* and all its sequels, in one of which he himself, as Roscoe Bowltree, grovels at the feet of some unknown porn actress, on the floor of a hotel room, kissing, worshipping her toes as he masturbates—stops the car and shuts the engine. He turns in his seat, very slowly, to look at Joey and Jon. His face contorts into a mass of squished wrinkles, twisted eyebrows, sour, pursed lips, and squinted blue eyes—all to convey total disgust with Joey's insinuation. The actors burst out laughing and a smile sneaks through Patrick's accomplished expression.

He restarts the car.

Patrick drives a couple of blocks down Ventura. Joey points out truly nondescript pedestrians along the way. "Man, she was hot! Did you see her?" he says. It happens three times. Joey wasn't nearly this excited about having sex with a porn actress at Tom Byron's house.

"Nothing like *real girls,*" Joey reasons.

There's a doughnut shop, closed, just one guy sitting in his car in the lot. The porn guys have plenty of ideas about what he might be doing there. He notices them checking him out, leaves, and we take over, do more nature shots.

THERE'S A TAXI pulling out of Patrick's cramped driveway. "Is Tianna home?" Joey asks. He says I should shoot her if she is. Jon agrees. "You can certainly ask her," Patrick

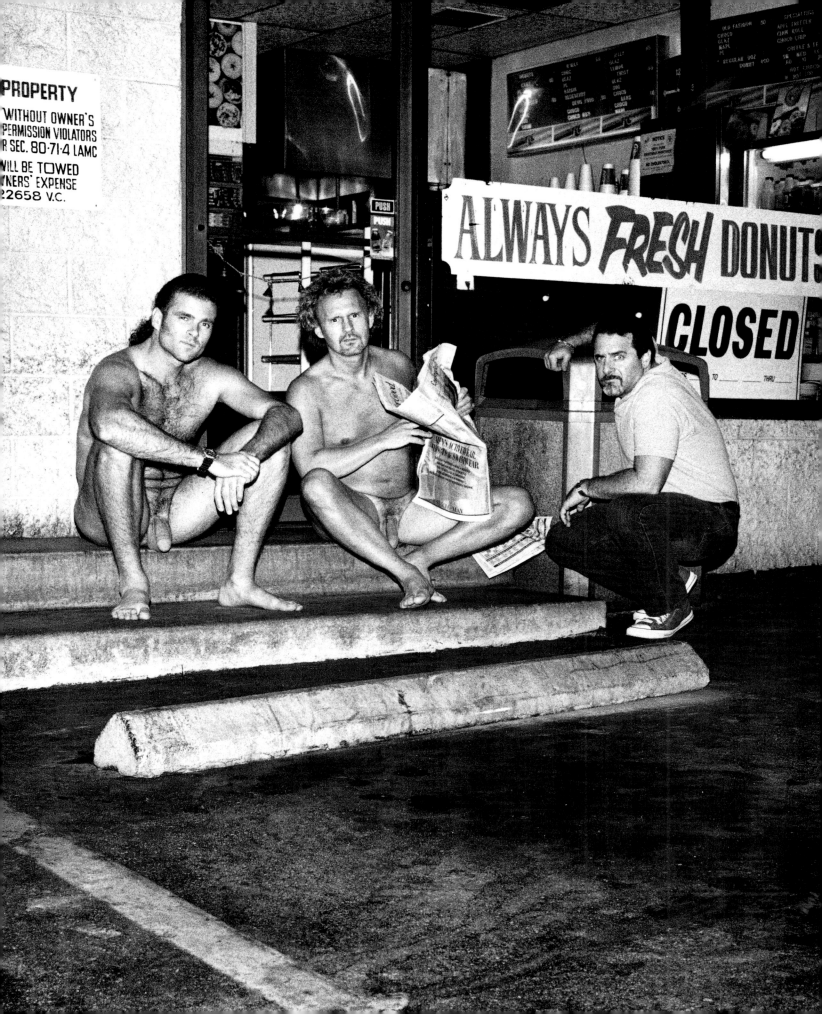

says. Tianna is Patrick's wife. She's a porn star who was popular in 1991 and '92. Patrick says his wife retired.

Joey and Jon are like sixth-graders saying hi to their friend's mom, except they kiss Tianna longer and Jon squeezes her ass. They've all had sex on film at one point or another. Patrick complains about Tianna's breath, about her eating too much garlic "again," then kisses her anyway. The guys leave for the strip bars without me.

A couple minutes later Tianna is posing in the big, suburban kitchen. The little blonde woman plays with herself, plays with her tits, and ends up pulling off her picnic–tablecloth-checkered dress. Naked, she prepares some leftovers for Patrick, in between rolls of film. It's like taking dirty pictures of Florence Henderson.

Tianna says she and Patrick have been married a long time, that she stood by him through a lengthy series of moneymaking schemes before they finally got into porn together and Patrick "found his niche." She's proud of her husband and explains that their love for each other is strong and "pretty normal" even though it "doesn't fit most people's standard" of a healthy relationship.

There's a handwritten, page-long letter about "friendship" and "loyalty" stuck to their refrigerator, along with snapshots of nieces and nephews, a grade-school ballet performance, stuff like that.

Even though she is, or was, a porn star, when Patrick returns to find me hanging out with his wife, who's still naked, it's embarrassing for me. It doesn't bother him, and Tianna doesn't mind Joey and Jon seeing her naked, either. Patrick says the clubs were a disappointment tonight. The actors agree. They say good night and go.

Patrick stands at the center island in his kitchen picking at the leftovers. Tianna stands near him. She looks admiringly at her husband. He yawns, and she wraps her arms around him, gives him a big hug. Patrick mentions the title of a mainstream Hollywood movie from the eighties, and asks if I've seen it. I haven't. Patrick rubs his face. He has a worn out, thoughtful expression.

"My psychoanalyst really thinks I should see that," he says.

A GUY WITH A LONG PONYTAIL OPENS THE DOOR.

"You're gonna have to move your car to the end of the street and park it around the corner," he says in a friendly voice. "You'll see the others. Bruce's neighbors don't like when the street gets all blocked up."

I park in between Jon Dough's Land Cruiser and Marc Wallice's Thunderbird. The guy with the ponytail comes around in a Toyota pickup. His name is Glenn Baren. On the way back, Glenn says he shoots the stills and composes the soundtracks for all of Bruce Seven's movies.

"Bruce is on the phone with Billy Idol," Bionca says, smiling. Then, "Hey, Ian," and a tight hug.

My behavior on Sunday, in Compton—the mask, Debi, et cetera—had the opposite effect on Bionca than it did on Marcy Hirsch. Bionca trusts me more. This isn't the kind of shoot outsiders usually get invited to. The other Evil Angel directors I know—Patrick Collins and John Stagliano—said an outsider's presence on one of their sets was an impossibility. The entrance hallway is lined with Bruce Seven's videotapes—*The Distress Factor, Autobiography of a Whip, A Compendium of His Most Graphic Scenes Vol. 4,* dozens more—and the awards he's received for writing and directing them.

TAKIN' IT TO THE LIMIT

The hallway ends at an L-shaped living room with sliding glass doors that open onto a patio, pool, parched desert backyard, and mountain views. One wall has a series of five Betty Page portraits hung on the same incline as the slanted ceiling.

Bionca says Billy Idol called last night, out of the blue, to tell Bruce he wants him to direct his next rock video. Bruce invited him to this shoot.

"He's giving him directions," she says.

Today Bruce is helping Bionca direct. She's going to do it his way: one scene, no rush, in real time. Bruce is sitting on a striped sofa in front of a mirrored wall. He hangs up the telephone, shrugs.

"That kid sounds high," he growls. "Let's see if he finds us."

Bruce coughs deeply three times then extends his hand to shake.

Marc and Jon are hanging out in the kitchen with Careena Collins. Jamie Summers had talked about Careena back in 1991. Careena was once Jamie's roommate, how Jamie got into porn in the first place. Jamie said Careena got out of the business when she got into law school.

"Yeah. I just finished. I'll take the bar exam in about six months," Careena says. "I've done, I don't know, six or seven scenes since I got back into it. Only for Bruce."

A small kitchen table is littered with bags of Cheez Doodles, Oreos, carrot and celery sticks, canned dip, liters of Pepsi and Diet Pepsi. It's kind of blue collar, but not negligent or stingy like the lack of food on the set of *Easy Love.* It's homey. Bionca slices more vegetables and spruces up the spread like she cares, like someone preparing snacks for a Super Bowl party.

Glenn's wife, Lissa, an unassuming woman in her late twenties, is an assistant or production coordinator. A French couple arrive. The blonde girl is called Barbara Doll. The guy is her husband and manager. Lissa leads Barbara Doll to a bathroom off the hall where a tall, bleached-blonde woman is doing Rebecca Bardoux's makeup. The makeup artist, who looks like she's had collagen injected into her lips and a breast job, will do Barbara next.

Glenn and Jake, the cameraman, haul a black-carpeted platform into the middle of the living room. They set up two lights on stands. There's a four-inch Sony monitor on the floor near Bruce's feet.

The actors trickle into the living room. No one's in a hurry. Jon sits on one of two sofas at the lived-in end of the room. The coffee table is covered with issues of *Hustler's Erotic Film Guide, Adam Film World,* a couple of half-full ashtrays, a bag of reefer, a mini-bong, a cordless telephone, and two remotes for the large-screen TV and VCR.

Careena climbs onto Jon's lap. She's in a black stretchy dress, no panties. She fires up a bowl and takes a hit of Diet Coke. Jon lazily gropes her crotch. She passes the bong to Rebecca, who's sitting on the other sofa with the makeup artist. The French actress decided to do her own face. The French couple don't fall into step socially with the rest of the people here.

Careena walks off toward the kitchen. Jon plops down in between Rebecca and the makeup artist. Nodding at Careena's backside, he whispers, "Keep your eyes on her. She's the hot one today. Just watch and you'll see."

Jon kisses Rebecca on her mouth, caresses her thigh. She gets up and takes the bong over to Bruce, who takes a hit then coughs some more. The makeup artist rubs Jon's neck, leaning in close to his back, pressing her big tits against him. Jon closes his eyes,

sighs. She asks Jon to come watch her strip at a bar on Ventura Boulevard. She says she works Friday nights.

Glenn photographs Rebecca nude in the shade of a small palm tree in the back-yard. It's over a hundred in the sun. She can only take the heat for a couple of minutes. Glenn says Lissa occasionally does "girl-girl" scenes for Bruce, and that he doesn't mind at all.

Barbara Doll curls up on the striped sofa, resting her head on Bruce's shoulder. They haven't been introduced. Barbara's husband is across the room reading a maga-zine, keeping to himself. Neither one speaks English well.

Rebecca lies down topless, on the platform, in front of Bruce. Bionca sits nearby. Then Careena. Then the small crew, too, and the makeup artist, and finally Marc and Jon, though the guys stay to the sides; one leaning in the doorway, the other against the opposite wall. They all hang around Bruce, hang on his every word. He doesn't say much. When he does speak it's barely audible.

It's not quite cultish, more like an extended family. Bruce is definitely in charge, though, in some weird, loved way. Normally, directors are off on a set somewhere: Their assistants have to coax performers out of dressing rooms to get them in front of the camera. Then the directors take over, half guilty, half embarrassed, a little apologetic, and also kind of indifferent about what they're asking their cast to do.

Bruce isn't embarrassed or apologetic, just dead serious. And he didn't call this con-gregation together, either. It just happened—everyone gravitated toward him. Everyone is right here. There's not much equipment to speak of. Everything is ready to go. This old, unshaven guy in jeans and discount-store canvas slip-ons is the center of attention. He's scary looking, but the girls especially like staying close to him, wait patiently to be told what to do. The guys look like sons, obedient out of grudging respect or fear. I only know Jon admires Bruce because Jon told me so last night.

Lissa lays an arsenal of dildos, vibrators, harnesses, prods, lubricants, oils, and two bear-shaped honey jars on the floor in the corner near a pile of fresh towels. She helps Glenn set up two Japanese screens that divide the living room and create a backdrop behind the platform. The set shrinks: Anyone watching will be no further than three feet from the performers.

Bruce tells Bionca to put some music on. She chooses a Nine Inch Nails tape, cranks it up. Glenn gets the three actresses—now all in black dresses—to line up on the platform. He shoots a series of stills that will end up on the video box cover. The ac-tresses wiggle to the drum beat, stick their rear ends out in unison. When Glenn has what he needs Bionca turns the music off.

Jake sets two bar stools in the corner near the screens. Bruce tells Marc and Jon to "just watch." They take their seats fully clothed.

Then Bruce gives his OK for the girls to begin.

They fondle one another. Then they're all nude, or exposed, with dresses around waists, shoes, thigh-high leather boots for Careena. The girls tumble around the plat-form, trying out various positions and combinations. Each actress has a chance to use her fingers and mouth on the others.

"OK, move on," Bruce says.

Bionca was supposed to direct but that isn't what's happening.

Rebecca complains there's no Astroglide, only the thick, gooey Abilene. Somehow

that stuff makes the scene even raunchier. Rebecca stands and straps on a long, fat dildo. She strokes it, slathers it with lube, acts like it's her own. Careena rummages through the pile and finds a ten-inch-long, ridged, flesh-colored prong with a five-inch handle.

Barbara Doll sees that and becomes alarmed. She stands, approaches Bionca, and the two women engage in a whispered but heated discourse. The language barrier doesn't help. Barbara leads Bionca off the set, behind the screens. A minute or two pass and they return.

Bionca tells Bruce, "She didn't like the size of that thing Careena's gonna put in her tush. I guess it's pretty big," with an expression like, "sorry this chick is such a wimp." She continues, "Me and the husband settled it, though. Barbara gets a hundred more for the scene. I thought it was worth it."

"Let's do it," Bruce announces.

He hasn't budged from his spot on the sofa.

For the next ten minutes Careena and Rebecca assault the French girl methodically, relentlessly. Marc and Jon watch with their dicks in their hands.

Barbara screams at first, but somewhere along the way loses the strength to do even that. Her moans are drugged with misery. Rebecca rams her with the dildo from behind while Careena pushes the prong into her rear end as far as it will go—over and over. Barbara reaches under herself and holds a vibrator against her clit until Bruce says, "That's good enough."

Barbara rushes out of the room.

"Well, that was bullshit," Bruce says, coughing. He eyes Bionca, looks mean. She looks at the floor, doesn't respond. Bionca cast the French actress.

Careena and Rebecca are giving Marc and Jon head when Barbara comes back. She joins them.

Jon pairs off with Careena, Marc with Rebecca. As the scene progresses Barbara's role is subordinated. She helps the others do things without doing them herself. Then she just watches.

Marc sits on the edge of the platform. Rebecca straddles him, riding Marc "anal reverse cowgirl"—reverse because her back is to him. Rebecca's shrieks are horrifying, inspired. She's desperately into it.

"Good, Becky," Bruce says.

Rebecca hears this and slams down on Marc harder, yelps like an animal in a trap. Anything for Bruce. Her eyes are filled with frozen panic. Her heavy, oddly doctored tits swing and bump.

Careena has Jon's dick in her throat. Tears stream down her face. He pulls out and turns her around.

"STAY RIGHT WHERE YOU WERE, JON," Bruce commands.

Jon obeys. Careena resumes with her mouth and hand. Marc is ready to let go and Bruce gives him the OK. Rebecca climbs off and takes his come on her face and in her mouth.

"OK, Jon, now go ahead," Bruce says.

Jon takes Careena from behind, hard. The tiny actress's ability to handle a man of his size defies reason. By the time he nudges into her rear end, Careena is drenched in sweat.

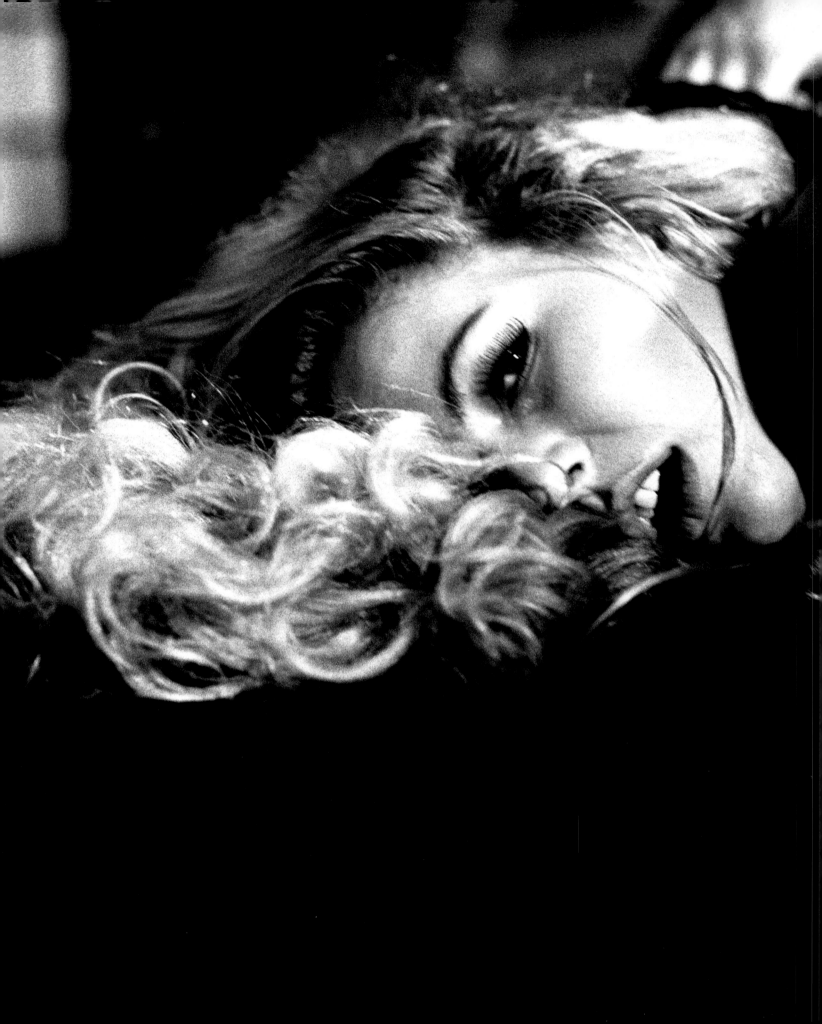

Barbara Doll, taken to the limit.

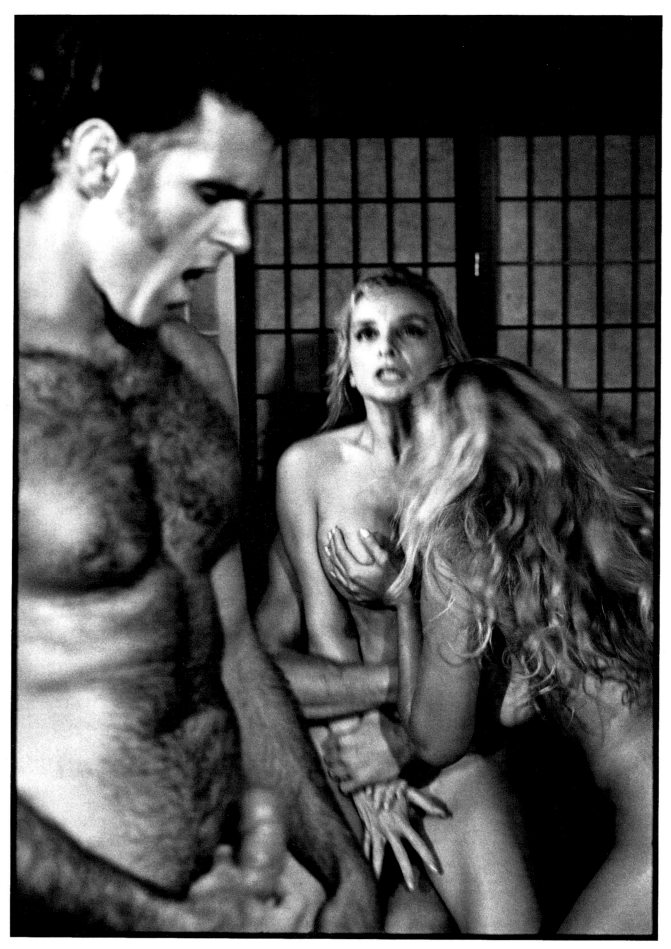

Jon, Rebecca, and others

Patrick Collins slips into the living room, past the cameraman, and sits near Bionca and Bruce just in time for the finale.

Jon holds nothing back; the pounding is merciless and exhaustive. One wouldn't know it, though, from the sound of Jon's whimpers and sighs. Jon sounds feminine when he fucks. He climbs onto the platform with Careena and parts his legs wide. This way Jake, crouching behind the actors, can film everything in clinical detail.

After a few more minutes pass Bruce says, "OK, Jon."

This is the cue for Jon to work up to his orgasm. Careena doesn't scream, she heaves long gasps in rhythm with his thrusts, maintains her resolute resistance. Her eyes are blissed out, and it's not easy to fathom. Bruce's girls go all the way, or go all the way for him, anyway, and it reminds me of Debi Diamond. The hard-core ones have some kind of *need* to go all the way. Bruce Seven understands this—can take them there—is apparently involved in exorcising his own demons—needs them to do it—and along the way facilitates the girls' needs too. It's a powerful dynamic, arguably dangerous for all participants, and the process is not devoid of qualities normally associated with "art." Money is only part of it.

Jon pulls out. Jake hangs tough on the from-behind shot. I crouch right behind him, two feet behind Jon and Careena. Jon jerks himself off the rest of the way, three or four strokes, and comes. A lot.

Careena's decimated, stretched-wide-open asshole coated in a drippy window of Jon's semen is the most hard-core thing—maybe the most disgusting thing—I've ever seen. Like a car wreck, it's impossible to ignore.

The title of this movie: *Takin' It to the Limit.*

All eyes are focused on the exact same spot. Jake doesn't move the camera, but after a few long beats, he looks over his shoulder at Bruce for a sign, for a direction.

Sixty excruciating seconds pass before Bruce barks:

"Now turn around and suck his cock."

Careena follows the director's orders. Jon's erection eventually subsides in her mouth. Careena rests her head against his belly.

Hushed silence.

Now all eyes are on Bruce, waiting.

"That was nasty," he growls.

The tension is broken. Jake laughs, wiping his brow. Patrick Collins applauds, then the actors do, too. Bionca hugs Bruce. Glenn and Lissa start breaking down the set, cleaning up.

"You see the difference, don't you?" Bruce asks me, then turns his attention to Patrick before I have to respond.

Lacy Rose, another porn actress, arrives to pick up Rebecca. Bruce asks her about "the baby." Lacy hadn't told me she was pregnant, and once I'm given an affirmative nod, she dismisses further inquiries. Jon and Marc are gone within ten minutes, and Patrick, too, but the women stay close to Bruce—except for Barbara Doll and her husband. They disappeared before the scene was over, or right as it ended.

Careena doesn't even get up to shower, at first; then, when she is dressed in her street clothes again, she lies across the platform listening to Bruce speak. She finally leaves, reluctantly, after Rebecca and Lacy. Then it's just Bionca and Bruce.

They pose for pictures. Bionca gets naked, spreads, sucks her thumb at Bruce's feet.

She's hard-core, casually. He scowls, pets a black cat, squeezes its paw to show off the points of a claw, and pets Bionca's hair.

Bruce complains again about the French actress.

"She was just in the way, that's all."

Bruce coughs. He calls his emphysema "a fucking hassle."

Bionca tells her story. She was nineteen when she saw an ad for World Modeling. She went to Jim South's office. Bruce was there. He invited her to come over and watch some of his videos, to see if it was something she might want to try.

Bionca was working at Jack in the Box at the time. She thought about Bruce's offer for a couple of days, then said OK. Bruce put her in an orgy scene in a video called *Teacher's Pet*. Bionca and the then-forty-five-year-old director were married soon after. That was over ten years ago.

"Right when I turned twenty, I got stopped for DUI and I had coke on me, just a little. I spent four months in LA County Jail. It was rough. But Bruce showed me what loyalty is. Bruce would give me the shirt off his back and the skin off his body if he could. I love him with all my heart," she says.

Bruce and Bionca don't live together anymore, but they still work together most of the time and are still in contact every day, still close, like husband and wife, or father and daughter, or something in between.

"We never got officially divorced," she says.

Bruce helped Bionca start Exquisite Pleasures, her production company. Bruce says he'd like to see Bionca do as well as he has. Bruce says he makes around a hundred thousand dollars a month, the same as Patrick Collins. That's after they each give John Stagliano—Evil Angel—a cut for manufacturing and distributing their tapes.

I mention I met Gene Simmons from Kiss and that he said he wanted to publish this book.

"Gene is one shrewd man," Bruce says. "How many elementary school teachers from the Bronx do you know who've made ten million dollars?"

Bruce isn't surprised by how the day with Debi Diamond ended. Bionca smiles knowingly. She and Debi starred in a bunch of Bruce's videos together.

Bionca pulls a tape off the shelf.

"This one is really hot," she says.

She hands me *Buttslammers Part 4: Down and Dirty*. It features a scene with Debi and Bionca.

"Debi and I were best friends for years. I still love her," Bionca says. "I hope she finds someone who can take care of her. Sometimes I think she resents that I have Bruce."

Debi said she does.

"You have her number, right?" Bionca says. "If you give her some time—"

Bruce cuts in, impatient and annoyed by the Debi Diamond obsession.

"When it comes down to it Debi is no different from any other girl in this business," he scowls. "She has no sense of her own self-worth."

Bionca gives me a lift down the street in a red sports car, a race car, really. Bruce bought it for her. She waits until I start my engine then smiles, waves, and pulls away. Billy Idol never showed up.

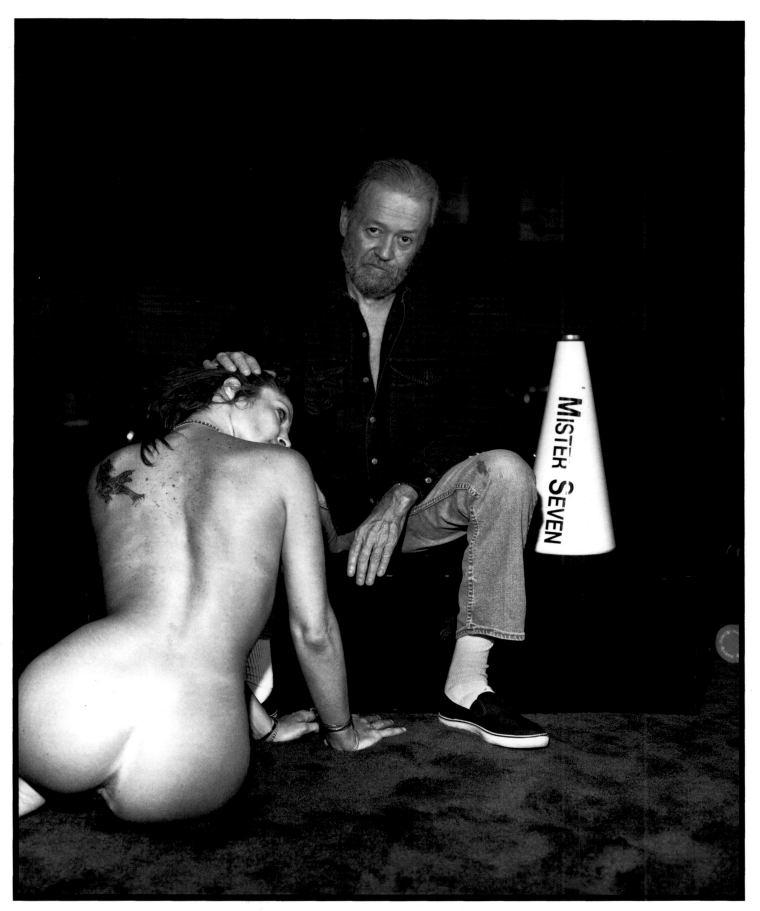

Bruce Seven and Bionca

I FOLLOW JON DOUGH TO MORE SETS, WATCH HIM HAVE SEX WITH MORE PORN AC-tresses. His effeminate whimpers and moans interest me, but there's no diplomatic way of asking him about it.

It's another hundred-degree day in the Valley. Jon is here to do a scene for Cass Pa-ley, a large, friendly director in shorts and a Hawaiian shirt. Paley says he shoots pro-motional clips for "clients like Warner Bros. Records" when he's not making porn videos, and says everyone working today is doing it as a favor, on spec, to help him get his production company going. A porn star named Trinity Loren's ex-husband is the cameraman, the ex-husband's new girlfriend the caterer.

Jon's scene is with Tina Tyler, a Canadian. Last night Jon said, "It won't be anything special, but she'd be good for you to photograph."

Jon means she'd be good to photograph because she's pretty.

The scene begins with three or four drops of candle wax—what the scene with Debi was supposed to be like; light, not foreboding—then Jon and Tina go into the "normal" sex. It isn't "anything special." But any journalist who writes that he or she was bored on the set of a porn movie is just posturing, attempting to distance him-self: Jon and Tina are *doing* it, casually, in front of a film crew, and that in itself—though I've seen it many, many times already—is still bizarre. Jon's assessment is true only in the sense that the kind of stuff being played out on this set is tame—de-tached and professional—compared with what transpired at Bruce Seven's house, al-most unrelated.

Jon and Tina achieve no momentum, and don't appear to be trying to. They accommodate one another. Tina asks for breaks to use the bathroom a couple times, say-ing she has her period. During one break Jon sits on the floor of the set, leaning against a sofa, relubing his dick with Astroglide, stroking it. He used the lube before the scene began, too. I ask him why, if he has to. He already has a hard-on.

"I don't think about it," he says, then thinks about it.

I suggest it may disconnect him from his partner to not have to rely on her wet-ness, which could be a barometer of whether she's into it or not. Once again, the au-thor, fully dressed, camera around his neck, imposes his own ideas about sex on a naked, six-foot-five-inch porn stud, while the actor lazily strokes his cock.

Jon smiles.

"It didn't occur to me. I do it automatically," he says, then, "It doesn't help *me* if I know she's not into it. But I guess I could try it sometime, without. That might be cool."

RON JEREMY OPENS THE DOOR IN A TOWEL. HIS FACE IS COVERED IN SHAVING CREAM. Even though he's just showered, and presumably washed, his humid, dilapidated apart-ment is dank. The place, and Ron's manicured but still hairy, fat body, make me feel icky all over.

There's a balcony with sliding glass doors, gray from months and months of grime, smog residue. Ron and his roommate use their balcony as storage space. The roommate shows up. He's a rude, nerdish fellow in his forties with thick glasses and red, irritated skin. He curses Ron out, then dials a number and curses out someone over the phone, then leaves again. The roommate sleeps in the living room. Ron gets the bedroom, which looks like one of those hidden rooms some of the porn actresses have—it's that

RON JEREMY

out-of-control messy. Ron says, "It's never like this"—like some of the girls have—that it's because he just got back from a swingers convention.

The greater part of the visit is spent waiting while Ron is on the phone ironing out details for his latest brainstorm, *John Wayne Bobbit Un-Cut*. He says the film is really going to happen, "next week," but that the set will have to be closed—"for obvious reasons"—and goes on to explain that it's a "gamble," that the man whose severed penis was recovered from the front lawn of a 7-Eleven may not even be able to "perform." As a consolation prize, Ron extends an invitation to the set of a "lesbian show" he's filming out at Vince Neil's house in Malibu.

Debi Diamond said Ron has a million dollars in cash stashed away. Looking at this guy, wrapped in his towel, on the floor, working out of a tattered date book, the idea seems so ludicrous that it could actually be true.

Ron does eventually pose and even gets out the devil's scepter he mentioned two years ago when he first agreed to sit for a portrait. He's a good sport. "Have you met Ron Jeremy?" is the first question most often asked by friends and acquaintances, *by far,* whenever the subject of this book comes up in conversation. There's a feeling of having documented a legend as I pack up the camera equipment. A bright yellow T-shirt confirms this. An iron-on patch has pictures in bubbles that make Ron look like a seventies TV cop.

RON JEREMY—AN AMERICAN HERO—A LIVING LEGEND.

"Some UCLA kids did this," Ron says, holding the shirt in front of his chest. "It's the only one I have, or I'd give it to you. Can ya believe I don't get anything for it? I hear it's selling."

THE TRIP IS WINDING DOWN. A FRIEND WHO LIVES OUT HERE FORCES ME TO TAKE ONE night off and get together. We hit some bars and end up at Jones. It's empty, but an attractive hostess still acts like we're lucky she let us in.

Jones fills up around us. There are a lot of hot girls. It's mostly hot girls. A tall, blonde Texan in a micromini plops down between us, doesn't mind the tight fit. She takes my twenty to the bar to get us a round, but ends up sitting in between two guys in business suits. She finally hands my friend two glasses of wine but doesn't rejoin us. It's OK: The amount of attention we receive over the course of a couple hours, from a number of different girls, is totally out of the ordinary, for us, anyway. Outrageous, really. We do feel lucky. Finally a nineteen-year-old who calls herself Wendy explains it this way:

"I'm two thousand a night or five hundred an hour with a two-hour minimum."

"Go easy," I tell her. "Have mercy on a poor boy."

Wendy laughs, then goes on to say that a lot of high-priced hookers "don't have representation anymore, since the whole Heidi Fleiss thing." Meanwhile a guy who could be a fresh-faced Beverly Hills High senior is trying to negotiate a date between my friend and his, a giggling girl in a party dress. Jones is crawling with prostitutes that look like high school girls. Wendy names guys who've hired her on a regular basis; a couple are old-guard Hollywood royalty and a couple more are lions in the new generation of powerful record execs under thirty. So I know she's not kidding.

In years of hanging out in New York—even at MK at the height of the crazy eighties, Nell's, any one of Keith or Brian McNally's establishments—there was never a sense

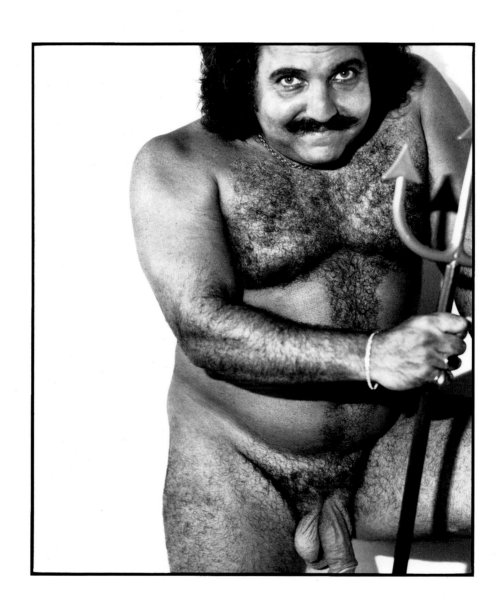

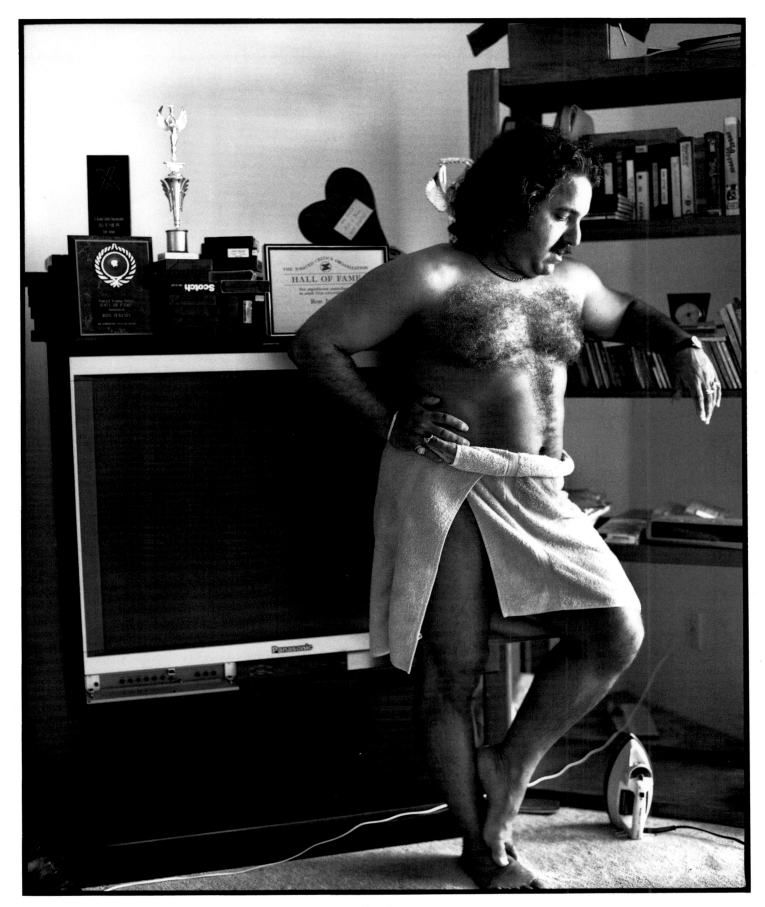

Ron Jeremy

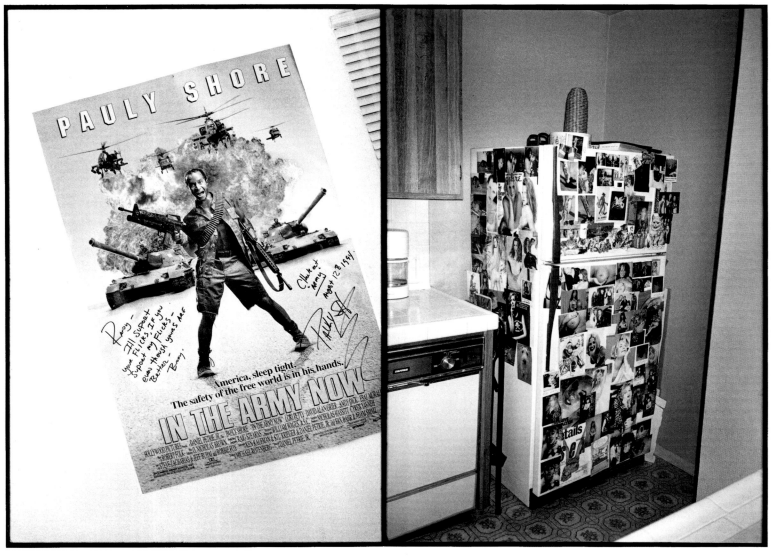

Actor Randy West's dining room wall; Sarah Jane Hamilton's refrigerator.

that prostitution was so *openly* woven into the social fabric of the city's night life, not the way it is here. Jones is a Hollywood hot spot.

The bar is crowded. When my friend returns from the bathroom, he has someone in tow. "Look who I found," he says. It's Pauly Shore. In the wake of Savannah's suicide, Shore and I have spoken on the telephone. The comedian was once her boyfriend.

Pauly squirms down into the banquet and shakes my hand.

"Do you have two thousand dollars in cash?" I ask him.

"Why?" he says, deadpan. "She doesn't take credit cards?"

NICK EAST LIVES LIKE A COLLEGE BUM IN A CONVERTED GARAGE BEHIND A HOUSE IN North Hollywood, right over the hill from the real Hollywood. There are psychedelic tapestries on the walls, acoustic and electric guitars lying around, a dusty computer on

a desk in the corner. A stack of typed pages sits on his unmade bed: the twenty-four-year-old porn star's first book.

"It's called *A Guide to Living in the Fourth Dimension,*" he says. "I've started two more: *The Rise and Fall of Satan*—that one's really gonna flip people out—and *Angel Training.*"

Nick demonstrates how the initials in his real name, when superimposed on each other a certain way, form a yin-yang symbol. Nick asks if I believe in guardian angels and claims he'll be president in eight years.

TRACH TECH VISUALS. MARIANNE WORKS ON DEBI'S FACE AND TEASES OUT HER HAIR into something wild, predictable. Debi talks nonstop. It's the same kind of stuff as before. She swoops from innocent and lovelorn to hardened criminal, no illusions, the "I'm so fuckin' horny I need to fuck a stranger" rap.

"What do you really do when you're horny?" I ask.

"I work cheap."

I ask Debi about a guy she's been seeing, if she doesn't ever just want to be close, to be treated gently, loved.

"Sure, but I'm gonna get hurt, y'know? It's a given."

I stand close to her, really close, while she puts in her contact lenses. Debi says, "hmm" softly. She looks at my eyes for a split second, then something clicks. She looks down, maybe at her hands, or at nothing.

"Love?" she says. "No way. People say they want love, but that's *bullshit.* What they really want is *power.* They want power so they can *control* you, *suck* you in, so they can *fuck* you over, so they can *split* and leave you *wasted.* I'm not ready for that. [*Breath.*] Did I tell you I'm getting *out* of this business?"

Debi brushes past me and changes into fluorescent-green spandex. Her transformation is kind of like the first time we met: cartoony sex armor. Debi looked prettier in her street clothes, but I guess that's not the point.

She swings the door open and dashes down the stairs. Debi is surrounded by the time she's reached the tall picket-fenced-in area outside the entrance of the building, in the parking lot, where half-dressed actors go to smoke, hidden from the studio's neighbors. No smoking inside.

Debi is cornered, relents, chain-smokes, and riffs out, in her way, for the Playboy Channel documentary crew. She keeps Cass Paley's frustrated AD at bay, answers questions, and gets videotaped sitting on a white plastic chair.

She's funny, charismatic. The other smokers, girls and guys, watch her with curious expressions to see what she might do or say next; it could be anything is the general consensus. Debi doesn't mention her fan club or touring—she's the rare star who's never tried it—and she doesn't give personal details about her home or car—nothing that would make her life seem "ordinary." She's not at all ordinary. Debi doesn't play the "sex star with an all American approach to everyday life I learned in the Girl Scouts" game.

The people from Playboy set out to make a program that'll prove porn stars are "just like us"—so says the director. The other *stars* don't even think Debi is just like them. If the Playboy guy edits out all of Debi's "fucks" and "shits" and evil stares and tiny pupils and naughty snarls, all they'll be left with is piercings, meditation, tattoos, mud baths, pets—pets. That's something. Maybe it will work.

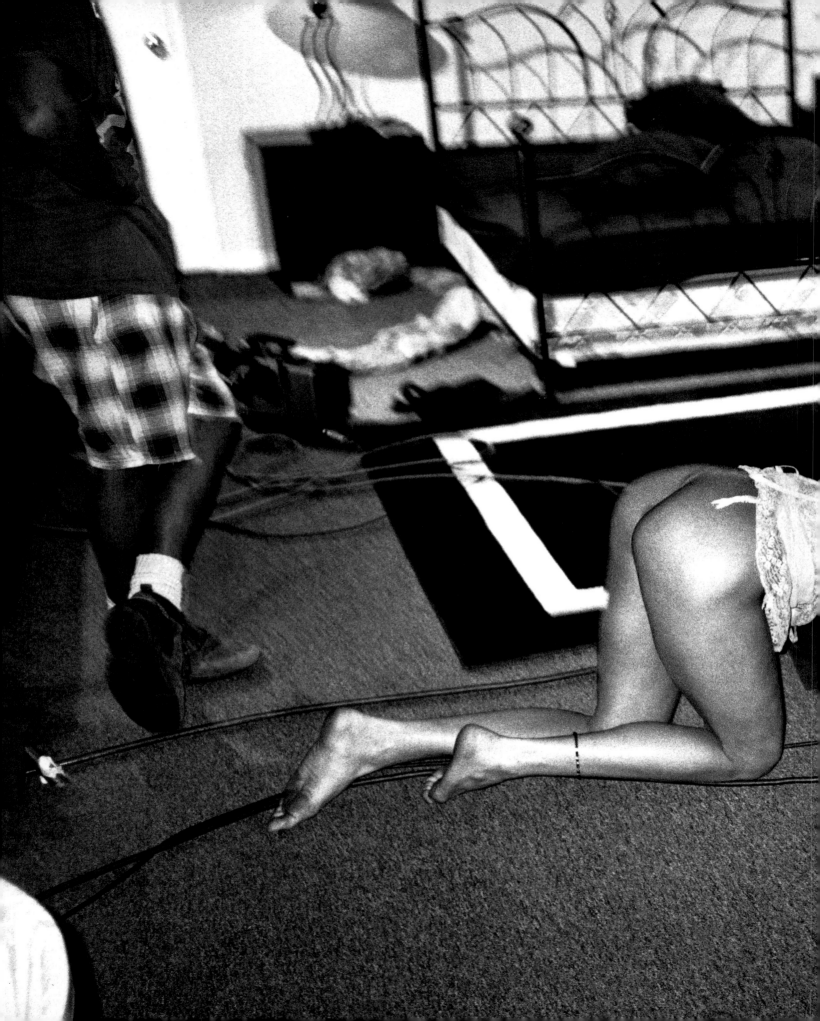

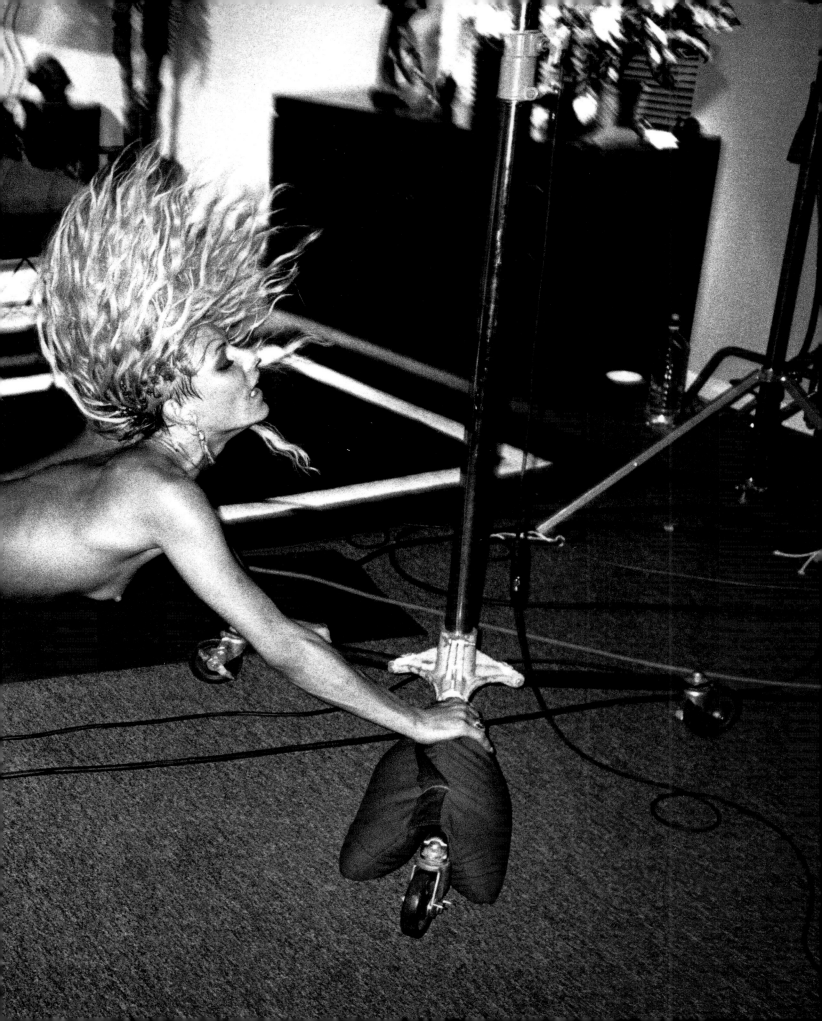

Debi stomps out her third cigarette, stands, heaves a deep, anticipatory gulp of air, holds it in with tight lips, and stares forward at some arbitrary point in her mind like she's bracing herself for something. She takes a beat, then steps back inside through the glass door with black, drawn blinds. She's a big talker, but Debi is about to get fucked by three guys.

She ignores the AD, walks right past him onto the set, surveys the cheesy appointments, gets to know the bedroom, and just kind of nods, distracted, to any tech or actor who greets her.

Al Goldstein, the notorious publisher of *Screw,* and his entourage—Mel Blanc Jr., the cartoon guy, Blanc's centerfold wife, and Veronica Hart, a retired porn star who looks like a country-music singer—are upstairs eating lunch, but the dwarf from *Twin Peaks* is here now, looking like a swarthy, three-foot-tall French seaman. He's with his obese, six-foot girlfriend. So there's still a bit of celebrity commotion on the set.

Kaitlyn Ashley recognizes him instantly, runs out of the building—home, presumably—and returns three or four minutes later with her point-and-shoot camera and *Twin Peaks* boxed set, and has the dwarf sign the videos. Jay Ashley, Kaitlyn's husband and one of the guys about to fuck Debi Diamond, shoots the snapshot.

Once that's taken care of, Kaitlyn approaches Debi gingerly, but not to be ignored. She stands straight, facing Debi, close; then their bodies press together. Kaitlyn caresses Debi with hushed, romantic tones. For a minute the two actresses are oblivious to everything around them. Kaitlyn pets Debi's hair, and the girls share a long kiss on the mouth. Whatever their history together may be, the moment isn't dirty or about sex.

Kaitlyn pulls herself away, still holding Debi's hands. When they no longer reach she lets go, continues to back off, and finally starts up the stairs that lead off the set.

"I love you Debi," she says, waving, smiling, still ignoring everyone else. Debi smiles too, but weakly. She doesn't say anything. Kaitlyn looks across the bedroom set as if it's an afterthought and says, "See ya at home, honey," to her husband, who seems preoccupied, like he has presex-scene jitters. Jay acts like a little kid who just wants his mom to *go,* doesn't want his friends to see her fussing over him. He grunts a response, then ignores his wife.

Cass Paley strides in, greets Debi gently, friendly, but unaware. Whatever just happened between Debi and Kaitlyn has evaporated, left no trace of itself. Cass sees his crew is ready, his cast is all here, and the dwarf and his girlfriend have found apple boxes to sit on out of the way. Cass gives the word to go.

The other two guys in the scene are Jake Williams, a veteran, and Billy Rocket, a PA from one of Jay Shanahan's shoots. Today is Rocket's second or third chance in front of the camera.

Jake is by far the most confident of the three. He knows what Debi responds to—rough treatment—and he gives it to her. His face twists up angrily as he rams four fingers in and out of her, setting the tone for the other guys.

The sex is dark and sad, like the first time I saw Debi perform. She acts out her own private tragedy. She only smiles—it's really a taunt—when she's impressed by the abuse the boys are able to muster up; like "not bad . . ." when one thrusts into her ass with particular vigor. The guys look like they're just doing their best to hang on, to not get hurled off the bed in a gust of Debi's adrenaline.

During a break—she doesn't need it, the guys do—Debi can't slow down. She

crawls around the set on all fours, thrashing her head from side to side, shouting, "Fuck, fuck, fuck." She walks out. Cass follows. Now it's his job to keep her cool until the scene is complete. He stands with her while she sucks a Marlboro in the doorway, her makeup smeared, green dress around her waist, bottomless, topless, barefoot.

The guys are recongregated around the bed when Debi returns. They're friendly, like before the scene began, naturally, like that's them. They even get Debi to laugh, but it passes. What's required of them by *this* actress is that they dig down deep into whatever source of rage they can find inside themselves, summon whatever hatred they can access, and give it up. Debi mugs for my camera, contorted, in the midst of horrifying aggression.

This scene confirms what I felt the first time we met. Debi's not the weird one. It's the ones who walk through their sex scenes like emotional zombies who are whacked out. Debi's trip rings true. Why shouldn't this experience be gut-wrenching?

The last guy comes on her chest. Cass Paley says, "Cut, thanks everyone," and Debi is left hanging off the edge of the bed, her head on the floor, spent. It's a dramatic pose, and she knows it. She could be hanging there a little longer because I'm here, seeing it, but that doesn't make the pose any less accurate at all, any less real. It just means Debi is aware, again narrating her own existence with amazingly expressive body language.

She's just performed "Dance of the Tragic Life of a Porn Star" and still somehow managed to give her director what he needs.

The guys sift through tangled sheets to find a pair of Jockey shorts, or a belt, or a sock, but none offers her his hand, like maybe now they really are pissed, all jacked up (even though they've each just come) and blame her for making them feel this way. Debi pulls herself up and storms off the set.

She bounds up the stairs toward the dressing room.

"Oh, fuck. That was bullshit. *Bullshit*. I'm so fucking horny . . . I need to go fuck a stranger or something. That gave me nothing . . . shit. *Nothing*."

Debi keeps talking while she changes.

"Those fucking guys *have* to come or they don't even get paid. It doesn't matter what *I* get out of it. Ugh. This is bullshit."

She scrubs her face, packs her bag. Debi says she has a mermaid costume in her trunk. I don't give her much of a response. I'm numbering film canisters. She tries again, sounding hopeful.

"Can I show you my mermaid costume? It's really fuckin' cool."

THERE ARE CHIPS and scratches on the roof of her silver Mercedes. Debi jiggles the key until the trunk pops open. There's a dry-cleaning bag, thin plastic. Debi pulls it off. She holds the hanger up, proud. I'm expecting something realistic, or literal, but it's not. The costume is made of iridescent hosiery material, transparent, in pale green hues, coral. It looks delicate, and Debi handles it like it is. She savors the chance to handle something delicately.

It's an awkward moment. I'm not good at giving her what she wants here, not sure what it is. I'm more interested in the scratches on her roof. Maybe I'm angry about the scene I just watched, angry at Debi for putting herself through it, and maybe a little shell-shocked myself, simply from having witnessed it at all. *She* seems to have left it behind.

Debi examines the material of her mermaid costume lovingly, with childlike fascination. I can't resist any longer. I break the moment by asking about the roof of her Mercedes.

"Oh, that?" she says. "I know it's fuckin' crazy, so please don't even say anything, OK?"

Debi pauses, makes a "whaddya gonna do" kind of face, like she's about to tell a story about some wild teenager she knows, then she continues, softer, sounding wistful but focused.

"Sometimes if it's real late and I'm all amped up, and there's nobody on the road that I can see, I climb out the sun roof and, y'know, just fuckin' stand there with my arms out in the wind. For like thirty seconds I really move, y'know? . . . really fuckin' move . . . until the car slows down."

I can almost feel what she feels as she describes it. I know she's out of her *fuckin'* mind. But I can picture Debi Diamond as the Silver Mercedes Surfer, in the middle of the night, or maybe as the sun is rising over the Santa Monica Freeway, and I imagine the freedom she might experience for those few seconds, even if it is a hard story to believe.

Then, in a quicker, detached voice comes Debi's coda: "When I do it in heels it fucks up the finish, y'know? Chips the paint. Other than that, I take pretty good care of this car."

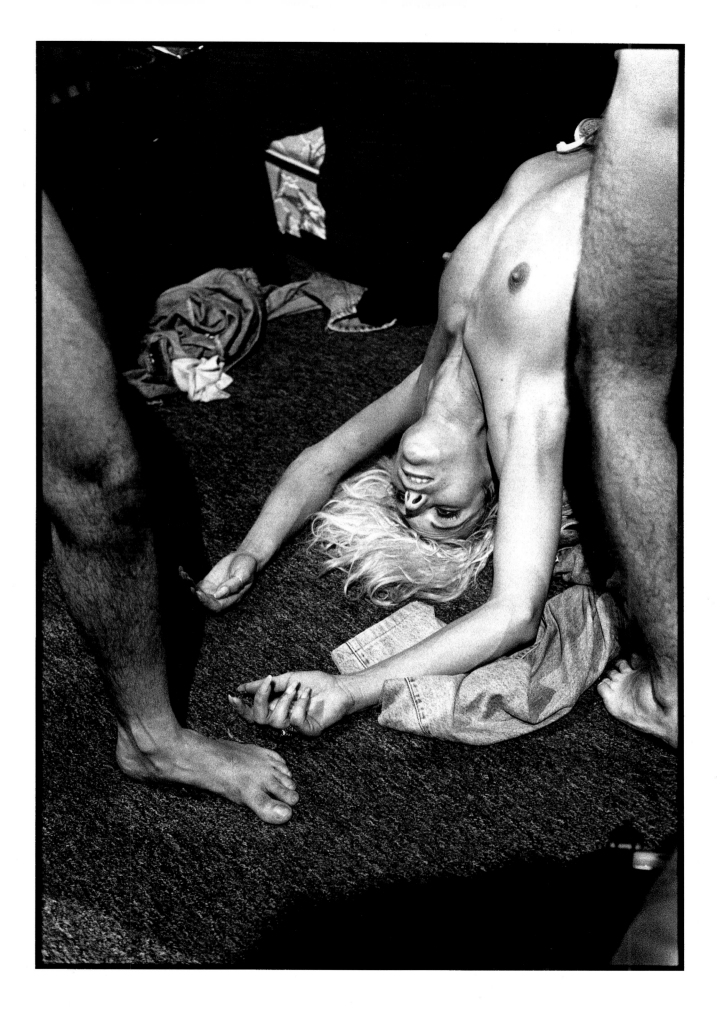

LAS VEGAS. THERE ARE LINES EVERYWHERE. LONG LINES TO CHECK IN, LONG LINES TO check out. Long lines for taxis. The line to get into the Sahara Hotel and Casino's ballroom, into the porn domain, is the longest one so far, a hundred fifty yards at least. It cuts across the dark and smoky, dingy casino, past coffee shops, cocktail lounges, and gift shops, each with *its* own line crisscrossing the big one.

Who are all these people? Their CES '96 badges say they work for companies like "Alpha"-this and "Beta"-that. "Tek," "Tech-," "Techno," "-systems," "-tech," "Technologies": all popular. Then there are endless variations on the three-letter initial theme—CFX, ATI—all blurring together. The men wear leisure-type stuff, pale-yellow nylon golf shirts, light-blue terry cloth, Dockers, Rockports. The women—their peers—are in business suits: skirts, pumps, like for them it's required, like the way they laugh along with the guys at all the "male" humor. These are people from all over the world. Most of them are carrying identical blue-and-white cardboard IBM briefcases—that company's ingenious giveaway. Even the sprinkling of longhairs in jeans and black T-shirts with biker wallets chained to their belt loops are carrying the omnipresent promotion.

It's only the middle of the first day of the Consumer Electronics Show, but thou-

The Bruce Seven effigy.

SEVEN 7 Online
(818) 787-7717

TRACI ALLEN

LIMIT 6

Payne-Full Revenge

BIONCA

STARRING WITH MISTY RAIN, FEL...
Sean Michaels, Tiffany Million, Danyel Ch...
TOM BYRON & AN ALL STAR CAST
IN

BRUCE SEVEN
PRODUCTIONS

HEADMOST

ORDER NO.9305
LOS ANGELES
C/NO.356
MADE IN TAIWAN

evian

sands of people, all presumably with legitimate business reasons for being in Las Vegas, are already making time, pulling themselves away from the main convention center—shuttle buses are running nonstop—to take in the convention's sideshow attraction. The anticipation—the collective sense that soon they'll all get their jollies—is palpable.

There are aspiring porn girls in the line, too, no-names, some with budget tit jobs, in slutty getups and heavy makeup. They have hardened, impatient expressions, like they don't enjoy the goofy attention from computer geeks, especially the ones speaking in foreign languages they can't understand. The girls stand next to their boyfriend/manager/pimps looking tense and offended—like, "*why* are you *looking* at me?"—shiny hot pants tugged into the cracks of their asses. *Their* business *is* in the ballroom. It's where they might conceivably make the jump from small-town stripper to "star." They aren't carrying IBM briefcases.

The huge ballroom is steamy, way, way overcrowded, windowless, fluorescent. The air has a taste, like it's being sucked out—maybe once an hour—chilled, then blown back in again without the benefit of any filtration. No one made an announcement, but pushing is allowed. It's the only way to get through the web of intersecting lines—more lines, all lines—of men and women (mostly men, by far) waiting for porn stars to sign their posters, to sit on their laps and pose for snapshots. They wait for brochures describing new video releases with tiny, explicit pictures of porn stars in action: free porn to pack into their IBM briefcases. Mostly, they wait to see what they're waiting for—sometimes there's no way of telling, it's so mobbed. They're just like the placid-faced tourists standing in the rain outside Planet Hollywood in New York: They wait because that's what they're supposed to do, because that's what their friends and relatives did before them. America's new national pastime—phenomenon—is waiting in long lines.

Anyway, there's exposed flesh in every direction. No matter which way they turn their heads, being in line is an excuse to stand and gawk, take a couple steps forward, then gawk some more. But this is one place where no excuse for gawking is needed. If there isn't a long line of gawking, sweaty guys jutting out from each exhibitor's booth, then someone hasn't done their job. Gawking is the point.

I move across the room, toward EXQUISITE PLEASURES glowing in neon letters—the company Bruce Seven helped Bionca start—passing the booths of rubber-goods manufacturers—falsies, dildos—specialty-video distributors—*Fatties, Young & Natural*—and dozens of others: lubricants, bondage attire, "virtual porn." There's more neon the closer I get: BUTTSLAMMERS in bright red, BIONCA in green, TAKIN' IT TO THE LIMIT 6.

What from the distance looked like a clearing in front of the booth turns out to be a handful of conventioneers down on their knees jockeying for position, all with lascivious grins, cameras and camcorders at their eyes, stealing shots of Careena Collins's naked crotch. The porn actress/sometime law student is signing a poster, one leg up on a stool, miniskirt hiked, fully aware of the commotion she's causing, acting oblivious.

Careena looks hungover. She only sort of recognizes me. Bionca smiles, kisses my cheek, then gets serious and asks if I heard about Bruce's stroke. There's a two-foot-long Bruce Seven doll sitting on a shelf behind her. The mouth is partially open, yellow teeth exposed. The mean expression is accurate, eerie. A fan on the other side of the counter gets Bionca's attention. Before tending to her business Bionca says, "Hon, I'll see ya

PORNSTAR

150

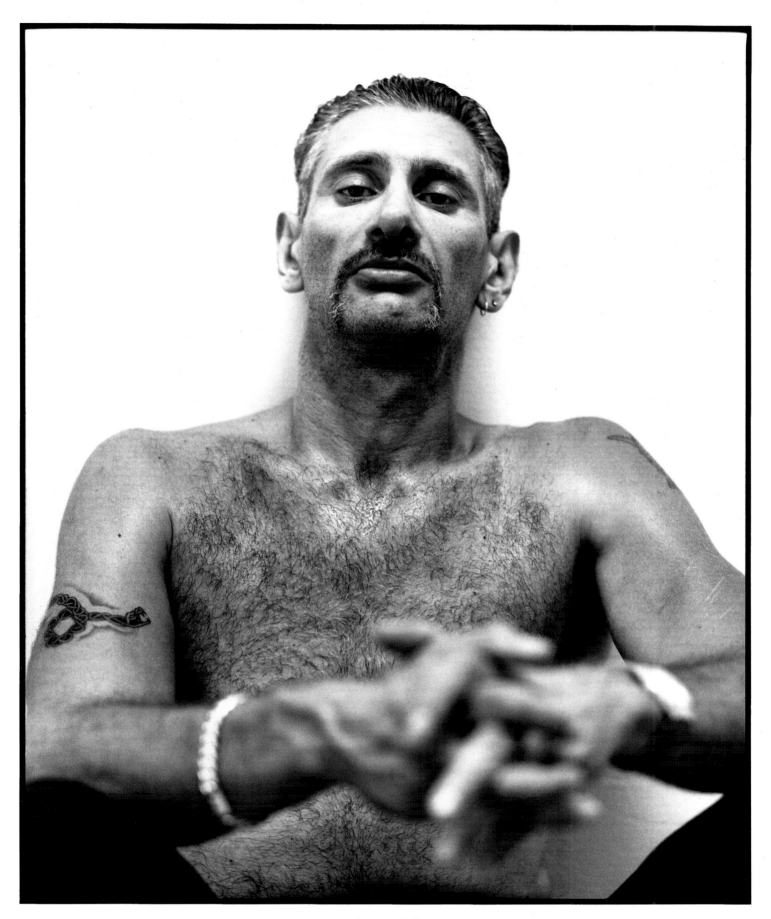

Gregory Dark

later, OK? Come back tomorrow morning. Bruce'll be here." She signs an autograph as I continue toward the back of the two-football-fields-sized ballroom, in search of the Evil Angel booth. That's where Jon Dough and I agreed to meet.

12 NEW HUMAN FUCK DOLLS
7 EXPLODING SEX SCENES!
INCLUDING 7-WAY ANAL GANG-BANG
2 DPS ★ 6 ASS POUNDINGS ★ 5-WAY LESBIAN FUCK-OFF AND LOADS MORE
36 GLISTENING HOLES STRETCHED TO THE LIMIT!!
"THE MOST PERVERSE ACTS I'VE EVER DIRECTED IN MY LIFE!"
PROCLAIMS GREGORY DARK, KING OF MONDO PORN

Evil Angel, in the middle of the back aisle facing the wall, is tons of neon, cheesy basement-game-room wood paneling, and two elevated witness stand–like signing stations. There are posters for upcoming releases—*Fresh Cunts, Gregory Dark's Sex Freaks,* many more. The booth itself is relatively low tech and smallish, but it has the most boisterous mob so far, fifteen deep, no lines, just a crush. And there aren't even any girls signing right now.

These are fans here to see their heroes: the *guys,* the ones who narrate the tapes they love, the directors whose hands reach into the frame from behind their three-chip digital video cameras to pinch a girl's ass in the middle of a sex scene, the ones who *really live* the pubescently vigorous masturbatory-fantasy as day-to-day reality, whose existences revolve, maybe to the exclusion of anything else, around the gratification of their hard-core urges. The Evil Angel stable is all name-brand directors, each of whose titles are synonymous with his own particular arsenal of sexual proclivities, his own persona, each a star in his own right whose work carries the implicit message, "You too, can do this, *if* you dare."

These are guys who weren't to be reined in by society's accepted standards regarding social mores and family values. "Porn chicks are the hottest fucks in the world," the intelligent, forty-fivish Gregory Dark once said as justification for the trade-off. These are men who don't seem to possess the gene for embarrassment, who kind of jumped at some point and never looked back when most guys just wouldn't have taken the risk. These are not the typical failed mainstream auteurs anonymously "moonlighting" as porn directors. These are guys who failed miserably, knew it, moved on, found a way to "say something" and in the process get laid and earn millions of dollars.

Standing against the back wall, near Private Video's booth, I watch the Evil Angel scene with as much perspective as space will allow. It's a total traffic jam, impossible not to be in someone's way, in the way of someone's snapshot. Patrick Collins, John Leslie, Gregory Dark, John Stagliano—the stable, minus Bruce Seven and a couple of others yet to arrive—all in various states of semiformal attire, stand behind a large table covered with glossy handouts. Dirty stuff. They engage whoever shouts their names the loudest, whichever fan can get their attention, shake hands, step in front to pose for pictures—flashes pop continuously, from every angle—and sometimes give an autograph. A lot of actors and actresses are *visitors* here, receive big hugs. The whole thing is a hugfest. The directors hug the girls, each other, old friends, critics, interviewers,

new girls looking for a break, even fans who themselves have somehow become part of "the family" simply by showing up year after year, loyalists. It's a carnival.

It's different. There are more mall-rockers with bandannas and painted, bleached-denim vests, and frat boys, too, in Vuarnets, all traveling in packs and looking like they've found exactly what they came here to find: this booth. They spot a director they recognize, hold up a clenched fist, whistle or shout things like "man, you're the fuckin' best!" and "you rock!"

Stagliano's three assistants are here to identify the video-store owners who order big and make sure these guys get through to the front, get special introductions, to make sure that at least some actual business gets done. That sometimes means dragging Stagliano out from his hiding place in a closet at the end of the booth. Patrick Collins, as always the ringleader or master of ceremonies, sucks it all in, wafts in the recognition. But Stagliano, the founder, seems like he'll just make it, survive this at best—all the eyes on him, all the attention—as long as it's in small doses, with regular intervals out of the spotlight. The surging crowd around his booth is intense.

After ten or fifteen minutes my sense of who these directors are begins to crystallize. It's like they're trapped in a state of arrested development, like their priorities were frozen at seventeen and the tide of their teenage libidos just carried them away. They made a life out of that, glorified it. It's juvenile, but still annoying, since I understand the sexual urges well. I can relate.

The next time my eyes scan to the end of the Evil Angel booth, I find a pair of wraparound shades staring back at me from a head or so above the crowd. It's Jon Dough, grinning. I make my way through the crush. His smile broadens as I near. He pulls his sunglasses off.

"Man, Ian. I'm happy to see you," he says. Then, "Are you bored yet?" in a tone that assumes I must be, that says he is. He looks much trendier than he did summer '94: He has a Caesar cut, a goatee, an expensive-looking casual T-shirt, and earrings in both ears.

"Man, I was watching you. You looked serious," he says.

Jon points at the poster for *Fresh Cunts*.

"That's mine, my first for Stagliano."

So it is. One of Jon's first directorial accomplishments was to convince three female skateboarders, all burgeoning LA tournament celebrities and all still teenagers, to perform hard-core sex on camera.

Jon sees me eyeing his mod black boots.

"Do you like these?" he asks. "They're cool, right?"

Jon says he met a girl in Spain, started buying her a lot of presents, clothes, and he liked it, liked shopping. Since then he's been spending "much cash" on his own wardrobe, too.

"It feels really good for some reason," he says. "Healthy."

The conversation is choppy. Fans and other porn people keep interrupting.

"Are you feeling any better?" Gregory Dark asks Jon.

"Not much," Jon says, "but throwing up definitely helped." Then, to me: "Greg made me do it, said it was the only way. I ate some tainted chicken in that Sahara coffee shop and I really had a bad reaction, like I could die."

Dark keeps looking across the aisle toward Private Video's booth.

"I'm supposed to meet a guy about a deal," he says, distracted. "European distribution."

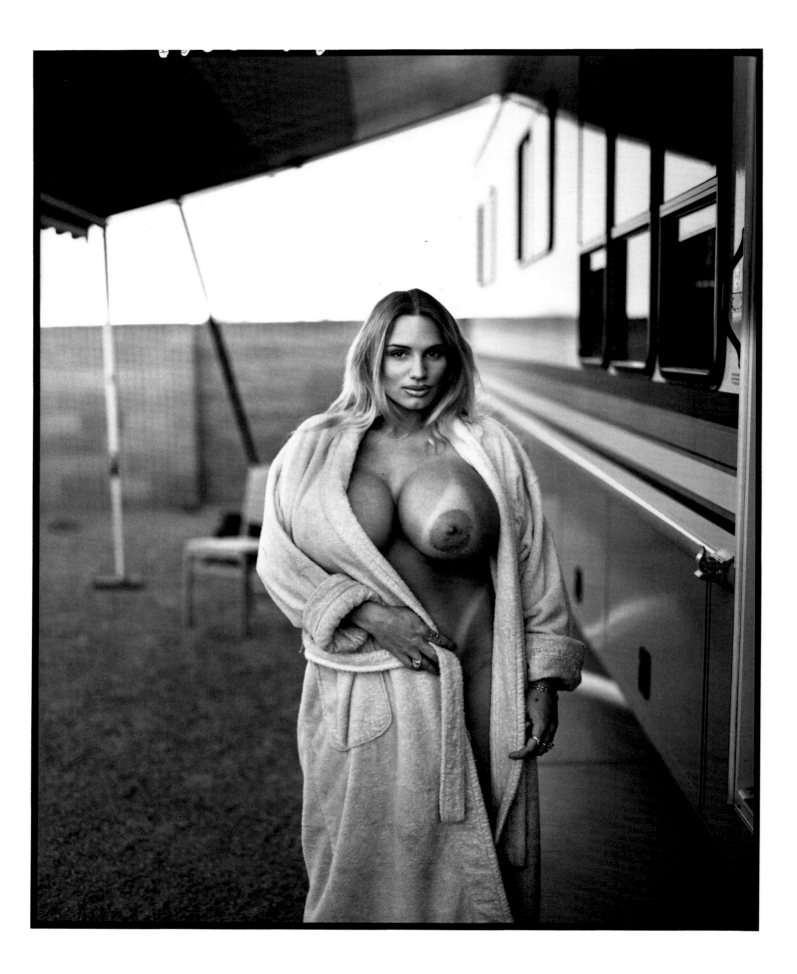

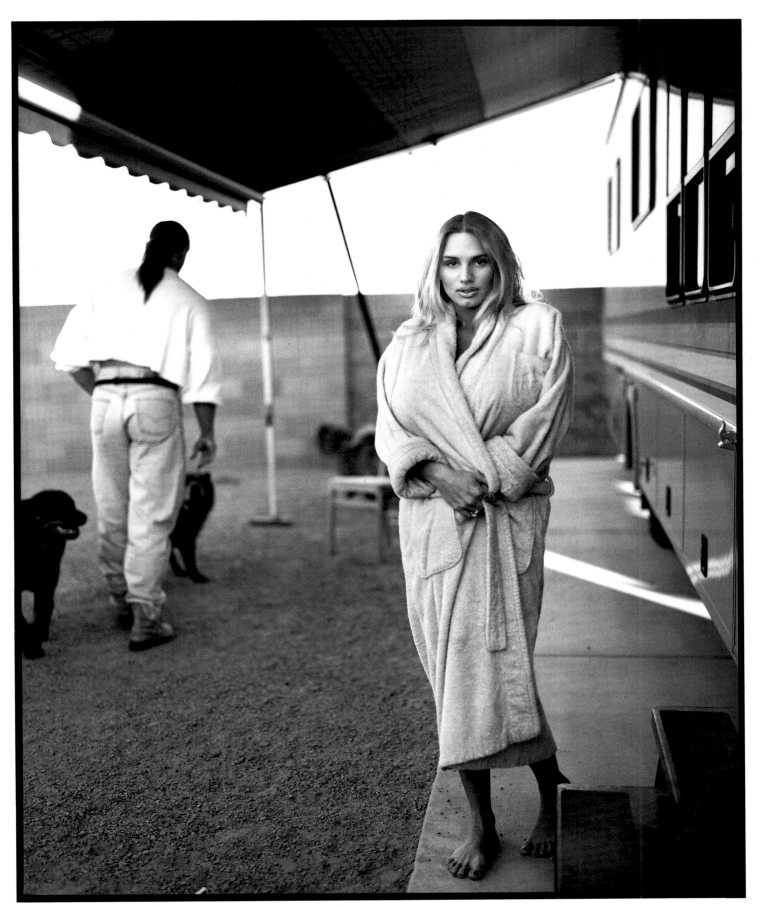

Lisa Lipps and family at home, Boomtown RV Resort, Las Vegas, Nevada.

Dark is about to wander over there when someone from *Hustler's Erotic Film Guide* pulls him in the other direction, tossing off "Hey, congratulations, Jon" as they go.

"What's that guy congratulating you for?" I ask.

"Oh, it's nothing. I, uh, well, I might sign a deal—I'm supposed to sign a contract with Hirsch, you know, with Vivid. I just can't figure out how everyone I fuckin' bump into knows already. God. Nothing's even been signed."

Jon is the first actor to be offered an exclusive deal like the ones Steven Hirsch gets his Vivid Girls to sign.

"Well, Stephen St. Croix is doing one, too. But yeah, it's like the new thing, Hirsch's latest way of waging war with VCA. You know, get the guys, too, into exclusive deals. I mean I'll be able to direct my shit, do that, and even still fly up to Frisco to do loops for Damiano, which I enjoy. I just won't be able to do scenes for other big companies, which basically means VCA. What d'ya think, should I do it, Ian?"

Jon says he can make more freelancing, but that would mean working all the time. If this deal happens, he'll make somewhere around a hundred thousand a year for doing a couple scenes a month.

"That means I'll have a lot more time to get my directing thing going."

I congratulate him. "Thanks, man," he says.

Jon is a total insider, a ten-year veteran, but he stands next to me, watching from the outside, too, in a way.

"Look at Rocco," he says. "That guy is just tremendous. What charisma."

Jon explains how Rocco Siffredi performs in scenes in America in exchange for 100 percent of those films' distribution rights in Italy.

"That's brilliant," Jon says.

Rocco hugs his way over, dominating through sheer force of size—and charisma. He's even taller than Jon, at least six-foot-six, and broader shouldered. "Eh, Jon, man," he says in a thick accent, embracing Jon. "Wow, do you believe? Is fantastic!" meaning the scene around the booth. "I 'ave to take my wife back to the 'otel, you know, 'cuse me."

Jon makes a quick introduction, and Rocco shakes my hand with an apologetic expression, already moving away. "Sorry, my wife, you know, she's pregnant, so I 'ave to do the business, and go—really nice to meet you."

"Tremendous," Jon says, "That guy's too much. What a star."

JON'S ROOM, two nights later. It's 1 A.M. He puts Frank Sinatra on, then changes from his tux into jeans, Nikes, and one of his expensive T-shirts. He leaves the Best Actor, Video trophy he won at the Adult Video News Awards ceremony two hours ago in the closet.

"Sinatra, out of respect for tradition, y'know?" he says.

It is nice hearing Sinatra sing "Strangers in the Night" in a room with a view of the strip. Somehow, here, we're far enough away—at least for a minute—that the polyester tourists blowing their lives' savings on slot machines aren't the defining image—or weren't until they just popped back into my head. Jon sits on the sofa. I sit on one of the double beds with a leg up, facing him.

"There's a girl at Sharks who wants to fuck me tonight," Jon says. "Is that a good enough reason to go all the way back there? She's hot."

"You were out of sight for, like, maybe four minutes," I say.

"Oh, Ian. You don't even know. That's what it's like," he says. "Sometimes I have to turn it off. I just let the service or my machine pick up the phone. It's too easy. It got meaningless a long time ago."

"You're pathetic," I say.

I regret it in the same instant the words come out.

Jon laughs.

"Yeah," he says.

Neither of us speaks for a minute or two.

I say, "I'm sorry."

"Yeah, don't be an asshole. Every guy I meet is jealous of me. And they *all* think I'm pathetic. Anyway, it doesn't matter. I could die tomorrow. I'm not gonna build a life around some idea that everything lasts forever.

"That's why I'm not gonna have kids, a family, why I don't want that. Tomorrow I could hit a wall on my Harley. My parachute could fuck up when I jump out of a plane."

Jon talks about his brother. He was gay. He had a sugar daddy. The "old fag" gave Jon's brother lots of money, and his brother would spend it on drugs and on wild, three-day-long parties. Jon's brother posed for gay magazines. That's how Jon first got into porn. He changes the subject though, abruptly, before really going into detail about how he started.

"How'd you get your name?" I ask.

Jon is sitting on the floor.

"I did maybe eight or ten scenes and, uh, I get a call from Jim South's office saying, y'know, they need to bill me as someone. They told me to think of something.

"I was sitting in my apartment listening to *Los Angeles.* Real loud. Y'know, X. Great, great record. So I thought, 'I'll name myself after the singer, John Doe.' I just changed the spelling to 'D-o-u-g-h.' Everyone thought I was crazy. I think they wanted me to call myself something like Dick Hammer, y'know?"

Jon dials Penelope's room. She's a nineteen-year-old French porn actress he's been sleeping with since the first night of the convention. There's no answer.

"Hey, Matt Dillon gave me his number a couple of weeks ago. You think I should call him?"

"Why'd he give you his number?" I say.

"I don't know. I guess he thinks I could, y'know, act. That he could help me."

"Dude, call him," I say.

"I'm bad about that kinda shit. He probably already thinks I'm rude. Y'know, you don't say you're gonna call someone then not call them," Jon says. "Oh well. Maybe I'll call him, if you think I should. Let's go upstairs."

A BRUCE SEVEN GIRL named Felicia is throwing a party in one of the hotel's enormous, perfectly tacky, totally sixties Hugh Hefner–style penthouse suites. There are twenty-foot-tall windows, a winding stairway that leads to a balcony overlooking a sunken living room, and a white grand piano in the corner. Jon and Penelope are standing with Mark Davis, an Australian actor. He's still in his tux. He was a winner tonight too, got two trophies. "It's about time, right, mate?" he says. He and Jon shake and half-

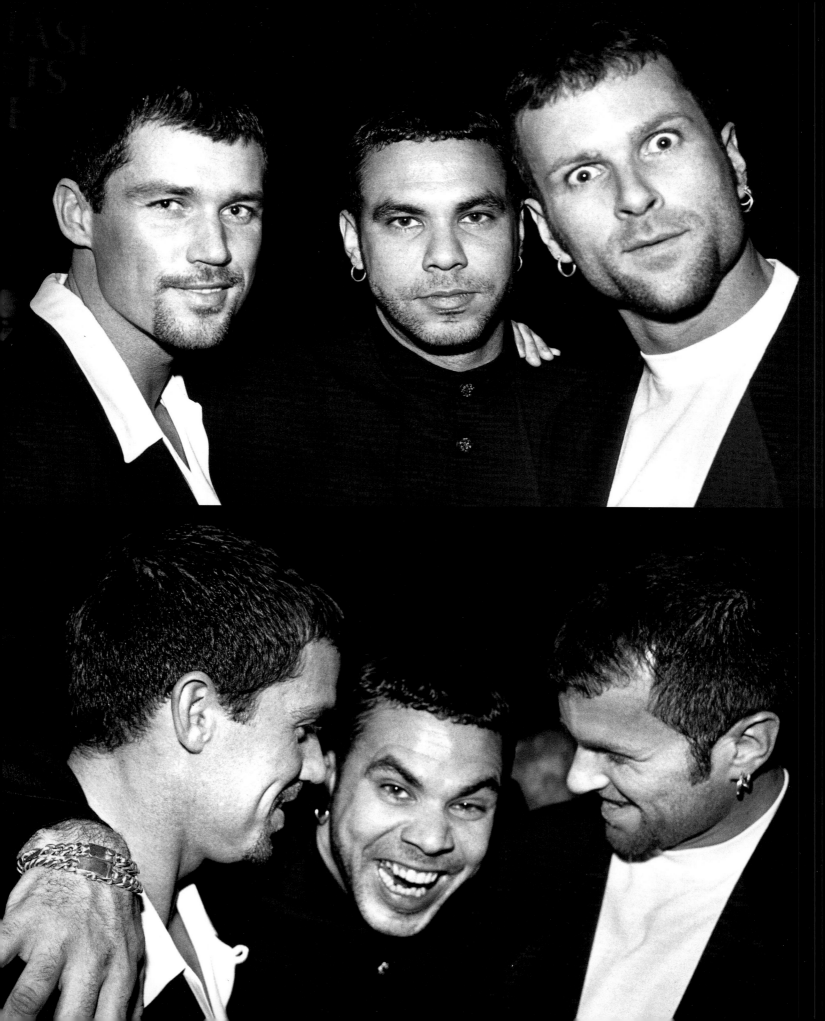

hug. Jon pats his back. Davis is handsome in a classic, hunky way. And he has that glint in his eye, the "you know that I know that you know that I've fucked every girl in this room up her ass at least twice and been paid for it" male-porn-star glow.

Penelope was having sex with Mark on an Anabolic set in Paris when Jon first saw her, and joined in. Penelope is beaming, just loving getting pressed in between the two actors. She has an arm around each of their waists. Before he leaves, to "circulate," Davis hands me his business card:

MARK DAVIS XXX ACTOR, MODEL
XXXXXXXXXXXXXXXXXXXXXX
XXX XXX XXX XXX XXX

It looks like it was done on a manual typewriter. An 800 number and Santa Monica post-office box address run along the bottom.

THERE'S A FULL-PAGE AD in *Adult Video News'* "Super CES Issue" for two compilation tapes: *Debi You're a Fucking Slut, Parts One & Two*. Someone I ask says he heard she retired. Another person says *she* heard Debi got married.

THE NASTIEST SIDE OF DEBI DIAMOND!
THE QUEEN OF THE GUTTERSLUTS
SHE FUCKS, SHE SUCKS AND SWALLOWS WITH THE BEST OF THEM.
DEBI, YOU ARE A FUCKING SLUT!

The last time I spoke to her, before discovering that her pager and voice mail were disconnected, I read Debi my description of the first scene I watched her perform—I guess to be up front with her about the way I saw things, my take on it. She listened closely. It was the scene with the wax, the broken string of fake pearls dangling from her neck, the guys and their erection problems, Debi's demanding Marc to bang her head against the wall.

Debi was silent for a long few seconds after I stopped.

"Those were my grandmother's pearls," she finally said, "and they weren't fake."

Winners Mark Davis, Stephen St. Croix, and Jon Dough.

TWO WEEKS LATER

I CALL BILL MARGOLD, A BURLY TEDDY BEAR OF A MAN WHO HAS TRIED HIS HAND AT every job in the business at one point or another in the course of his twenty-plus years in porn. He doesn't miss a beat, kicking into gear the second he answers his telephone. The sound bites start flying.

"I wrote the line 'He Brought Them to Their Knees, But Not to Pray,'" he crows. "That's one of the greats."

Margold is at home in the Valley on a Sunday afternoon, watching football. He mentions his toll-free porn-star support line, and that's when I bring up April Rayne, ask him why no one talks about her death. Margold gets annoyed. "Because it never happened," he says, and demands that I show him some proof if it did. He goes so far as to say that since he never heard about it, it *couldn't* have happened. So I call Tom By-ron, the guy who told me in the first place, right after Savannah killed herself.

"Yeah," Tom says, like it's no biggie. "That wasn't true after all. Andrea's alive."

I ask for her number.

"Man, I had it," Tom says, "but I lost it. I think I threw it out by accident. When she gave it to me I was in a hotel. I think she lives in Sacramento."

Sacramento directory assistance has two numbers with Andrea's last name. The first one's been disconnected, the second one has changed. I dial the new number. A machine answers. It's an unfamiliar voice, but at the end of the outgoing message, the woman says, ". . . and if you want to reach Andrea dial ————."

It's four years since our last conversation—and *she* spent two of them dead. But Andrea, the former April Rayne, answers her telephone.

"Hey! Wow, it's so great to hear from you. That's so cool you found me. I was just thinking about you. I moved and I was hanging the pictures you took of me."

Andrea says she's in business school and that she's already doing some part-time accounting work. She also reluctantly admits, "Sometimes I'll do a bachelor party for extra cash," in a tone that says, "but we won't discuss that now."

"Hey, wasn't that rumor fucking strange?" she says. "Once I was in LA for a week and I ran into a girl I knew from when I was in the business. It was in a hair salon. She almost had a heart attack."

Andrea is upbeat, like even this conversation brings her back to a part of her life she's left behind, a part filled with charged memories and not all bad ones. Wherever she is, it's noisy, like a train station or bar. Then Andrea's voice starts to drop out.

"Sorry about the bad connection," she says. "I'm on my cell phone, and anyway, this place is really loud."

I ask where she is.

"Discovery Zone," Andrea says. "You know, it's a big indoor playground. My son loves it here. I'm a mom now. Listen, I'll call you in a couple of days and tell you everything, OK? Things are a little crazy here."

TWO DAYS LATER. Andrea says she had an affair. The guy would beat her, "severely," and eventually she said, "no fucking more." After they split up he moved back to his native Italy. Right about that time Andrea realized she was pregnant. She never told him, never tried to contact him. Instead, she went home to Sacramento, moved back in with her mom, gave birth to her son, and became a mom herself.

Andrea is into it. She doesn't ever allude to the universal headaches, nothing, not one complaint about the whole radical-life-change thing that occurs when you have a child, what some parents use as a way of qualifying their joy, like, "Well, my life is all about the baby now, but I love it."

Nothing of the kind from Andrea. It's troubling.

Because as excited as she is about being a mom, it's nothing compared with how she sounds when she reminisces about the "old days."

"It was so fucking wild," she gushes.

Andrea says she shot up fifty thousand dollars' worth of heroin—basically everything she'd saved while doing porn. At one point her habit was $1,500 a day. She says she quickly resorted to streetwalking.

"But I was fucking *shocked* to find Jeanna Fine on Sepulveda. We both ended up in the same junkie-hooker hotel. I can't remember what it's called, but I bet I still have a book of matches. I save everything. Anyway, we were all there for the same reason."

Andrea pauses, lingering on the memory like it's a picture in a photo album. "That was so weird. I mean I knew she was using—that was our thing. But you know, she was a big star. I guess that's what girls do, ones who can.

"So in the middle of all this is *Hold Me Thrill Me Kiss Me,* which was so wild. Did you know I went to Cannes? I was a junkie with nowhere to live, but I would get these messages, y'know, like sometimes from my mom, if someone could find her: 'Tell Andrea *Interview* magazine wants to shoot her.' A lot of stuff like that. It was really great."

Andrea is psyched to hear that someone saw Robert Risko's illustration of her in *The New Yorker, and* the story about her in *Interview.*

"You saw the drawing?" she says. "I heard about that but I never saw it. That's so cool."

Jeanna Fine later confirms that, yes, she was a junkie and, yes, she did end up in the same hotel as Andrea. But she denies *ever* streetwalking; then, unable to resist, Jeanna boldly states for the record: "No matter how bad things got, I was still a star. Jeanna Fine always commanded top dollar just to walk through the door."

Fine, emerging from her latest retirement clean, sober, and looking glamorous, won two trophies in Las Vegas. She's married—in what she calls a healthy relationship—and she's a mother now. Fine says her life is *normal,* that she's done a "complete 360."

TWO WEEKS LATER Andrea calls again.

"Guess what! I called up Tommy Byron and he said he wants me to star in a video he's directing . . . isn't that wild?! It's gonna be my comeback."

She says it like she's expecting me to congratulate her. It does sound wild, out of control. Andrea is so into doing this.

"My boyfriend is cool about it," she says. "He definitely wants to watch, and maybe even do a scene with me. He's not jealous at all. He *wants* to watch me get fucked."

I ask if she's always stayed in touch with Byron.

"Not always, but Tommy is definitely my number-one favorite 'Anal Intruder' of all time." Andrea makes a noise that incorporates a shiver, or a shudder, like just the thought of getting butt-banged on a set in the Valley makes her hotter than she's felt in a long time. Then she laughs.

I tell her I want to interview her after she does it, maybe right after.

"Totally," she says. "I'll know the details in a couple of weeks."

Then I say she should really give it some thought before she goes through with it, especially now that there's a kid involved.

"Don't worry, I will. It's gonna be fucking great."

JON DOUGH.

"Hey, man! How *are* you?" he says.

Encomium, the Led Zeppelin tribute album, blasts away in the background. He turns it off. I ask him about his stereo.

"It's a big one, Ian."

Jon says he finally signed his contract with Vivid Video.

I called to find out about his family, about his childhood, his mom. It's 9:30 his time, in LA. Saturday morning. Jon sighs and doesn't say anything for a few seconds.

Finally it's, "Oh, man. My mother?" then another long pause.

"She's still searching for happiness, never found it, just like all of us. She's a dreamer."

There's rustling, like maybe Jon lifts himself out of bed and resigns himself to dredging it all up.

JON DOUGH

"My father, he was gone with a new wife, kids, house by the time I was seven or eight. My mom and my grandma would talk bad about him, but I remember thinking, 'Wow, a real house, a real family, that would be nice.' I wanted what I saw over there.

"So anyway, my mom has this black guy named Bobcat Jones move in with us. He was bad. Over time there were rapes in my house. My brother and I—he was seven and I was eight—we wanted to kill him. I mean, my brother was very loving, but with this guy real violence entered the picture. I think if there had been a gun in the house, Bobcat would've been dead right then.

"My mom had a daughter when she was thirteen, put her up for adoption. So three years ago, through a service, my mom and her locate each other and we all get to meet. At the end of the evening, my new sister admits to Deirdre [porn star Deirdre Holland, Jon's ex-wife] and me that she's Deirdre's biggest fan—like posters on her wall and everything. She tells us she's a lesbian. Very strange. Anyway . . .

"So my mom—I don't know—Bobcat moves out. Pretty soon after that, a friend of hers, a black woman named Ann, moves in with us. By this time I've already been dumped in whoever's lap would take me. Back and forth, back and forth. My mom and Ann drove me up to Bakersfield—they were gonna leave me with my mom's stepfather.

"I'm lying awake in the dark. I'm twelve at this point. So I'm listening to my mother and Ann talking. My mom was saying she was like the man in their relationship and so forth. That was when I first understood, or learned, that my mom was a lesbian.

"It didn't bother me," he says.

Jon describes the point in his childhood he remembers most fondly: He'd convinced his mom to let him come back and live with her in LA. He was thirteen.

"My mom was still so young and so were her friends, all her lesbian friends. A lot of them were beautiful. They liked me. They were affectionate with me. They would stroke my hair and stuff like that. I loved it. I remember riding my bike over to one of my mom's friend's houses on my own, to hang out with those beautiful women. Then I would go home and masturbate thinking about them. I was so turned on by those ladies."

It's crazy. The similarity between Jon's life and mine at that age takes me by surprise, nearly flips me out. His story rolls over me like a wave, an epiphany. While Jon was hanging out with beautiful lesbians in California, I was in New York sunbathing with lithe cosmopolitans. My early adolescent summers were spent—mostly unsupervised—in a group rental on Fire Island. During the week I was the only one there. A steady stream of my mom's and stepfather's and the other renters' friends—mostly sexy fashion and advertising types—made their way out to use the place. That meant constant, in-my-face, supercharged sexual stimuli, lots of attention—and the neediness that came with it—*their* neediness. It was way too much for a barely teenage boy to understand, or to insulate himself against.

While other boys were learning how to ask girls out, learning some kind of acceptable—respectful—language for addressing the opposite sex—a language that might serve them throughout their lives—I was smoking pot in a Speedo suit, curly hair hanging down my back, surrounded by horny, naked Me Generation career women. My best T-shirt at the time was one that a record exec friend of my parents' had given me. It

was tight, white cotton with long sleeves, and it made my bony frame look even skinnier. Three lines in bold black letters across my chest said it all: IF IT AIN'T STIFF IT AIN'T WORTH A FUCK.

Until now, Jon's favorite summer had always been my favorite summer, too. I don't know what it means, exactly, but at this moment I realize that my identifying with Jon is something deeper than I'd thought; that it has less to do with anything intellectual—like choice—and more to do with stuff that happened a long time ago, stuff that was out of our control. I'm thinking this guy *had* to be sexually abused—and for the first time it occurs to me that I may've been as well.

I ask Jon if he ever had sex with any of them.

"No. But what happened was enough."

I don't believe the second part. Being so close, so stimulated, so intentionally stimulated and not consummating was intensely frustrating. Confusing, painful. I don't buy it when he says it wasn't.

"Who knows, it might've killed the feeling if it really happened," Jon says. "But God, I was so turned on. Those days, I was jerking off in my classroom at school—literally—through my pocket, and actually coming. Is that common? I always wondered if other guys did that.

"So when I was fifteen, my mom sent me to live with another one of her relatives. He was this forty-five-year-old gay guy with money. I didn't mind, because he bought me whatever I wanted and I had a really nice place to stay.

"At night when I was falling asleep he would appear in the doorway of my bedroom. Man, he would become a woman."

"You mean the guy was in drag?" I ask.

"No, man. He would become totally feminine."

Jon imitates the guy's voice, sounding like a gentle woman.

"He would sit on the edge of the bed and coo at me. He would say 'I adore you.' It was bizarre. We didn't do anything, though."

Jon doesn't want me—or anyone—to think there's one gay molecule in him, that there's any sexual ambiguity there whatsoever. I don't buy that either; I don't believe it's true of anyone, much less Jon. Maybe for me it isn't an issue. I fooled around with enough boys in high school and college to know I'm not gay. But as I listen to this part of Jon's story, my cool, anything-goes attitude gives way to an unexpected burst of resentment—I can taste my outrage at a man so terrorizing a child. And suddenly I'm thinking about *my* first homosexual encounter, out on Fire Island with a man more than twice my age, and the experience takes on a hue of impropriety, of wrongness—I'm overcome with a feeling of having been wronged, or robbed of something. Used. It's a familiar feeling, but one I'd never associated with this memory before.

"So one night he actually gave me the ultimatum," Jon says. "'Put out or get out.' He told me nothing in life comes for free. So that was it for life in Sherman Oaks.

"That's when my mom sent me back to Pennsylvania to live with my real father. I was still fifteen. He was a cop in a small town. It was really tough. I was already set in my ways, real long hair. We would have fistfights. He would win, but I had heart.

"I got a job at Kroger's, the grocery store. I bought a Nova and souped it up. That's when I started stealing cars, for joyrides and parts."

Jon is sure of himself when he tells his "bad kid" stories. Proud. He recounts reck-

less teenage escapades and says the other cops in his town would cut him slack because they knew his father would kill him if *he* ever found out.

"One day I'm in Kroger's and Bobcat Jones walks in. It was so weird," Jon says. "I was scared. I'm like eighteen and I haven't seen him since I was eight. But I looked at him. When I was a kid, he was this cut, buff black dude. Now he had quite a beer gut. He looked totally spent. It was sad. I'll never forget it. We said hello. I said hello first. I don't think he would've even recognized me. I remember feeling like he was gonna die. So after we said hello I went into the bathroom in the back of the store. I just sat there. And all of a sudden I forgave him. I forgave Bobcat. It was so weird. About six months later we found out he died."

Jon stops speaking. I'm overwhelmed, saddened. Angry.

Jon's dogs bark in the background. I try to imagine his house in Topanga Canyon. I feel close to him but also freaked out by it. I mean I always kind of knew it wasn't just that we're the same age or that I'm open-minded.

I think "There but for the grace of God go I"—or something absurd like that—about how lucky I am that all I ended up doing—besides years of reckless promiscuity—was following these feelings through by making a book.

"How do you spell Kroger's?" I say, all dumbed out.

Jon laughs, and I'm relieved he's OK.

He continues, describing getting back to LA, getting deeper into the car stealing, into being bad, bad, bad: all the macho stuff. I can't take it in. I'm still trying to absorb the childhood years. Both of ours.

"Since I don't do drugs anymore, I find that high somewhere else," Jon says. "Every second of the day I have to fight some part of myself that's self-destructive. Ian—*every second.*"

This I can hear.

Jon tells me that on one recent afternoon he did a scene with a new girl. When they were through they got on his Harley, and Jon got it up to 105 miles per hour on the freeway. He says he almost lost it at one curve but kept going anyway.

"And I *like* this girl," he says.

Jon's call waiting beeps. He comes back and says he has to go.

"I've waited till the last minute. Now they need me. I have to go do a scene. It'll probably be boring on the set, so maybe I'll call you back. What's your number?"

Jon says his Wizard and car phone were stolen last week.

"I believe in karma," he says. "With all the bad shit I've done, this kind of thing doesn't surprise me."

Before hanging up I ask Jon who he's having sex with today, more for a vicarious thrill than anything else.

He pauses.

"I don't . . . I couldn't tell you," he says.

Jon lets out a chuckle, like he sees the irony, then tries some more to remember.

"Honestly, Ian, I couldn't tell you."

NINETEEN NINETY-SEVEN. IT'S BEEN MONTHS SINCE I'VE SOUGHT ANY CONTACT WITH JON Dough, and longer—a year—since talking to any other subject from this book. At last contact Jon was living with Cheyenne, a part-time porn actress he met shortly after

CES '96. He bought her a puppy, a Rottweiler. Jon was barely doing scenes at all, just directing.

We were becoming friends—or had already become friends—before I was the one who pulled back. Aside from any stated intent on my part to try and brave intimacy (I was enjoying the first successfully, rewardingly monogamous relationship of my life), Jon's willingness to be close—our closeness—made me uncomfortable. Change itself isn't a decision, I was learning, but a process: I was still me; Jon was up for being friends. The porn stars open to forging relationships with me seemed willing in as unqualified a way as I'd ever encountered—love and acceptance contingent upon nothing, except the same in return. That was the hard part. Initially I had entered their realm in search of an emotional freeze, a safe haven. They were *stars,* not people. Accepting them in their totality, with difficult pasts and complicated presents, and most of all, with a wealth of good love to give, was frightening. I wasn't prepared for that.

There were easy ways out: a girlfriend not too keen on my continued involvement with porn stars, and the fact that the porn world—a world Jon was inextricably connected to—was something I'd decided I needed to distance myself from in order to get on with my life.

I wondered if *that's* why Jon—or Debi—was so emotionally brave—if, because of what they did for a living, the threat of their being really loved and accepted for who they were was only a remote possibility. Any risk of truly getting what their hearts craved was slight at best. If nothing else, this line of reasoning was a way of letting myself off the hook. But it made me feel small.

NINA HARTLEY CALLS. The star says she's framed the cover of *U.S. News & World Report* and hung it on her wall. It's a close-up of her face. Actually it's an extreme crop of a photograph I shot for this book in 1992, in which Nina's body is fully, casually exposed. Nina says she loves the cover and that she's staring at it as she speaks.

"The reason I'm calling," Nina begins, "well, my girlfriend and I are always thinking of new ways to market 'Nina Hartley.' We were wondering if there was some way you might license us that cover picture—you know, we'd pay a fee, of course. We think it would work great as a *mouse pad.*"

Grinning—no, smiling, broadly—I decline as politely as I can. I don't know that it really matters, but I've never profited from this work *as a pornographer* and don't want to start now. Nina accepts that cordially and wishes me good luck. Before she goes I ask her what John Stagliano thinks of his full-page portrait in *U.S. News,* since I have her on the phone and don't plan on calling him myself. The caption next to his studly frame dubs Stagliano "The nation's leading director of hard-core videos."

"I don't know, Ian," Nina says. "I mean the last couple of times we've spoken, it hasn't been about that. I don't know if you've heard, but John is HIV positive."

It's like an afterthought, casual. Icy. She says everyone in the porn community knows and that all of Stagliano's recent lovers have been traced, that so far they're all fine. Hartley goes on to say that her organization has finally achieved one of its biggest goals: getting health and dental insurance for X-rated performers.

"C'mon, Nina," I say. "How's that really gonna help—except in degrees—if you've got AIDS? What if one of the *busy* actors was HIV positive, even for like two weeks, before anyone knew?"

NINA HARTLEY

She's undeterred.

"At least our bodies aren't being inundated with semen," Hartley says. "Thank God for cum shots."

I'M NOT SURE what I expect to hear or how exactly to handle it, but I dial his number, maybe half an hour later, and reach Stagliano at his home in Malibu. He sounds the same—totally present, casual, and somehow completely insulated all at once, and not surprised to hear from me. He confirms what Nina said, that he is HIV positive, in a matter-of-fact tone of voice. He only bristles when asked to talk about it more, to give an interview.

"Why? This has nothing to do with the industry. This is my personal life. Listen, I have friends over. I have to get off the phone now."

A COUPLE OF DAYS later I call Jon Dough to gear myself up for another conversation with Stagliano. Jon has to get rid of someone on the other line—"my buddy asking for girlfriend advice," he says. Jon tells a story where he leaves Cheyenne in a bar in the middle of Topanga Canyon after watching a De La Hoya fight, all because she threatened to leave first.

"That's not a good thing, y'know?" The story is Jon's way of illustrating how ill-advised asking him for girlfriend advice is. But the actor is still with Cheyenne. They've been living together for a year. Jon says he hasn't done a sex scene in almost four months, that he's still mostly directing for Vivid.

Jon says his friend at A&M Records has been asking him for music video treatments, that two A&M bands, Monster Magnet and Orbit, came close to using him to direct their videos before "chickening out."

Jon says that for a while there he fell off the wagon, "hard," but that Steven Hirsch, more than anyone else, helped him get it together again, get clean. "He was fucking great. You'd be proud of me, Ian."

Regarding Stagliano, Jon won't go into detail about what he knows except to say "those new Magic Johnson drugs work great" and that Stagliano didn't catch the virus from someone in the industry. Jon admits he wouldn't want to be HIV positive.

IN THE MIDDLE of all this Andrea calls. April Rayne. I assumed long ago I'd heard the last from her. After telling her I wanted to interview her, I hadn't tried very hard to make it happen, and eventually I gave up altogether. Andrea tells a story about an ex-boyfriend she sought out and found closure with as a way of saying she's trying to handle things differently now, not push people away. I think she means that to apply to me, which makes me squirm. She says she's been seeing a therapist twice a week and that sometimes she brings her son along, too. She never made that comeback video.

I tell Andrea I want to jump right in, do that interview. She says she's ready. She doesn't back off at all, so I proceed, stiffly, having cornered myself. Date of birth: August 21, 1967. Place: Culver City, Los Angeles. Education: Beethoven Elementary, Mark Twain Junior High, Ventura High School.

"How old were you when you lost your virginity?" I ask.

She says at twelve she had her first boyfriend, a twenty-eight-year-old guy named Hector.

Andrea in 1991.

"He had the coolest Vespa," Andrea giggles.

I ask again.

"I was raped when I was nine," she says. "You have to understand: My dad always called me his favorite son, y'know, he said he wanted to teach me to be tough. So he would drop me off in places like Sawtell, y'know, bad neighborhoods, and let me find my own way home."

Andrea tells the story like she's fine about it, like it is what it is.

"I wandered into some courtyard, a building with gates, y'know, and three—I think three—black guys basically passed me around. I know there were two more, Mexicans, standing watch by the gates. Then I think I blacked out," she says. "Anyway, I was more afraid of what my father would do to me when I got home. I had a broken nose and a bloody lip—I fought—so I knew he'd know something."

Andrea says she's not sure if anything happened before that, or if her father ever sexually abused her. She describes a second rape, at fourteen: A guy pinned her against a Dumpster behind the cheesecake factory where Andrea worked. This time she spiked the guy in his eye with one of her high-heeled shoes, then ran.

"That was an easy one for the cops 'cause they knew who they were looking for—someone holding his eye," Andrea says, laughing.

"What did your father do?"

"Oh, he died when I was twelve," she says. "Thank God. You pretty much know what happened from there. At twenty-two I became 'April Rayne.' "

Andrea says she has two brothers. One is a U.S. Navy Seal. The other, the younger one, writes and makes his living as a snowboarding instructor.

"He's like my son, really," Andrea says. "You know, besides my real son. I love him so much."

Six months ago Andrea's mom joined the Peace Corps. She's teaching English in Bangkok.

"Uh . . . I just wanted to let you know," I offer as a closer, "um, since I'm basically done with the book, you know, we won't be speaking again, probably. You know, I mean I'll probably be changing my number and everything."

It takes a second before she gets it; the shittiness of it, of my timing, of my having to say it at all.

"Oh . . . ," Andrea says. ". . . OK."

She picks up the conversation again. I'm useless. She makes small talk and stewards our clumsy good-bye. Then right before she goes Andrea reverts to her "great news" tone of voice—the one she uses for dropping bombs—and says she's just been certified to operate an escort service in Sacramento.

"Certified?" I say, thinking, *Jesus, escort service?*

"Yeah, you need a license," she says. "An escort service. I'm doing it under a different name. I don't need to know about anything illegal they do"—she chuckles—"just as long as I get my percentage. I have three girls so far. It's hard to find good ones around here. I'm thinking about moving back to LA, 'cause I'd make a lot more money down there."

Andrea says there are certain clients—"my favorites"—that she'll always keep for herself. Then she says she looks great, that she's more voluptuous than she used to be. Andrea says she has a boyfriend, a fireman, and that another friend told her she looks like *Police Woman*–era Angie Dickinson.

"I thought that was a really high compliment," Andrea says.

THE LAST THING I want to do is have this conversation with Stagliano. It's intrusive, and probably insensitive too, but I finally get the guts up to call him—it's almost a month already—when there's nothing else left to write, when finishing this book depends on it.

"This is not depressing," he says. "I don't want any sympathy. The drugs I'm taking are fantastic."

Stagliano says being HIV positive is completely different now than it was just a year and a half ago.

He says four or five months ago—before him—an actress named Nena Cherry tested positive. He says she worked with a few guys, but that they're all negative.

"Thank God it's such a difficult virus to spread. It's so hard to spread, it'll probably never really hit this industry." Stagliano says *Nena Cherry's* is an industry story, not his, then mentions it's his personal life again.

For some reason, the words "how did you get it?" won't come out. Instead, I remind him the personal lives of people in his industry is part of what this book is about.

Stagliano angrily blurts out the answer to the question I can't ask.

"I got HIV from getting fucked in the ass in Brazil by a transsexual with a cut on his dick," he says. "I make no secret about it. But I don't want to talk about it any more than that."

I nervously mumble something about wishing him good luck, but the discussion is over.

JON DOUGH, two days later. He says that what Stagliano told me is the truth, then adds that Stagliano is "doing great," that he's "not depressed at all," that they were just on the phone. Jon seems up, himself.

"You can tell this is the *sober* Jon Dough, right?" he asks. "The Jon Dough that gets angry, and all that shit." Then, "Man, you have to fly out to LA this weekend."

Jon says that on Sunday he's going to have sex with 101 girls, that that's more girls than any guy has ever "done" in one movie.

"It's gonna be fucking wild, Ian. I'm calling it *Gang-Bang 101,*" he says. "The number just sounded good. It's like a prerequisite course, y'know? I don't know how everyone found out, but it's already on the radio out here. Howard Stern is gonna pick it up, too. Ian, this is gonna make me famous."

Gang-Bang 101. My send-off. One last reminder—in the form of an over-the-top bit of inspired, goofball kink—that nothing—not love, not AIDS—will stand in the way of the impulse-fueled juggernaut that is porn. That's obvious, and fine, I guess. Jon at the helm is the letdown. In a way, the grandness of his gesture, the scope of it, is the ultimate *fuck you.*

All I can think to say to him is that it sounds like he's making up for lost time. Jon chuckles, ignoring my sarcasm, oblivious to my disappointment, and says the most difficult part is finding parking for 101 porn chicks.

I give in. It is funny. And I like Jon. He says he and his producers finally decided on a huge house up on Mulholland Drive. The guy who lives there owns LA's *Recycler* paper. Jon says his girlfriend, Cheyenne, is "totally into it," that she and another girl called Missy will wear strap-on dildos. "The Strap-On Girls—my henchmen. They'll follow me around," Jon says, "you know, to assist with DPs since I'm only one guy."

John Stagliano in 1992.

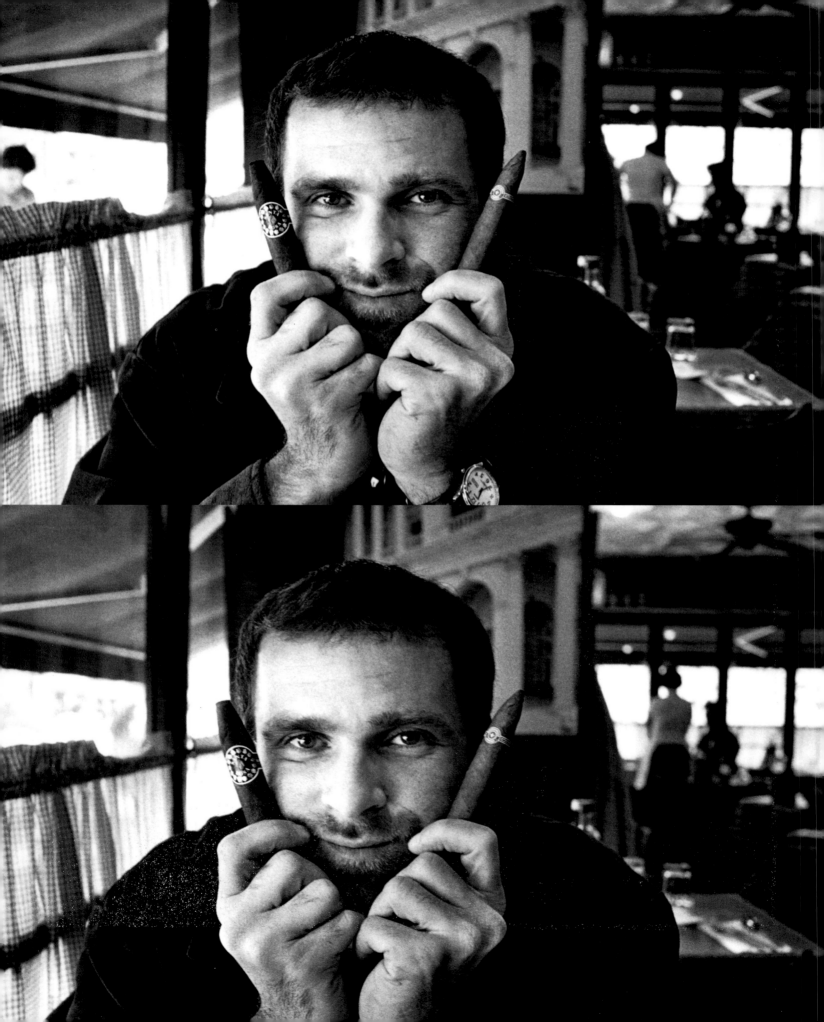

I ask him how much time he can possibly spend with each actress.

"Max tape length is 220, 'cause we won't use extended play. Extended play sucks. So 220 minutes. Figure it out. You do the math. It's not much.

"But I'm gonna employ—in one day—every girl working in the business. You know, who's in LA. Jeanna Fine, Nina Hartley. They'll all be there.

"Ian, did you ever see *On the Waterfront*?" Jon says. "Brando. All the guys hang out, try to get work that day. There's the boss, the guy who comes out and tells them yes or no. Most of the time it's no. But on that one particular day, he comes out and gives the good word. That's what I'm gonna say at the beginning of the video—you know, use his line."

Jon is laughing but he's not kidding.

"'Everybody works today!'"

Jon Dough in 1997.

ACKNOWLEDGMENTS

Francesca, Candace, and Richard DiLello

Bret Easton Ellis
Eric Schlosser
Shawn Dahl

Robert Love, Heather Schroder, Robert Asahina,
Lella, Massimo, and Luca Vignelli, and everyone at Vignelli Associates,
Richard Kelly, Donald McWeeney, Cary Frumess, Heidi Kelso,
Anthony Wilson, Elizabeth Corwin, Dave Sokolin, Marie Hennechart,
Chris Meyer, Robert Castro, Erin Fitzgerald, Michael Reichman,
Dan Siegler, Dale Ellis, Dr. Claus Herz, Mike Sager, Dahlia Elsayed,
Chris DiMaggio, Jesse Frohman, Baruch Rafic, Michael Daks,
Andrew Nehra, Michael Nehra, Al Sutton, Andy Sutton,
Gar Lillard, Sarah Ross, Scott Hagendorf, Patricia Katchur, Ethan Hill,
Ana Debevoise, Dominick Anfuso, Catherine Hurst,
Tamara Katepoo, Barbara Gittler, Stephen Lemberg

Black and white film processing by Gar Lillard at Lab One, Inc., New York
Digital work by Nucleus Imaging, Inc., New York

Black and white photographic printing by Ian Gittler

Shortly before its release,
Jon Dough's *Gang-Bang 101* was retitled
The World's Luckiest Man.